PRISONERS

PRISONERS

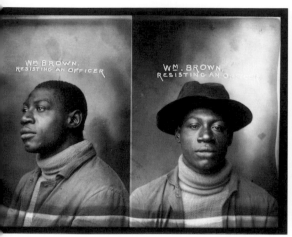
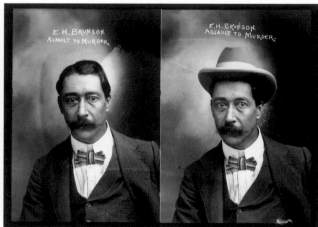
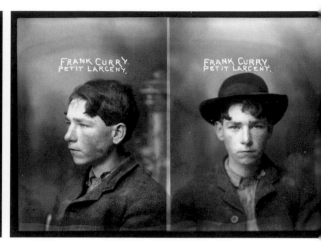

ARNE SVENSON

BLAST BOOKS
New York

The author would like to thank the publishers of Blast Books, Laura Lindgren and Ken Swezey;
Don Kennison; the staff of the Yuba County Library, especially Mary Robertson;
Karen Burrow of the Mary Aaron Museum; and his family.

Published by Blast Books, Inc.
P.O. Box 51, Cooper Station
New York, NY 10276-0051

DESIGNED BY LAURA LINDGREN

The text of this book is set in Monotype Bulmer.

ISBN 0-922233-18-7 (pbk.)
ISBN 0-922233-19-5 (cloth)

Printed in Hong Kong by Oceanic Printing Productions, Ltd.

First Edition 1997

10 9 8 7 6 5 4 3 2 1

For Charles

My grandmother died in 1978 at the age of eighty-six. In clearing out her possessions and readying the house for sale, I came across a little blue suitcase tucked away on a closet shelf. From the handle of the suitcase hung a small, faded tag that read "photographs of people I do not know, or do not remember." Intrigued, I took down the case and opened it. Within the little satchel were hundreds and hundreds of color and black-and-white photographs picturing every possible activity and occasion that a family might want to keep for posterity. There were school portraits, holiday and vacation snapshots, pictures of grandfathers and mothers and babies, landscapes and sunsets, parking lots and picnic tables. No family or location pictured seemed to bear any resemblance or have any connection to the next, and aside from the obligatory, and somewhat provocative, captions such as "where we parked at Disneyland" and "Father's father," there was absolutely no indication who these people were. I asked my family and friends of my grandmother if they could identify the people and places in the photographs, but no one could find anyone, or anything, familiar. To this day I have no definitive answer why Grandmother held onto these photographs.

■　■　■

For quite a while now I have been adding images to the suitcase from my grandmother's house. Perhaps it is an inherited trait; I have always been fascinated by images other people cast out or discard.

I have spent hours in antiques stores and flea markets, even dumpsters and garbage cans, sifting through orphaned images, looking for those that resonate and stand out from the others. My criteria for selection is not aesthetic. I search more for images that present narrative possibilities than for those that are pleasing to the eye. The photographs I seek out may at first glance appear mundane, but within their imagery they hold the promise of a story and the refutation of simple solutions.

It was on just such a search for photographs that I discovered, nearly obscured in a dark, grimy display case in a California antiques store, twelve vintage glass-plate negatives, the type used in late nineteenth- and early twentieth-century photography. When I took one of the negatives out of the case and held it up to the light I was immediately riveted by what I saw printed on its surface. It was the dual portrait of a man: he was in profile in the left frame and staring at the camera in the right; he wore a hat in one image, was hatless in the other. Across the top of each half of the negative the man's name was etched into the emulsion in reverse writing. Directly below the name were the words *petit larceny*. The negatives were stacked in a small green cardboard box with the name *Stanley Dry Plate, Eastman Kodak* printed on its stained and torn top. Written in pencil at the top of the box, barely perceptible through the surface dirt, was the word *prisoners*.

What I had discovered was negatives that when printed would each yield a mugshot. But even with just a brief scan I could see that these far transcended average prisoner photographs; there was a nuance to the lighting, the posing was natural and seemed idiosyncratic, and the faces appeared to convey more than is required for the simple purpose of identification. The fear, arrogance, resignation, and confusion in these men's expressions was legible even through the deteriorating old glass.

Hoping to gain some information about the origin of these images, I arranged to meet the dealer who had brought the negatives to the store. He was an elderly man who collected military artifacts, old toys, and photographs and periodically sold them to antiques stores in the area. He said he had come across the negatives in a rather unusual manner. His aged aunt, who lived in the small northern California town of Marysville, called him one day to report that the building near her house was being demolished and that in passing by she had seen a number of small boys throwing rocks at what appeared to her to be "glass faces" scattered throughout the rubble.

His curiosity piqued, her nephew raced to the location and over the next three days excavated hundreds of boxes of glass negatives from the site. Based on their location within the partially demolished building, he guessed that the boxes must have been stored under the stairwell from the first to the second floor in the three-story structure. His aunt said that the first floor had housed a beauty parlor for as many years as she could remember. At that point, there was no indication of who might have taken the photographs and subsequently stored the negatives.

As this man's story unfolded I realized that he must have thousands of these negatives in his possession and that he could spend years selling the collection off piecemeal. I was not sure if this unseen work represented the achievement of an individual photographer or of many, but it seemed imperative that the collection remain intact. To this end, I began pursuing the dealer in order to see the images and, I hoped, gain possession of them.

I finally saw the bulk of the negative collection about a year later, in 1993. The dealer and I agreed to meet in mid-January near the town of Petaluma, California, where he was keeping the negatives in storage. With my sister, Kristina, I drove out to what looked to be a defunct chicken farm on the outskirts of town. Behind the farmhouse three truck trailers leaned precariously in a muddy field. The dealer brought us to one, opened the back door, and invited us into a space stacked floor to ceiling with every conceivable kind of antique. It was very dark inside, but as soon as our eyes had adjusted to the light, we began to see boxes of negatives haphazardly stuffed wherever they could be fit into this mass of objects. There were also broken negatives strewn on the floor and loose negatives stacked in shoe boxes and poking through paper bags. I asked the dealer how long the collection had been at this location and stored in this manner, and he figured about five years.

Kristina and I began the arduous but exhilarating task of looking at every image as we also strategized about how to liberate the negatives from this archivist's nightmare. We sat on the open end of the trailer and held the negatives up to the sunlight. Our fingers bleeding from hours of handling the rough glass edges, and half-frozen in 30°F weather, we looked at every image we could find. We counted 1,497 negatives that day; remarkably, most still appeared to be printable despite their makeshift storage conditions and age. The dealer and I agreed on a price, and Kristina and I loaded the hundreds of pounds of glass into the car. We spent the next several days inspecting each negative, placing them into protective glassine envelopes, labeling them by subject matter and condition, and packing them for transport back to New York.

Back East, I began printing each negative in my darkroom. Of the nearly fifteen hundred negatives, approximately five hundred were of prisoners with the same dual-image format and inscribed name and crime as the initial twelve negatives I had found. The balance of the images were almost exclusively studio portrait shots of everything from brides and grooms to babies, families, and dogs. There were some location shots, such as store interiors, building exteriors, and landscapes, but these were in the minority.

The studio portraits appeared to be the work of a very competent photographer of the early twentieth century and were executed in the customary and, to our eyes, sentimental, style of the day. Most of the portraits were made using an artificial setting, a few props, and were backdropped

with a softly rendered pastoral scene. The subjects looked comfortable, though statically posed, and the lighting was frontal yet diffused and painterly. This photographer especially favored portraying young children with schoolroom props, babies on bear rugs, and women with extremely large hats.

There was a curious and homogeneously bland expression and affect on the faces of the portrait subjects. At first I thought this was a result of the limits of photographic technology of the day; a focused picture would require of the subject a lengthy pose and a sustainable expression. When I reexamined the negatives, I saw another element that I believe was much more responsible for this phenomenon: all but a few faces in the negatives had been retouched. The emulsion on the glass was delicately etched to correct the subject's appearance; unfortunately, in perfecting the subject's image, the subtler clues essential to discerning character were lost.

Fortunately, the negatives of the prisoners were spared retouching; these unaltered faces were as raw and marked as they were the day the photographs were taken. The representations of the prisoners could not stray into the territory of image alteration and enhancement. For a mugshot, the photographer had to turn up the lights, aim the camera dead center, and hope that the film captured every wrinkle and mole; it was imperative to highlight all the identifying characteristics of the face rather than selectively mask some. Only through the objective and accurate recording of the features could the individual in the photograph become readily and positively identifiable.

The longer I looked at the compelling images of the prisoners, the more curious I became about the lives of the men pictured on the negatives. Given a face, a name, and alleged crime all in one startling package, I began to feel the need to investigate further; I had almost *too much* information not at least to attempt a search.

It was likely that the town of Marysville, California, where the negatives were found by the antiques dealer, was where the crimes had occurred. The clothing worn in the photographs, the objects in the exterior location shots included in the collection of negatives, and the type of negative used led me to place these images as late nineteenth to early twentieth century.

Armed with these somewhat meager facts, I called Marysville 411 to ask if there was a town historical society. I was referred to the local museum in Yuba City, the sister city to Marysville, which lies across the Feather River and is connected by a few bridges. After I explained what I was looking for, the woman who had answered my call exclaimed, "Oh, of course, those pictures must have been taken by our Mrs. Smith over in Marysville around the turn of the century." I was astonished to be given such an immediate answer. To test my luck further, I contacted the Marysville courthouse to see if any official prison records of that era were extant. I spoke to someone who seemed to recall some large, very old casebooks from Superior Court that were being stored while

new facilities were being constructed. I called the office of the Superior Court, temporarily housed in a trailer, and after much round-robin questioning, I was told that such books did exist and the one germane to my research was the "District Court of Yuba County Defendant Book #1." This book could be made available to me, but it could not be taken from the office, nor could copies be made from it, because the book was too old and fragile. There was no question now but that I would have to travel from New York to Marysville to be able to see the book that I hoped would begin to unravel the mysteries of these prisoners' lives.

■ ■ ■

Marysville is a small town in the Sacramento Valley. It was founded in the mid-1800s at the height of the Gold Rush and was named after Mary Couvillad, a survivor of the ill-fated Donner Party who was "the first white woman in the City," according to reports of the time. Ideally situated near major rivers, Marysville became a thriving commercial port and from the 1850s until the turn of the century, an immense itinerant population flowed through the town in search of gold or, after the Gold Rush ended, in search of work in the vast surrounding farmlands.

The town's history has been marked by periods of affluence and poverty, aggressive growth and stagnation. At the turn of the century, when Mrs. Smith was an active photographer, there was a burgeoning middle class in this young town; ranches and farms were thriving, and successful gold excavation companies were still in operation. The labor force needed to support these enterprises came from the seemingly never-ending flow of post–Gold Rush drifters who traveled from all over the country to the region, many perhaps still following belated dreams of instant wealth. There was also at this time a large influx of Asians and Europeans who disembarked ships in San Francisco and came upriver to the Sacramento Valley in search of a new life.

Prostitution was legal in Marysville at the turn of the century, and the town police, accompanied by a doctor, would make official weekly checkups in the district where the women worked out of their cribs (small cubicles with just enough room for a bed). Opium use, though publicly condemned as a foul habit, was not illegal, and bars and saloons were scattered liberally throughout the town. Despite its appearance of middle-class propriety, Marysville at the turn of the century was only one generation away from its Wild West origins and still feeling the repercussions of a time when men and women went mad for gold.

■ ■ ■

My first task in Marysville was to seek out information about Mrs. Smith. I wanted to know beyond doubt that she was in fact the author of all these images, especially the prisoner photographs. I went to the local library and explained my project to the staff, who directed me to what was for my research an invaluable regional newspaper index. Culled from the town's two newspapers, *The*

Daily Democrat and *The Marysville Daily Appeal,* the index lists the name of prominent citizens and every important event in Marysville since the town's founding.

Through the index, I learned much about Mrs. Smith and the activities surrounding her photography. She was born Clara Sheldon in San Francisco in 1862, attended college in Napa, California, and moved to Marysville in 1884 to marry Frank Edward Smith. She opened her first photography studio in a tent building in 1896, and after subsequent relocations she eventually established a gallery and studio in the Odd Fellows Building, a large three-story structure in the heart of downtown Marysville.

Mrs. Smith seems to have been a prominent figure among the citizens of Marysville. A promotional pamphlet extolling the virtues of life in 1908 Marysville declared, "The most popular and skilled photographer and artist in this section is Mrs. C. S. Smith, who is an artist of talent and attainment and whose heart is in her work. This lady has had a most extended experience in the business, her studio is fitted up with neatness and good taste, while the reception room contains all conveniences.... She makes a specialty of children's pictures, executes work in all sizes and styles, and guarantees satisfaction in every instance. Mrs. Smith is a lady of unusual ability, she has a wide circle of friends and patrons and enjoys the respect and esteem of all in this community."

As I read more about Mrs. Smith, I finally came to the information I had been searching for: according to City Council minutes, she was under contract with the city from 1900 to 1908 to photograph recently arrested prisoners. These photographs were entered into a rogues' gallery kept by the local law enforcement officials. For this work Mrs. Smith was paid on a per-photograph basis, and she averaged about $9.50 a month for the eight years she was under contract.

The Odd Fellows Building was situated less than a block from the police station and city jail and was approximately three blocks south of the county courthouse and jail. Presumably, after arraignment a prisoner would be taken under guard to the building and escorted to Mrs. Smith's studio on the second floor. After she took his photograph, he would be returned to either the city or county jail and Mrs. Smith would develop the exposed glass-plate negative, inscribe the man's name and alleged crime on the glass, print the photograph, and give it to the police or sheriff. Knowing how and where the photographs were taken solved a mystery that had puzzled me for quite some time—why were some of the prisoners photographed before a painted backdrop of pastoral gardens while others were in front of a neutral background? Apparently when she photographed a prisoner in her studio, Mrs. Smith sometimes just didn't bother to change either the backdrop or the lighting she had set up for use with a previous portrait client.

I had further proof of the provenance of the negatives when I later learned that the Odd Fellows Building had been demolished in 1987. The date of the demolition corresponded so closely with

the antiques dealer's story that this had to be the same building where the large cache of negatives had been unearthed, although he had never identified the building by name. What later came to light was that in the 1970s the first-floor tenant in the Odd Fellows Building, the beauticians the dealer's aunt had mentioned, had discovered thousands of glass negatives stored under a stairwell in the building. Over the years they had removed approximately five thousand of these and donated them to a regional museum in a small town farther north. None of these images were of prisoners. They appeared to be the studio work of both Mrs. Smith and her successor in the photography business, Mr. Claude Greene. The 1,497 negatives in my possession must have been left behind and were recovered only when exposed to the light of day by the demolition of the building in 1987.

With the provenance of the negatives established, I turned now to the matter of identifying the prisoners. I visited the temporary offices of the Superior Court, where I found waiting for me, as promised, Defendant Book #1. This ledger listed all persons arrested and tried in Superior Court on felony charges from the years 1863 to 1922. Not only were the names given, but the date of judgment and, if the defendant was convicted, details of the sentence imposed and where the sentence was to be served (either Folsom or San Quentin Prisons). I cross-referenced the names on the negatives to the names in the ledger and was able to discover trial dates and sentences for about seventy of the five hundred prisoners of whom I had photographs. This information confirmed that these photographs had been taken between the years 1900 and 1908, which also coincided with the years Mrs. Smith was employed by the city.

I began to contact other municipal agencies within Marysville in search of information about the other 430 prisoners. The crimes ascribed to these men and boys as written on the negatives were misdemeanors ranging from petit larceny to mayhem. Unfortunately, everyone I contacted within these agencies told me the same story: records of lesser crimes such as these were kept by the appropriate department for ten to twenty years and then purged from the files.

This was disappointing news, but still I felt that all five hundred of these images had to have been taken around the same eight-year period. Stylistically the similarities were striking: the point of focus, the lighting, and often even the backdrop were identical throughout the photographs. But with such little information, I began to founder in my search for the facts about the majority of the men in my negatives.

I returned to the library where I had found so much information on Mrs. Smith. At that time I had also been able to read a number of the newspapers archived at the library and had been fascinated by the peculiarly inconsequential minutia that often received equal billing with other regional and national news. Stories such as "[Man] Goes without a Hat," "New Way to Bag Coyotes," "Arthur Margett Is Certain He Is a Cat," and "Insane Man Wore Corsets" were considered

newsworthy and reported in impressive, and sometimes humorous, detail. It seemed likely that crime stories of any magnitude would also have been reported in these annals of Marysville's daily life.

The library in Marysville has in its collection most, but not all, of the original issues of *The Daily Democrat* and *The Marysville Daily Appeal*. Leather-bound into large volumes, they are locked up in a room separated from the rest of the library by glass walls. Insufficient funding has made microfiche recording impossible, so the only way to see these papers is to sit in this room and review the actual aged, crumbling pages.

I began with the list I had made of the dates from the Superior Court casebook of when a man had been either convicted or sentenced. I then searched both newspapers on those dates for any mention of a trial. If I found nothing, I would check earlier newspapers, since sentencing often was not passed until some days after conviction. When I found a trial narrative mentioning the specific date of a crime, I tried to find articles reporting the crime.

If, as in the majority of the petit larceny and misdemeanor cases, I had no data showing trial dates, I started with the first day of the new year and looked through every page of both newspapers, scanning all the time for small articles with headlines using such terms as *crime, arrest, disturbance,* and so forth. Upon coming across such an article, I would check the name of the alleged perpetrator against my list of prisoners' names.

It was by this method that, over the next two years on numerous trips to Marysville, I was able to reconstruct the crime stories of more than two hundred of the men. For a handful of them I was also able to locate records at San Quentin and Folsom, where many were sent to serve their time. The lives of the three hundred or so others remain a mystery. Either their crimes were too mundane to report or, since the newspapers I was reviewing were literally disintegrating in my hands, the accounts of these crimes may have materially disappeared forever.

When the negatives bearing the prisoners' images were first unearthed in Marysville, they were little more than anonymous "glass faces" that made convenient targets for small boys throwing rocks. At first when the negatives had been rescued and had come into my possession and safekeeping, the men portrayed still retained their anonymity. Slowly though, the men became more recognizable and each individual became more distinct—the tilt of his hat, the condition of his skin, the look in his eyes. Soon they became familiar as individuals and I began to refer to the prisoners by name: John Holland, Ed Skur, little Claude Hankins. I wondered about their photo sessions with Mrs. Smith—had they been intimidated or reassured by having their mugshot taken by a woman? Did they drop their defenses when they sat for the middle-aged photographer or did they view her and her camera as an extension of their captors? Was it

this combination of fear and reassurance that produced such disarmingly frank and compelling images?

I still know so little about the prisoners I have researched so exhaustively. I have been allowed only a narrow view into the lives of these men who don't exist for us outside the parameters of the crime reportage—there is no life accounted for before the act or after the sentencing. Did some go clean, did others appear in subsequent rogues' galleries elsewhere, did some die soon after? We shall never know.

The photographs reproduced in this book were all printed directly from the glass negatives. To retain the unique properties in each image, I made no attempt to clean or alter the deterioration and wear on the emulsion surface of the glass.

PLATES

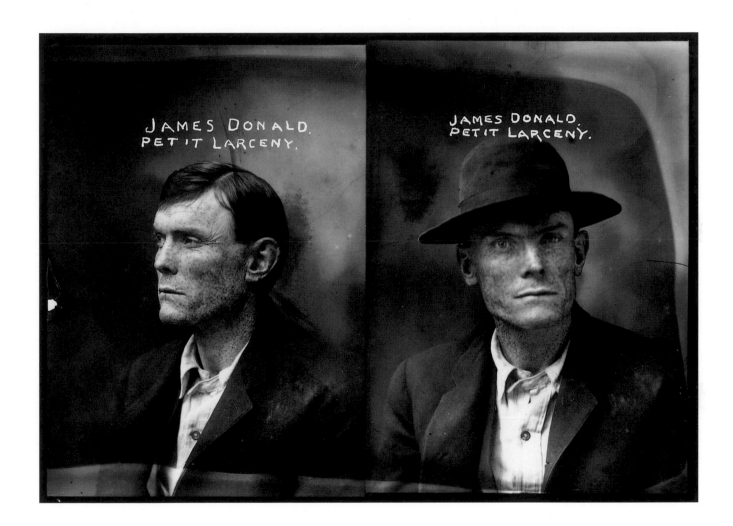

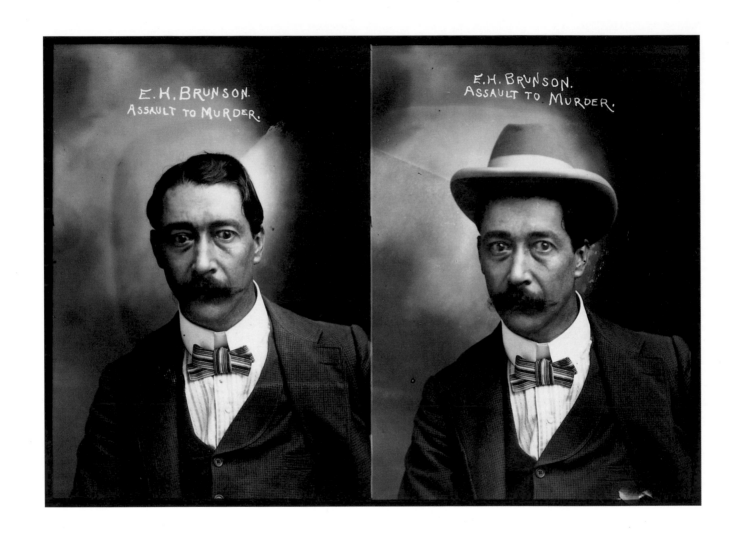

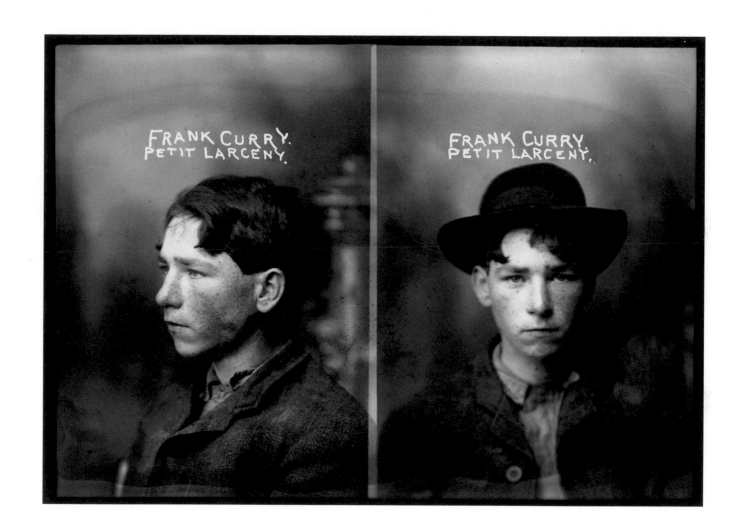

3

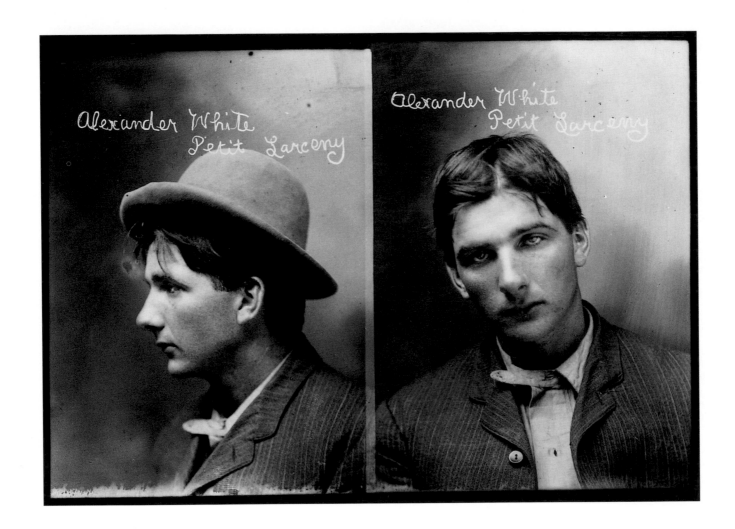

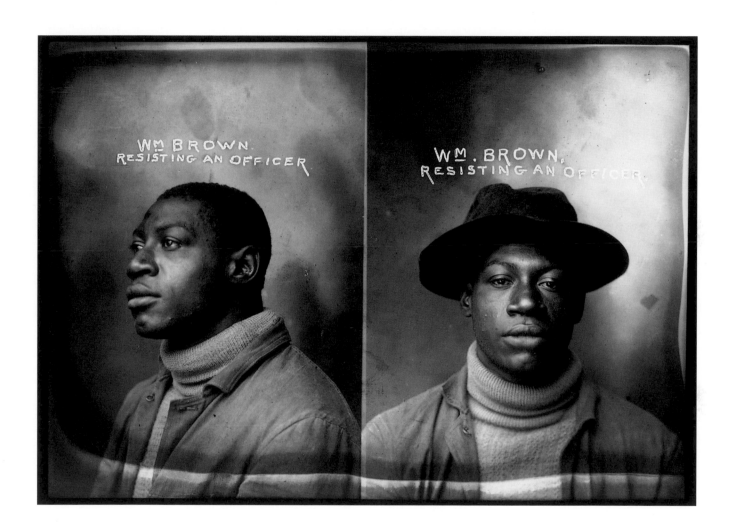

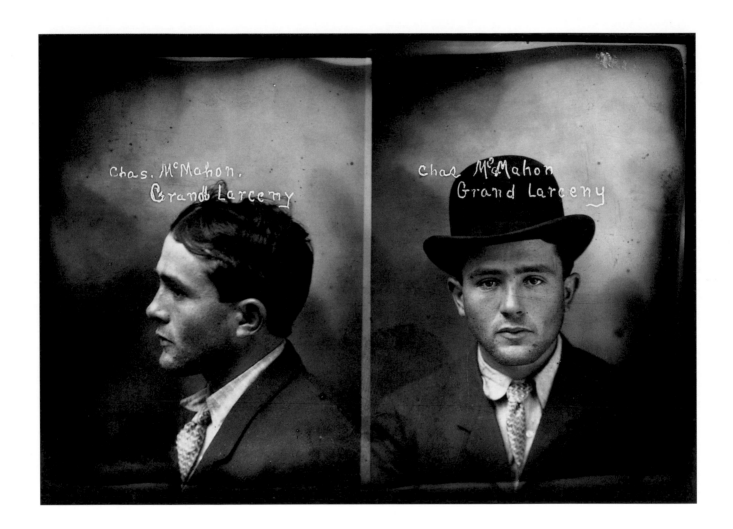

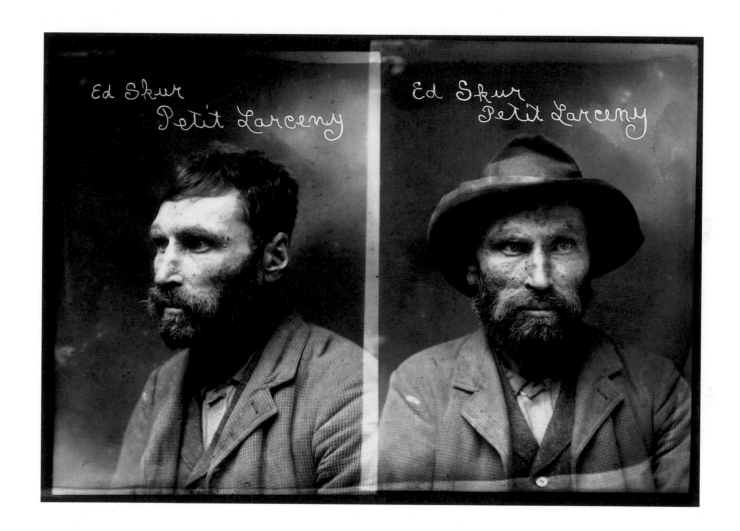

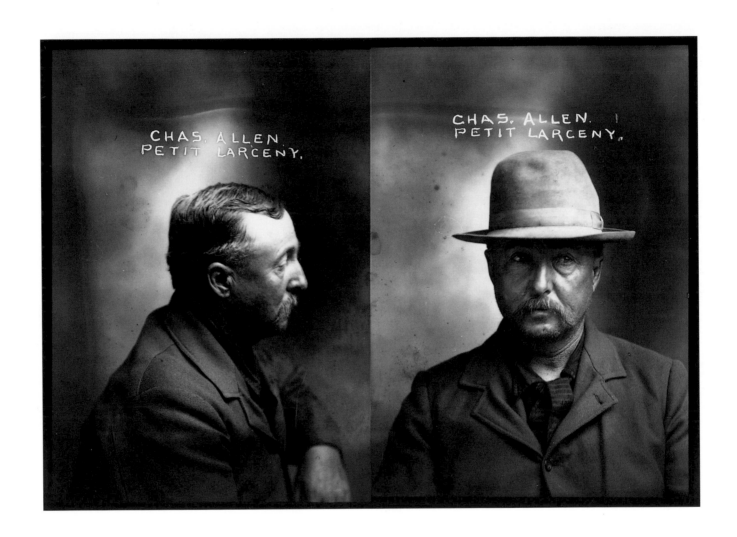

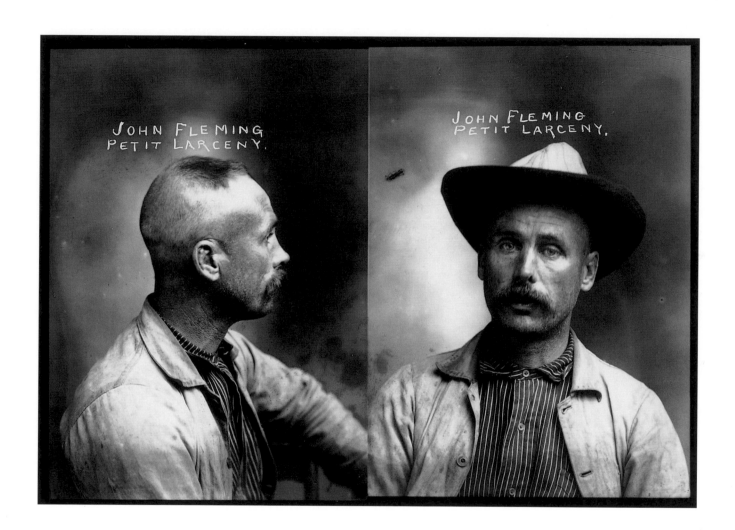

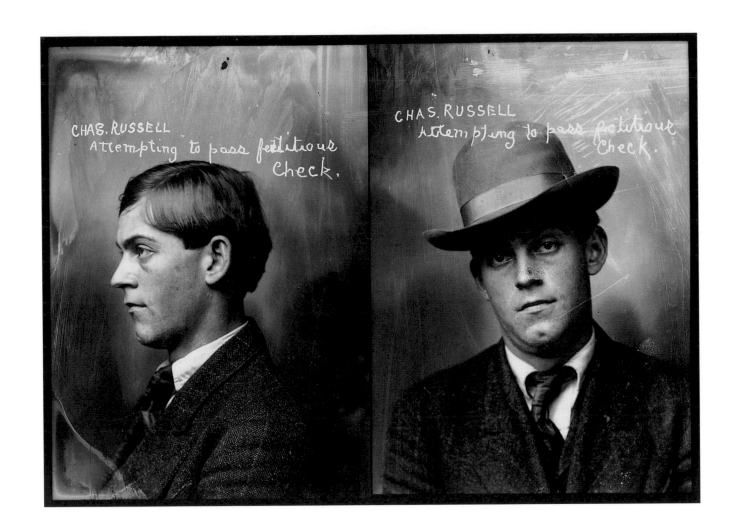

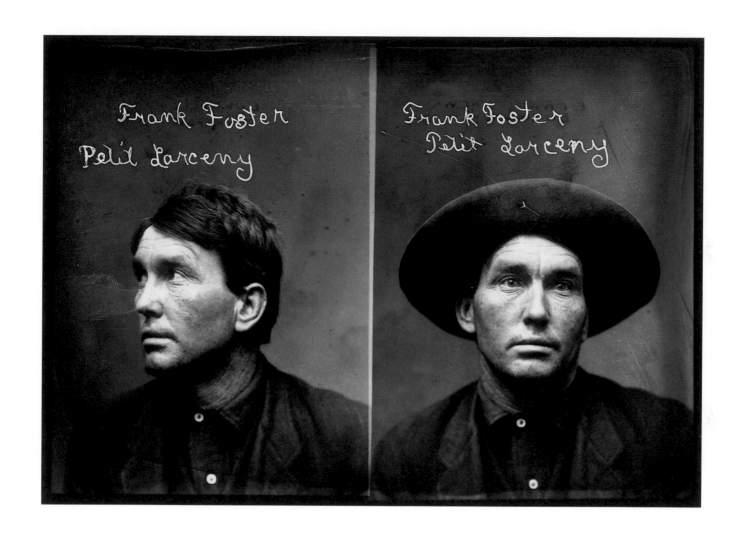

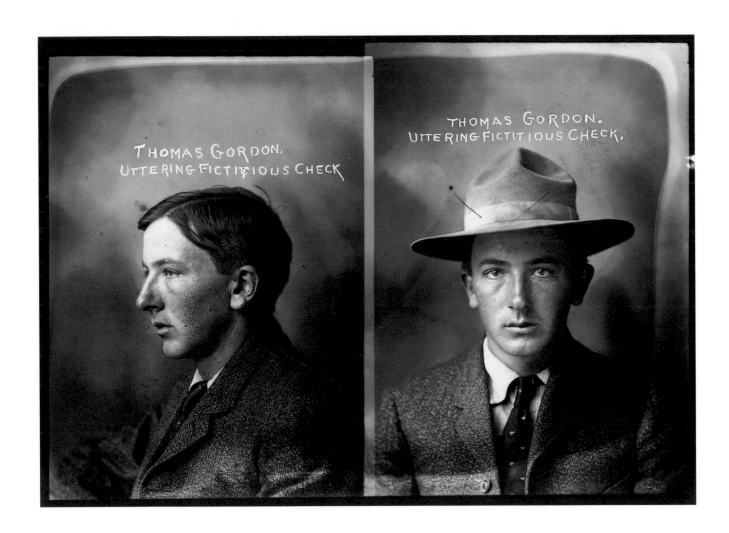

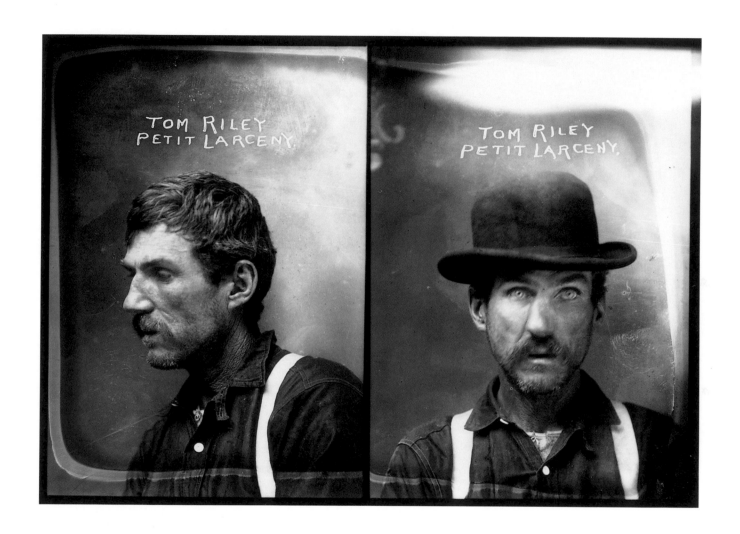

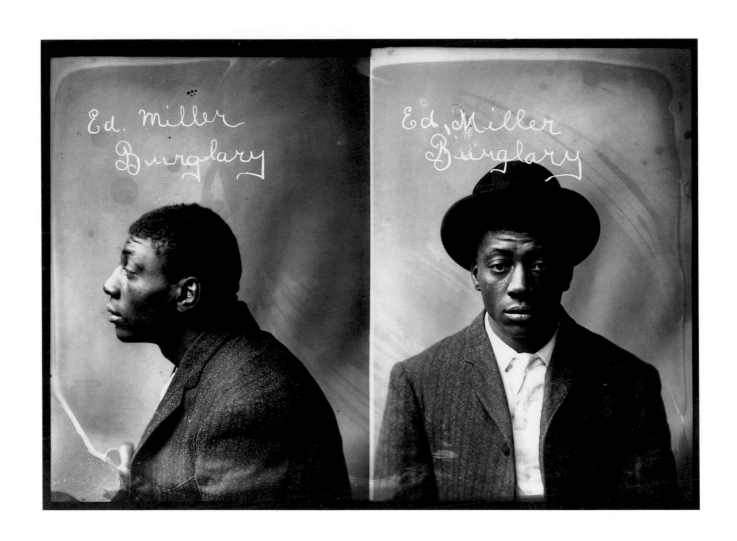

14

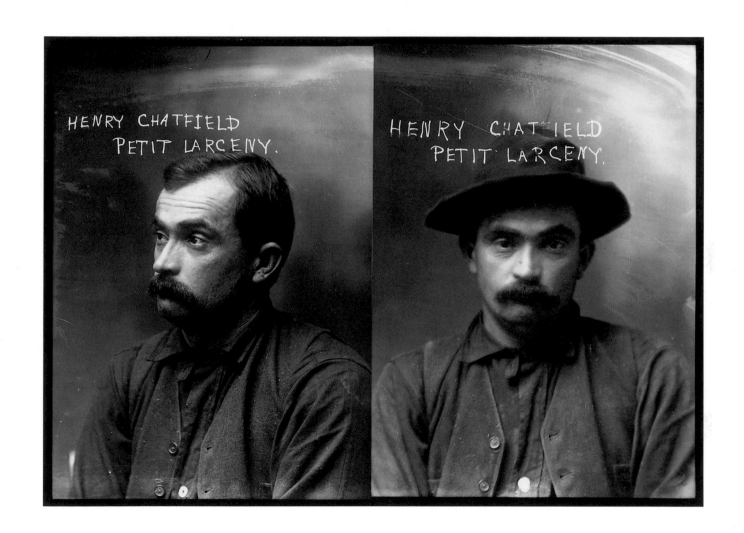

15

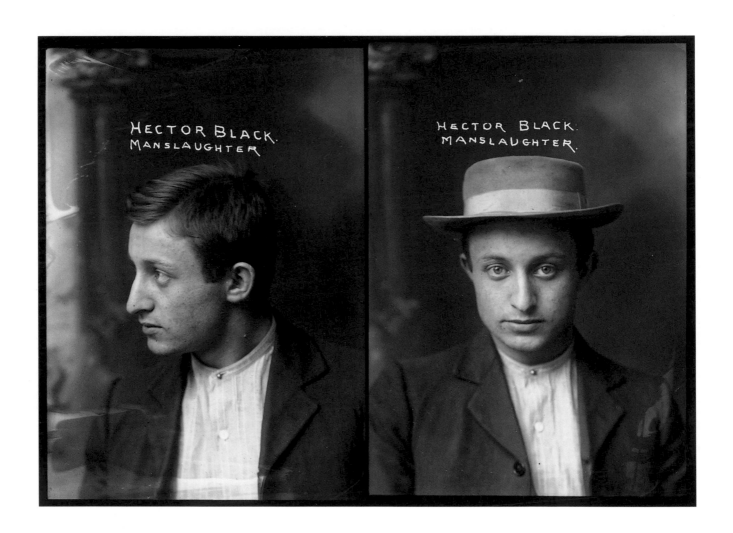

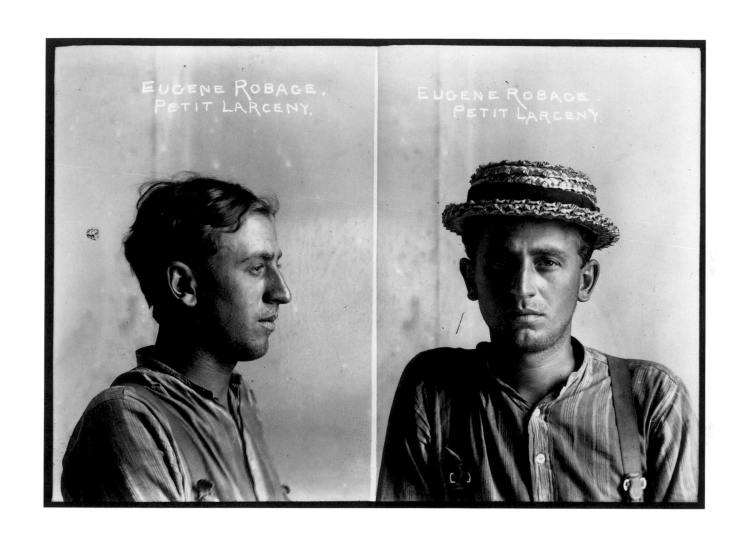

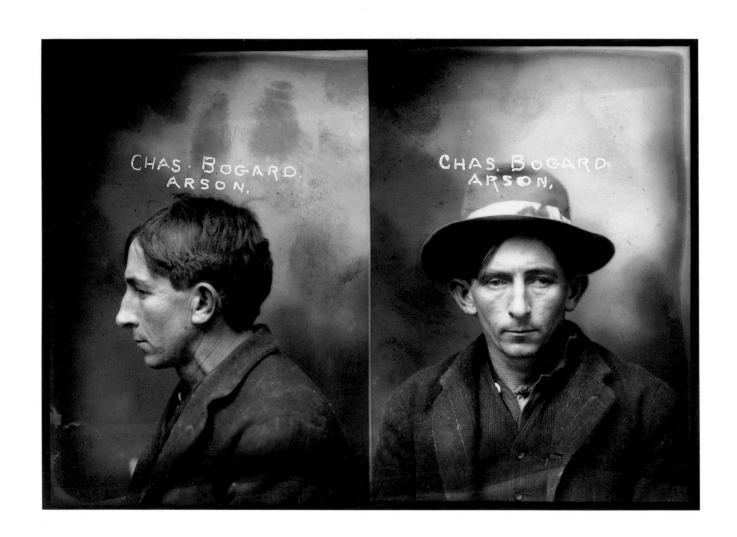

18

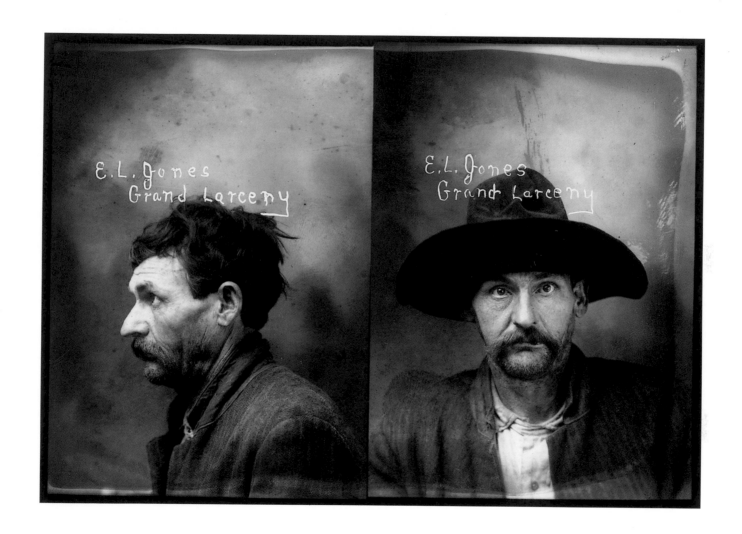

19

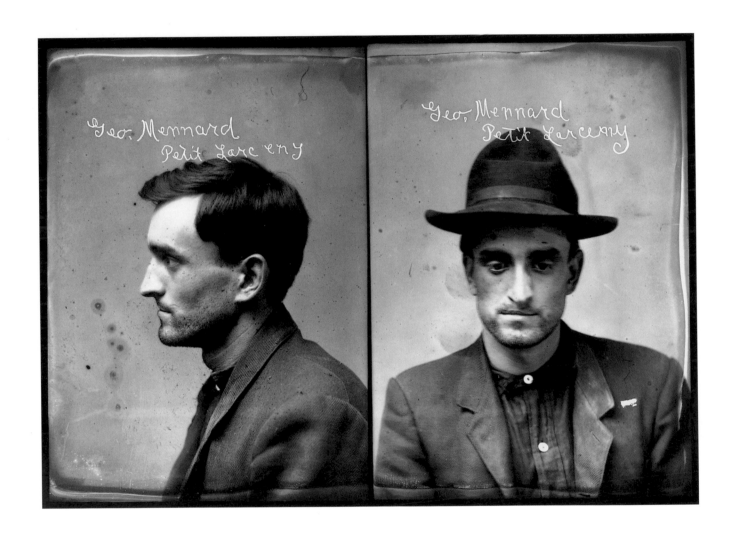

20

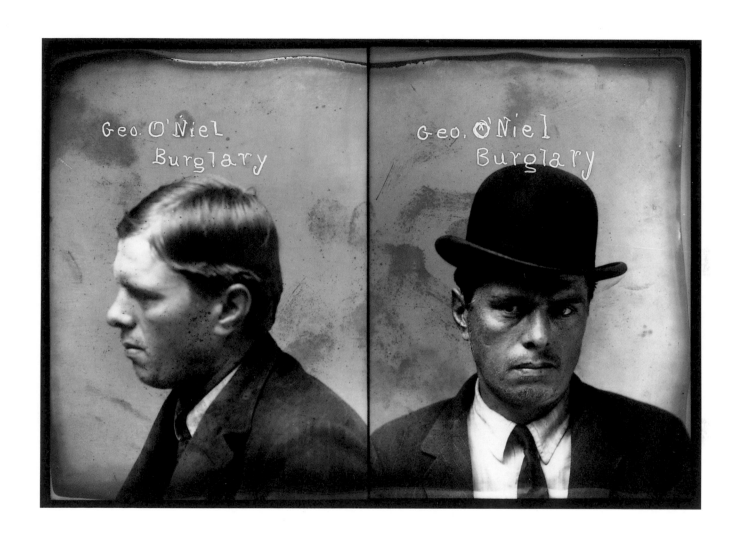

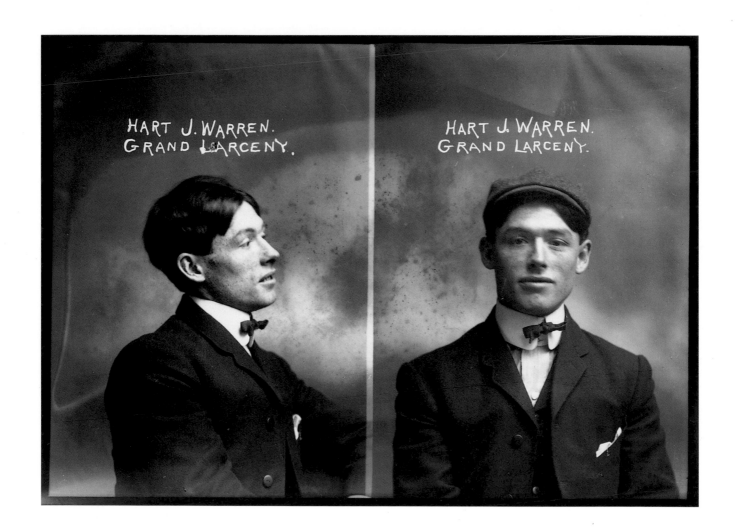

22

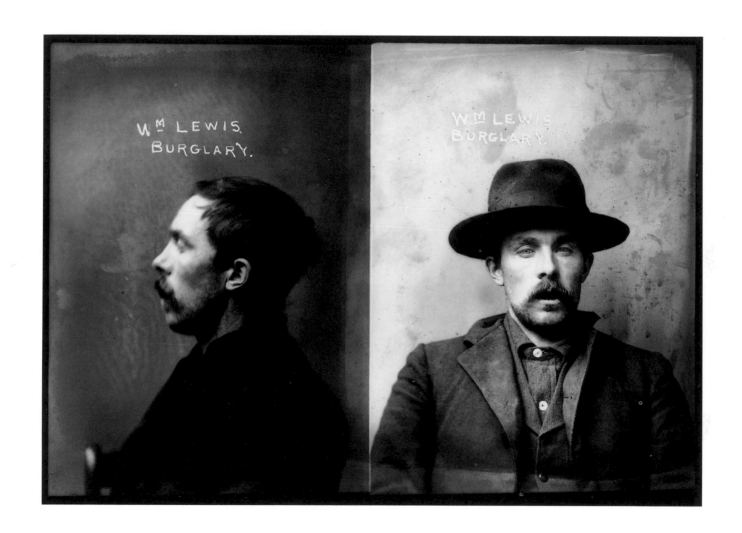

23

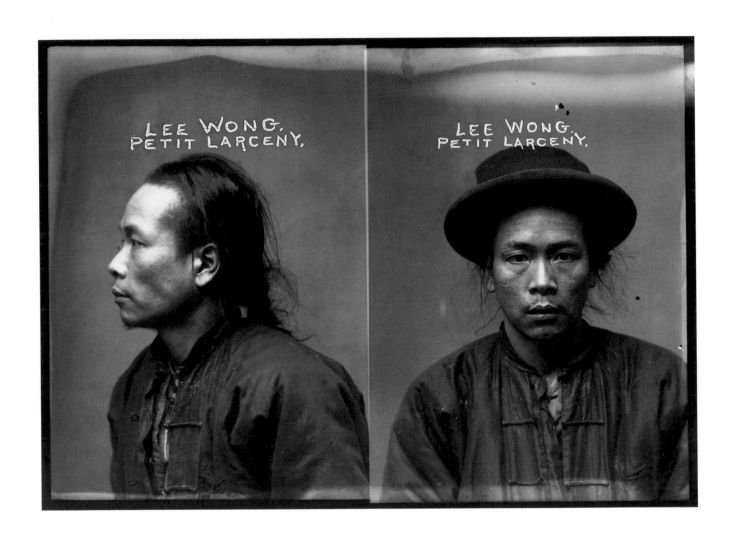

24

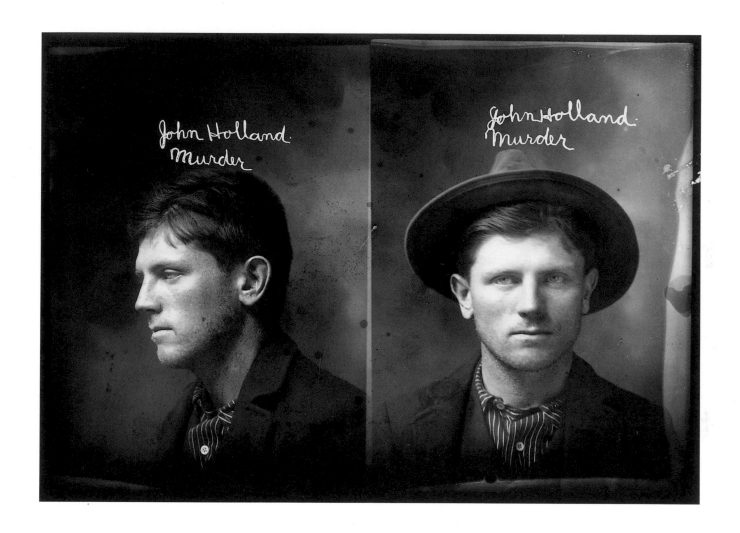

25

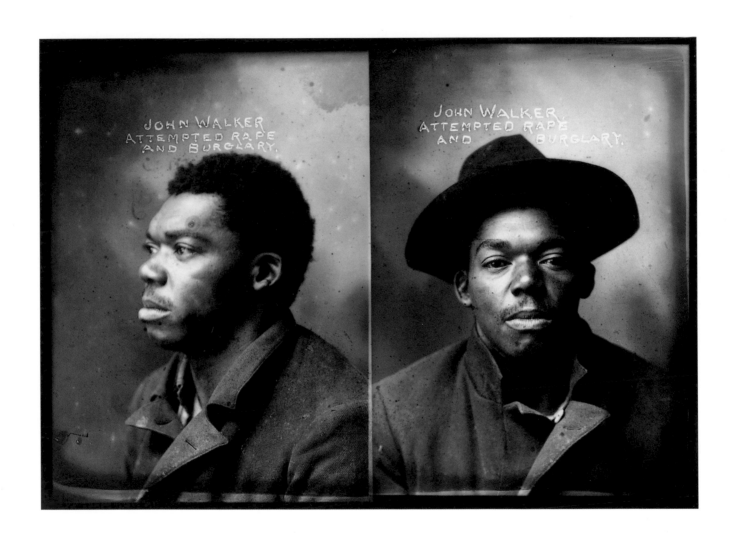

26

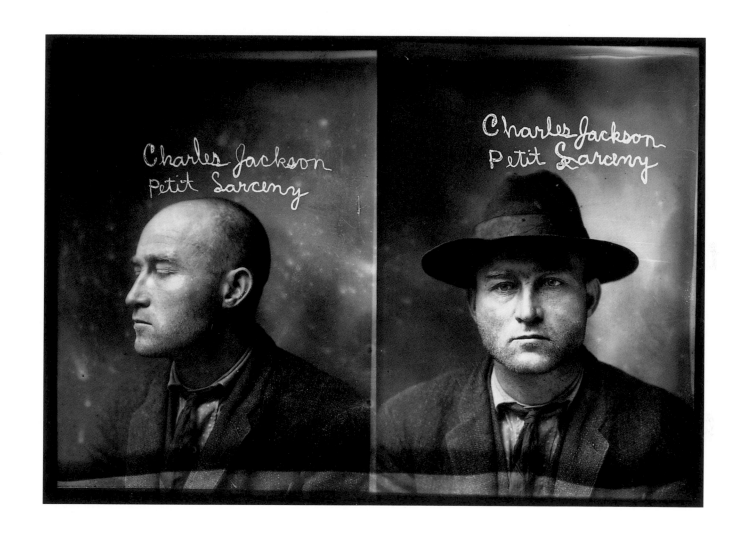

27

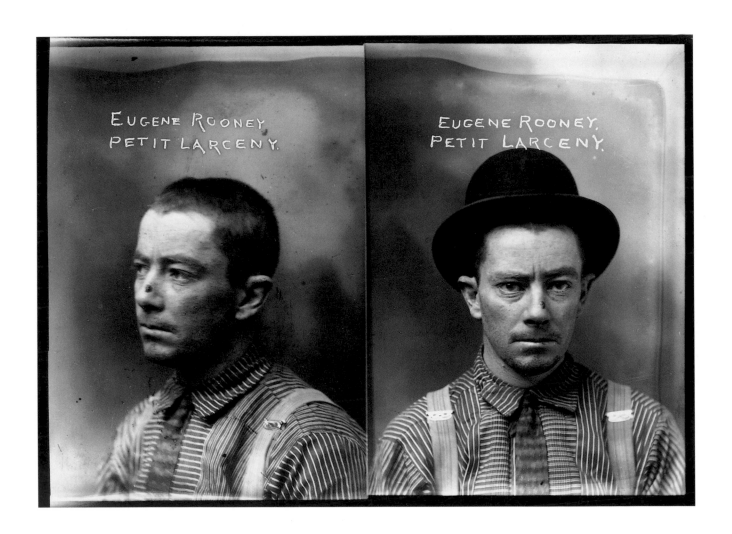

28

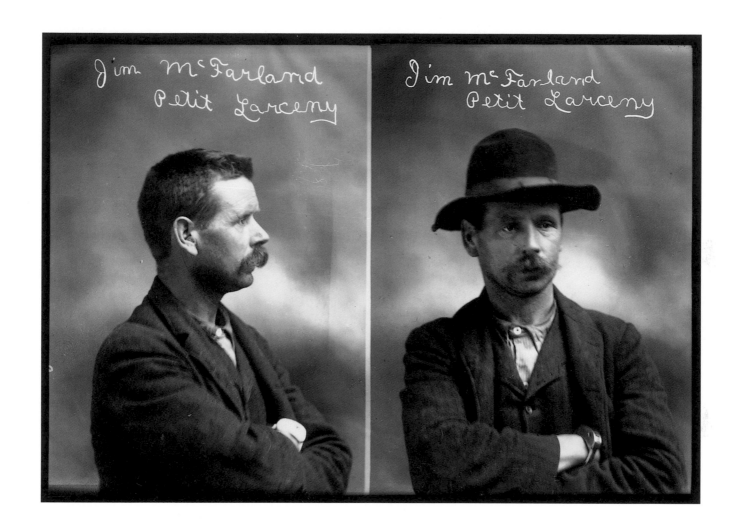

29

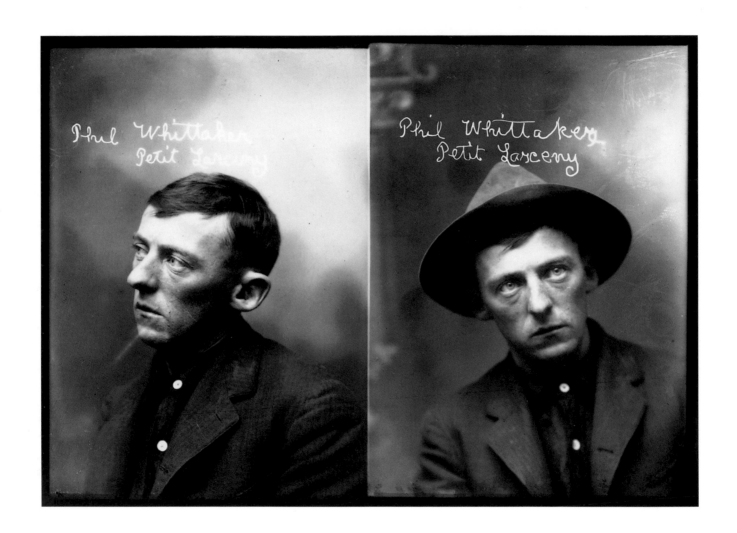

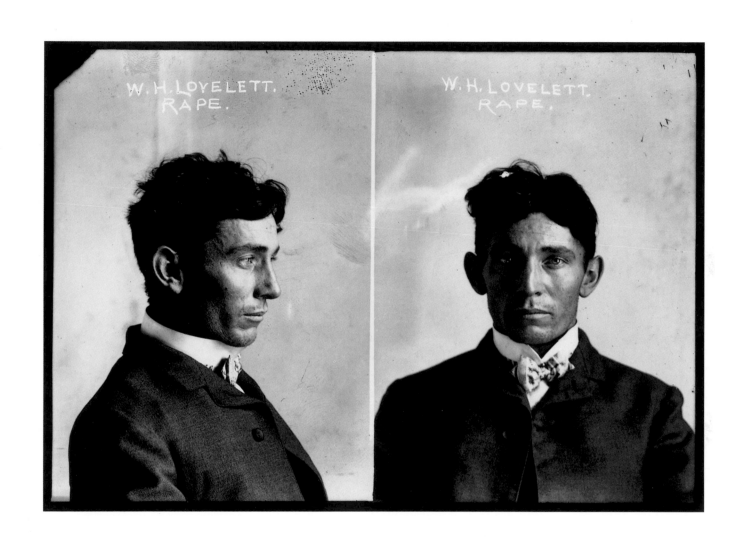

31

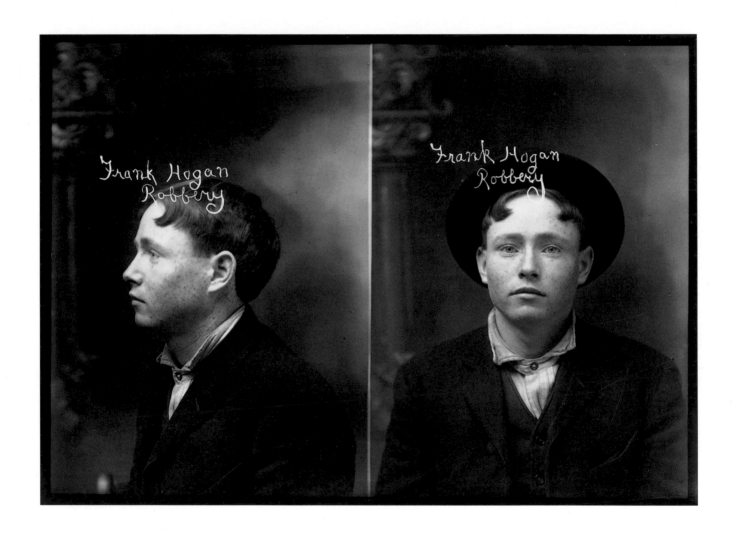

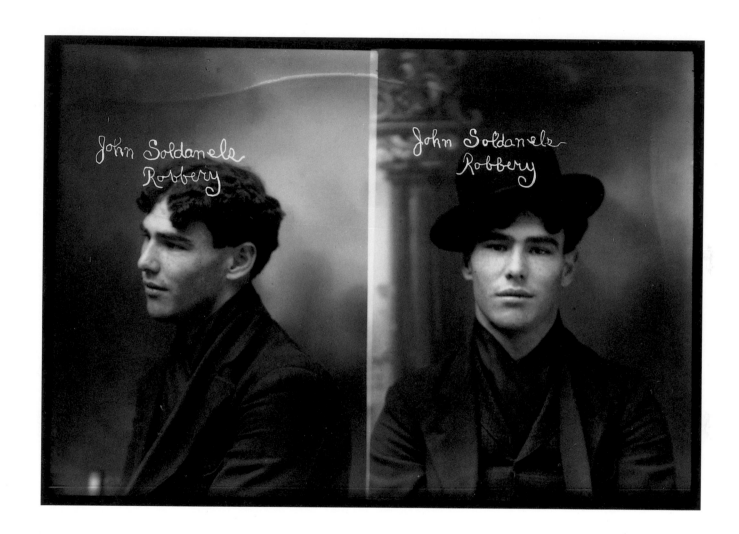

33

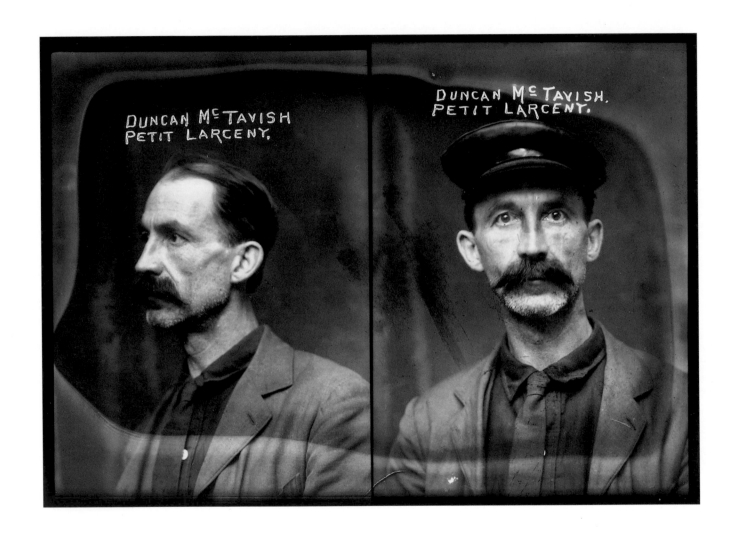

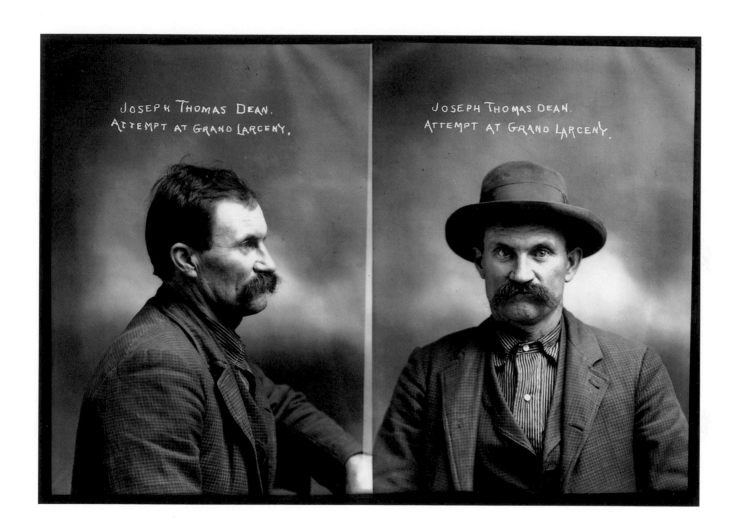

JOSEPH THOMAS DEAN.
ATTEMPT AT GRAND LARCENY.

JOSEPH THOMAS DEAN.
ATTEMPT AT GRAND LARCENY.

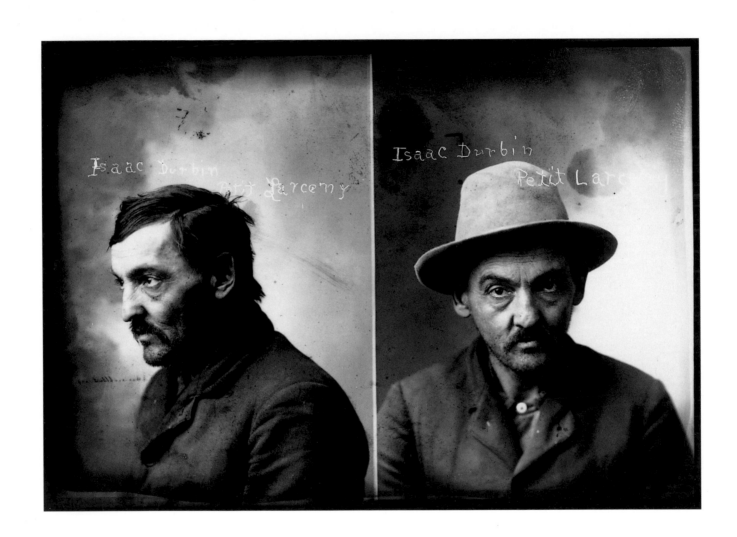

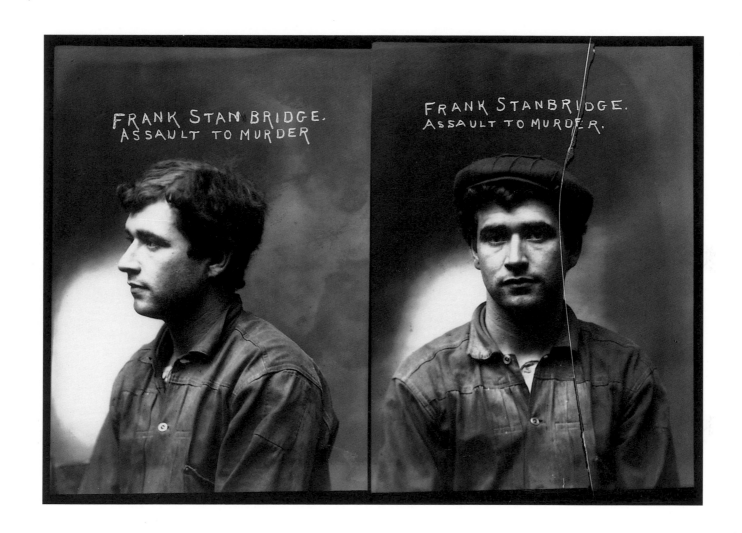

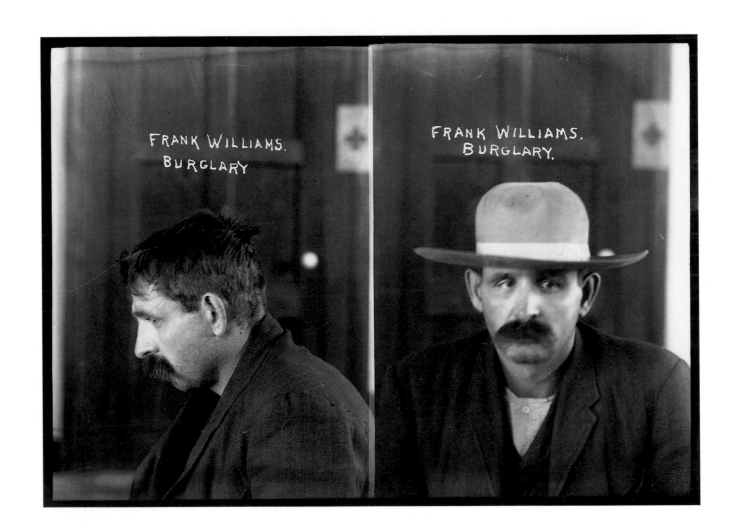

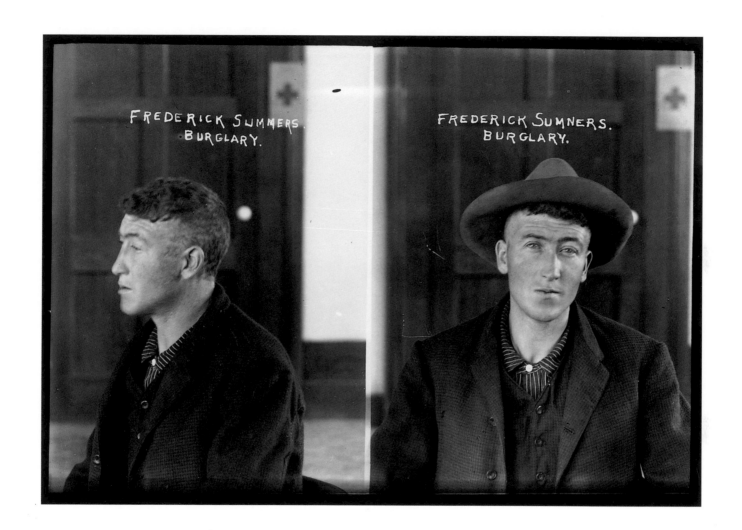

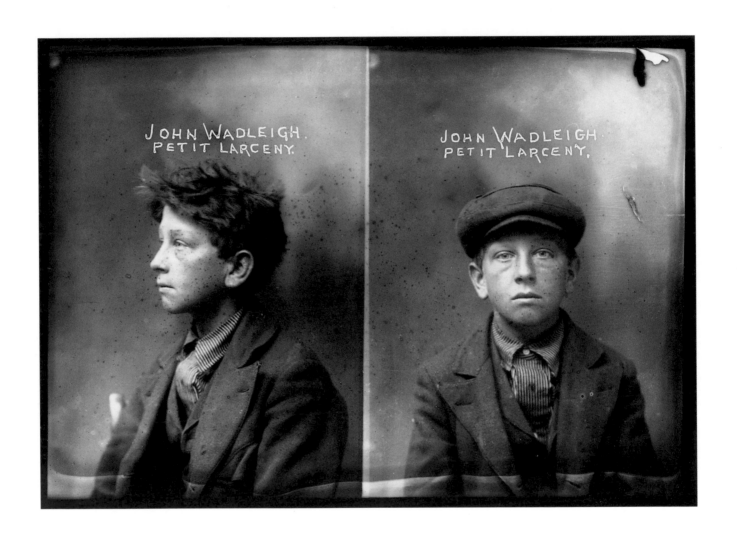

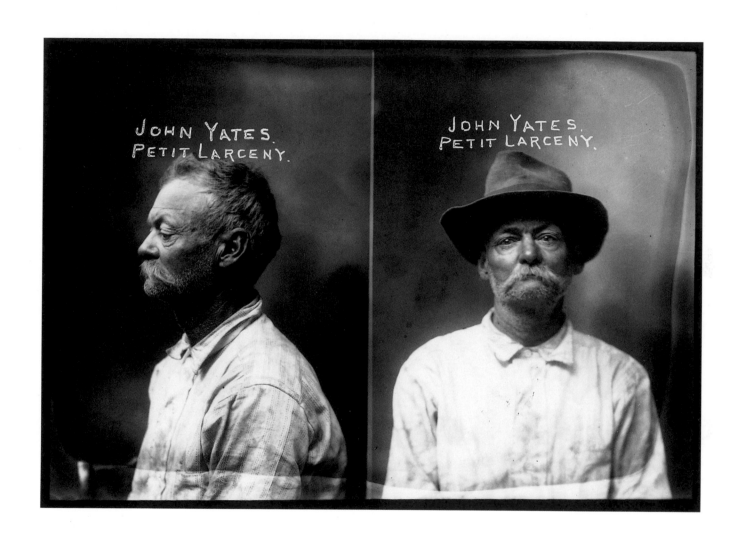

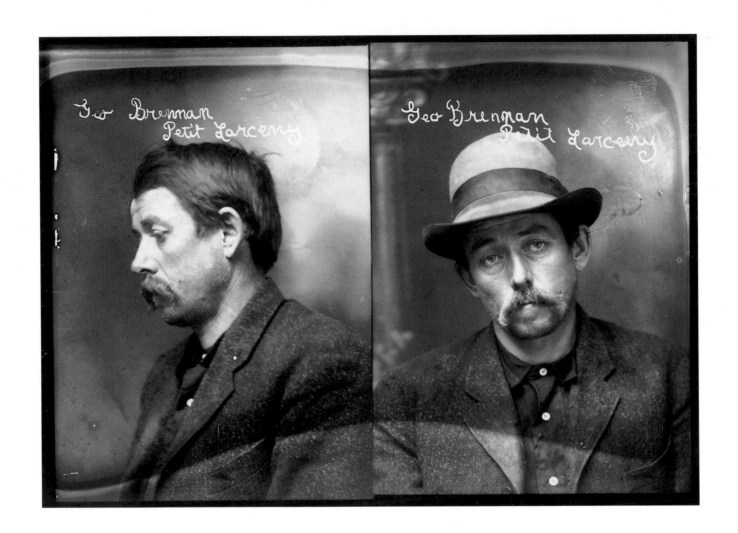

42

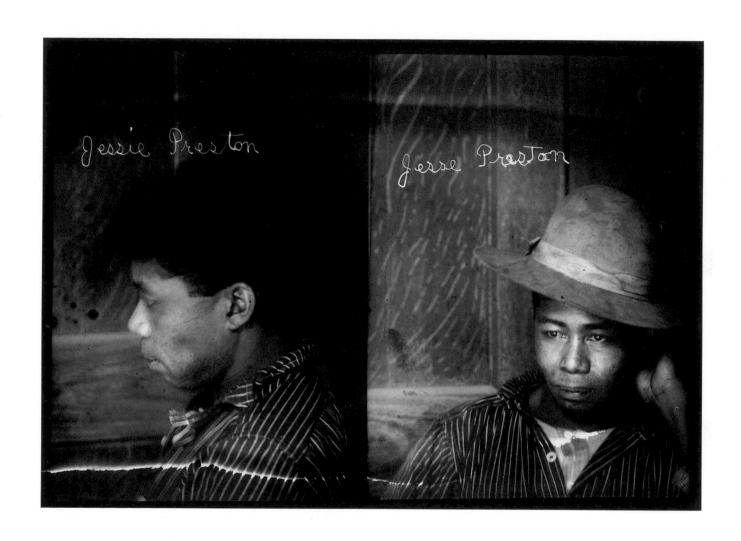

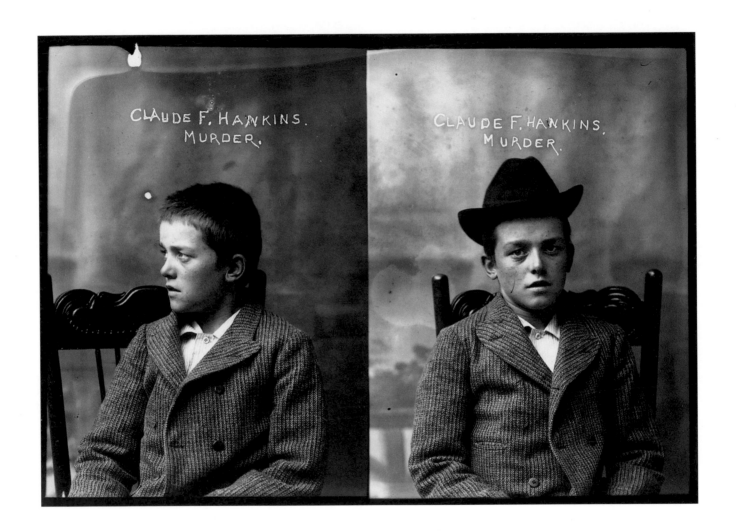

44

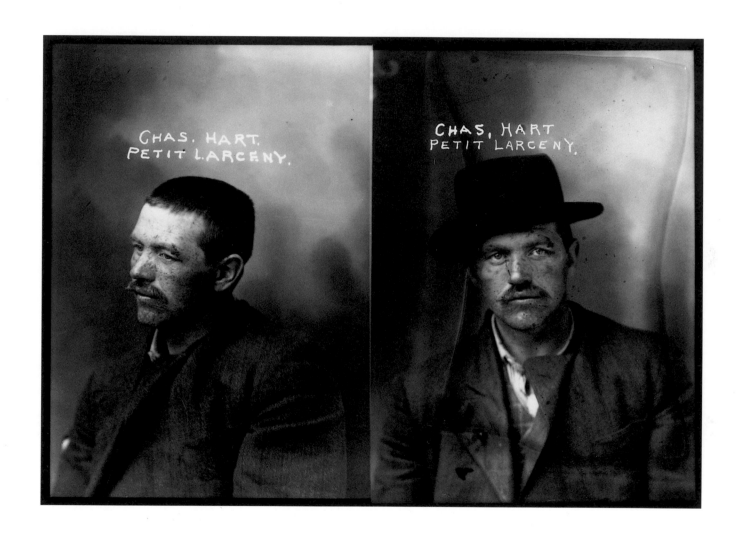

45

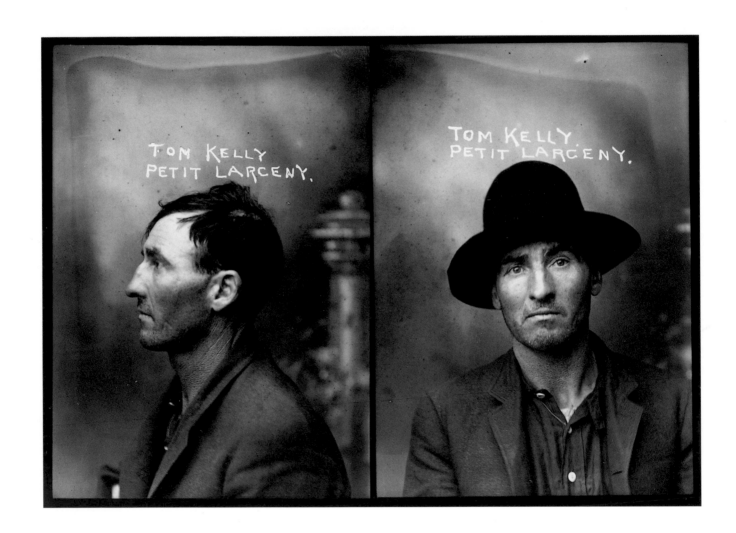

46

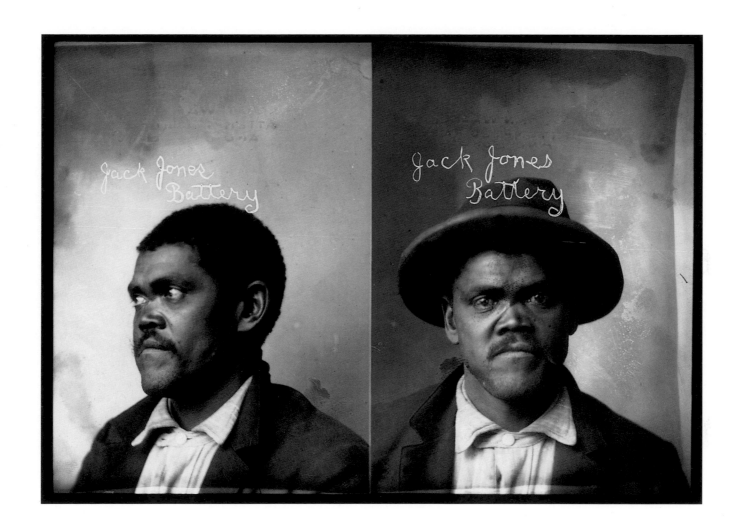

47

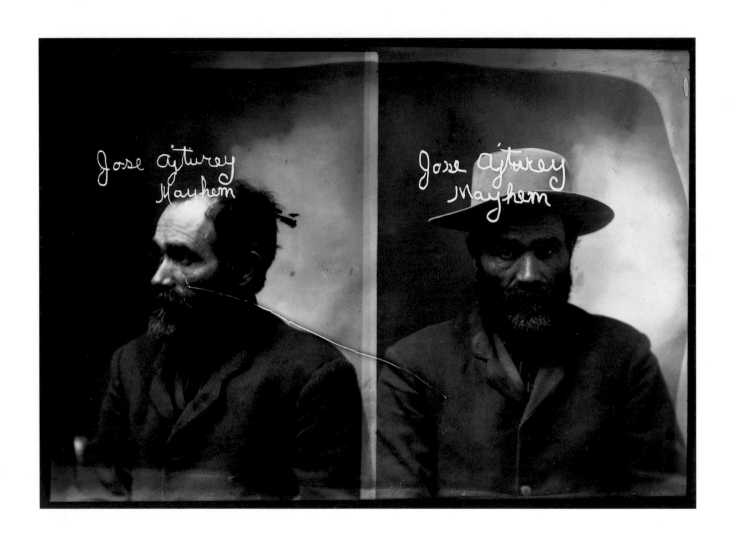

48

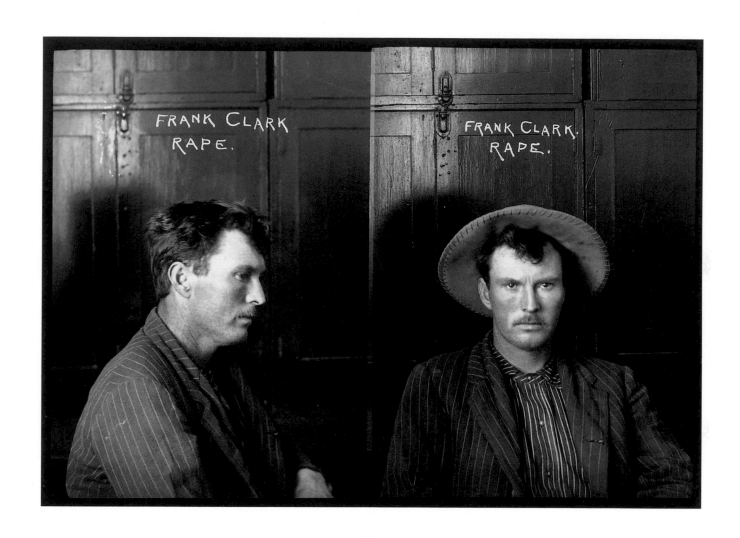

49

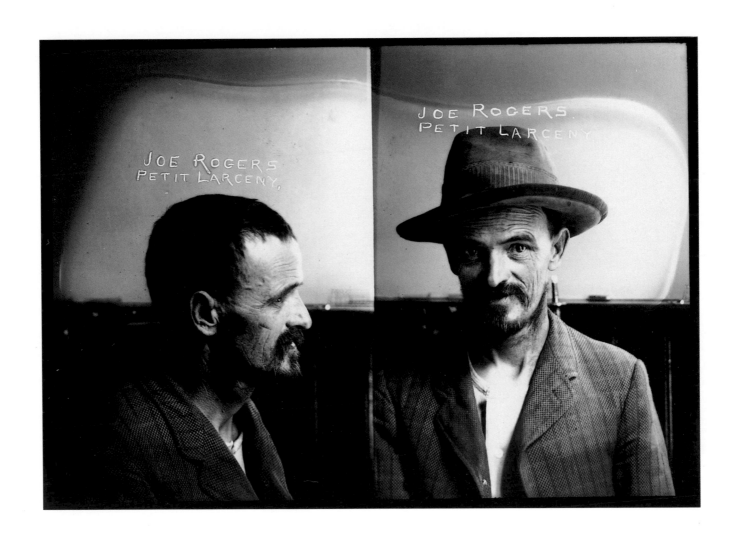

50

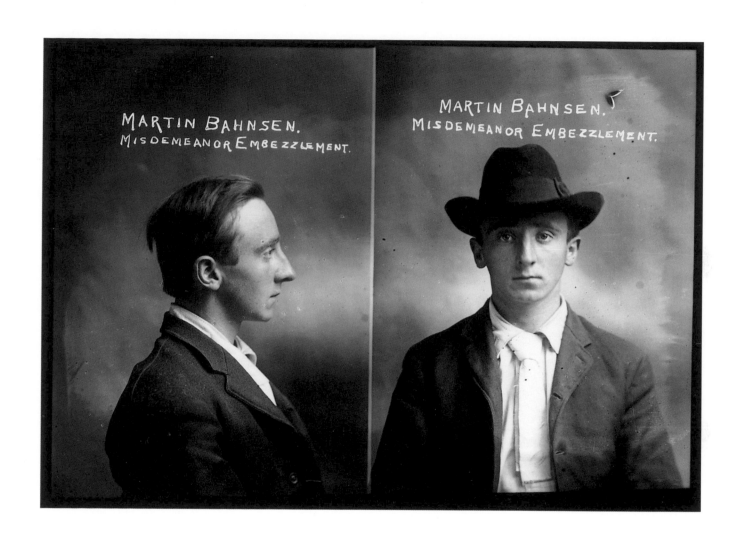

51

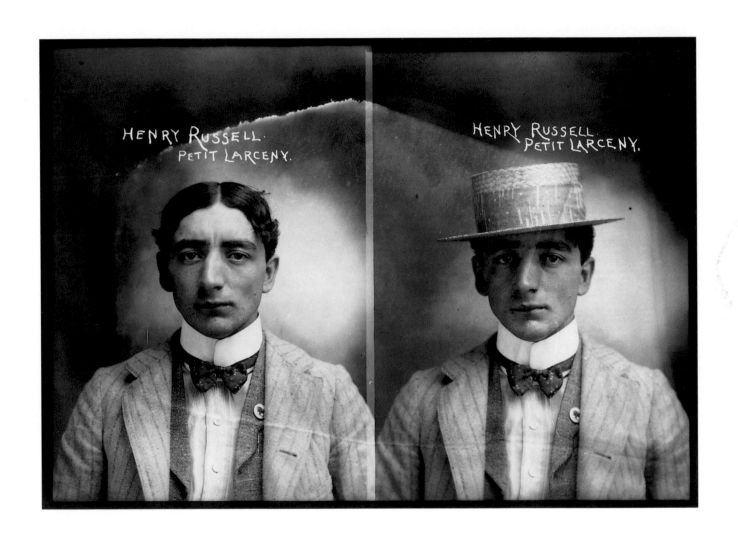

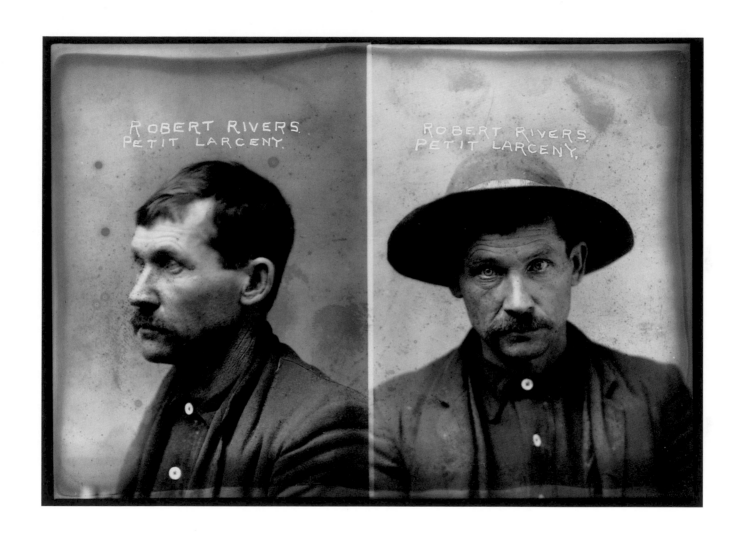

53

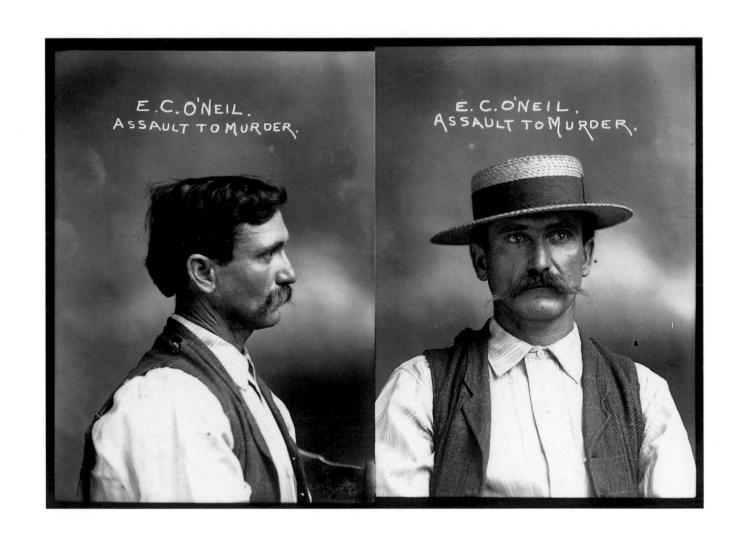

54

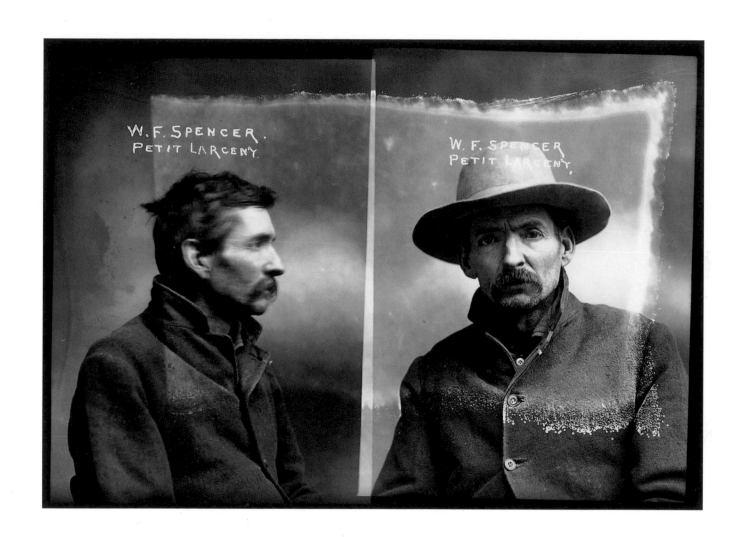

55

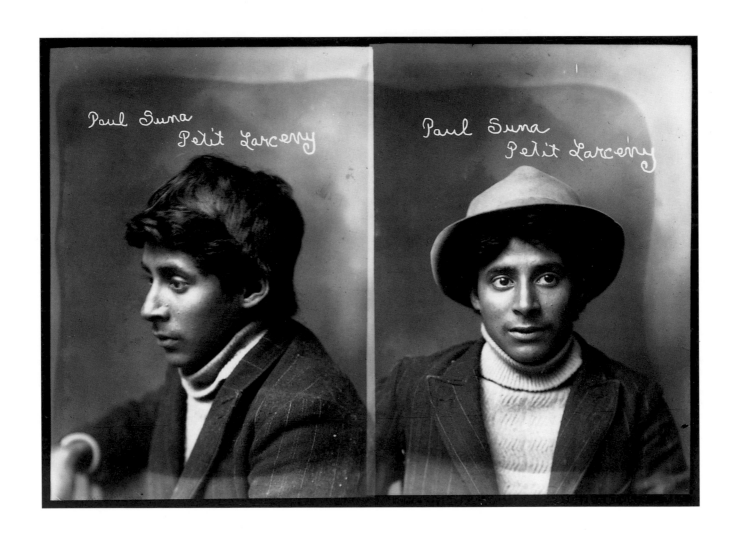

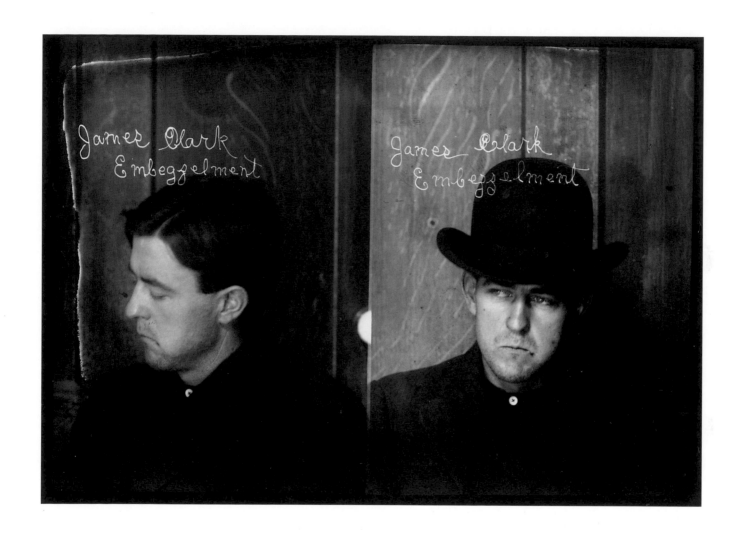

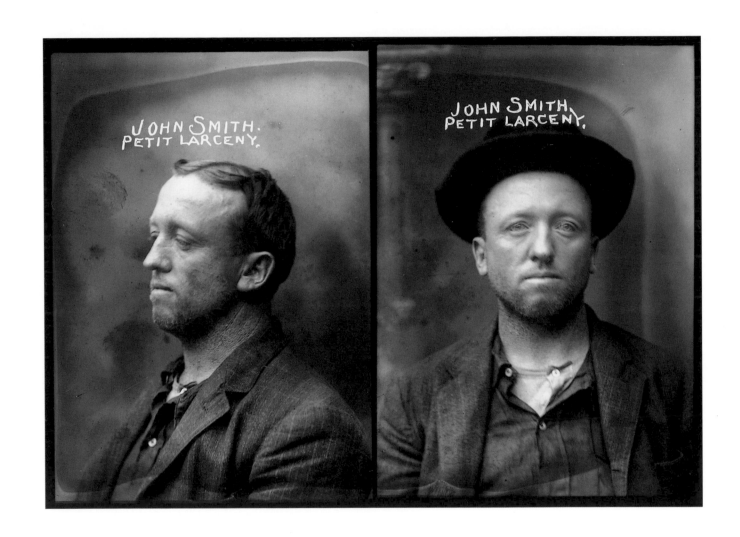

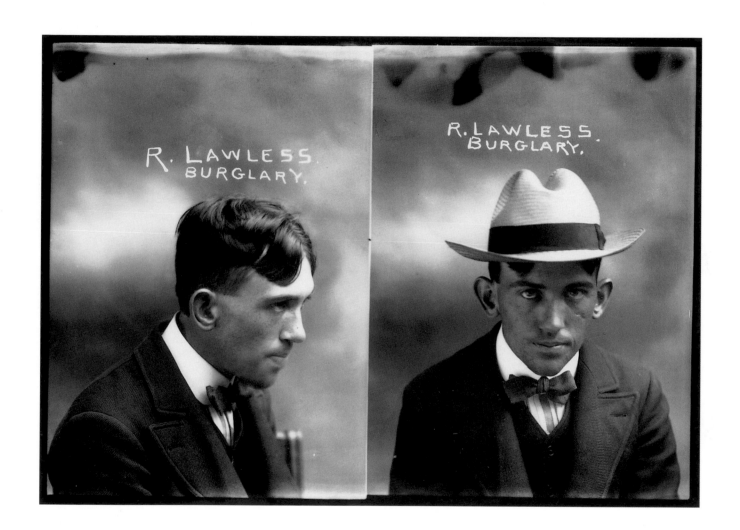

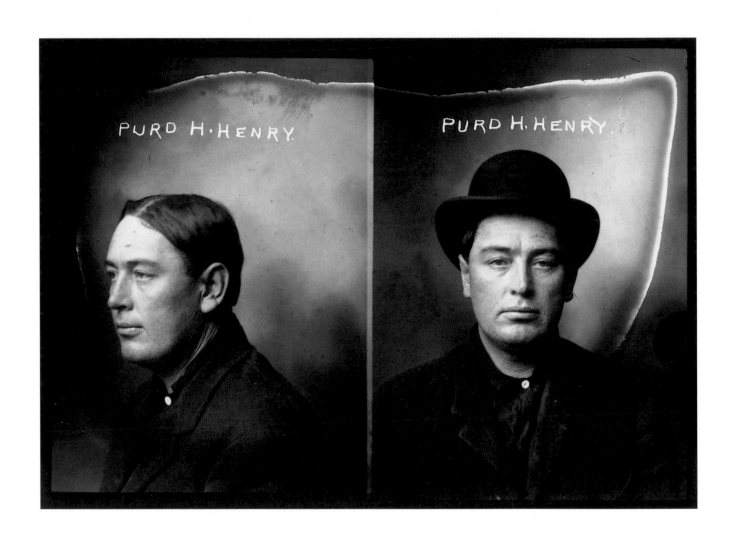

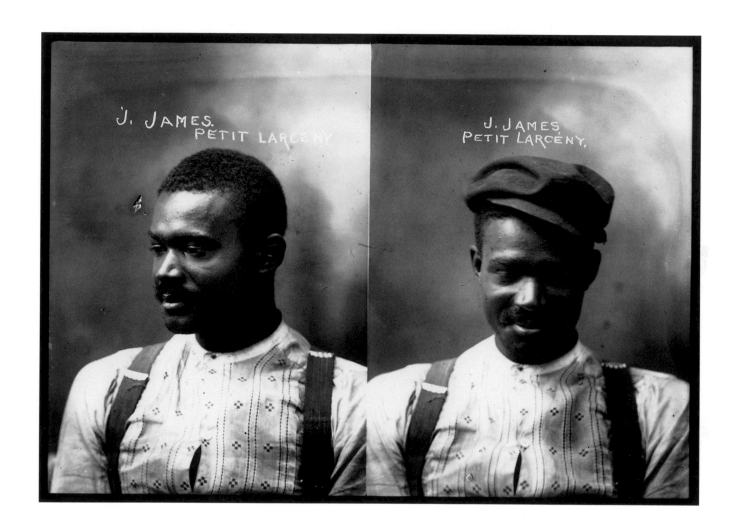

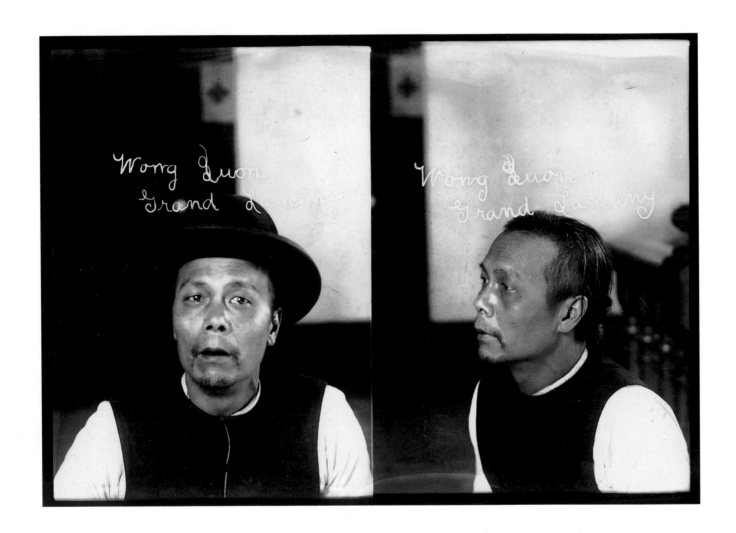

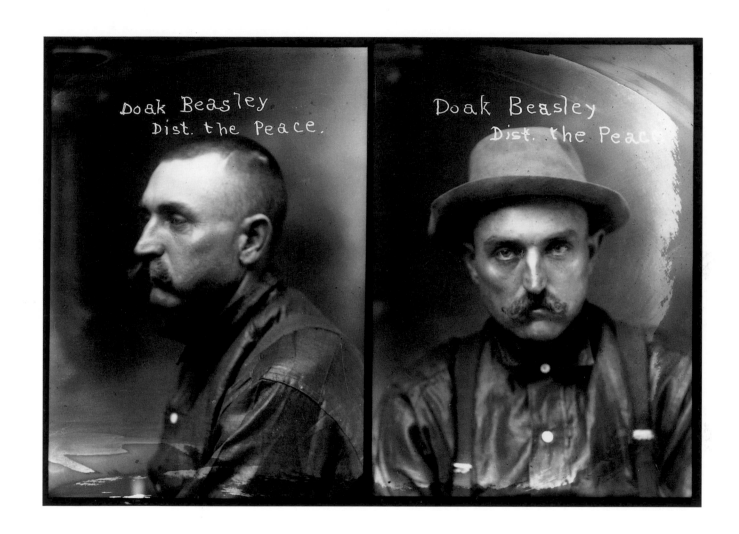

63

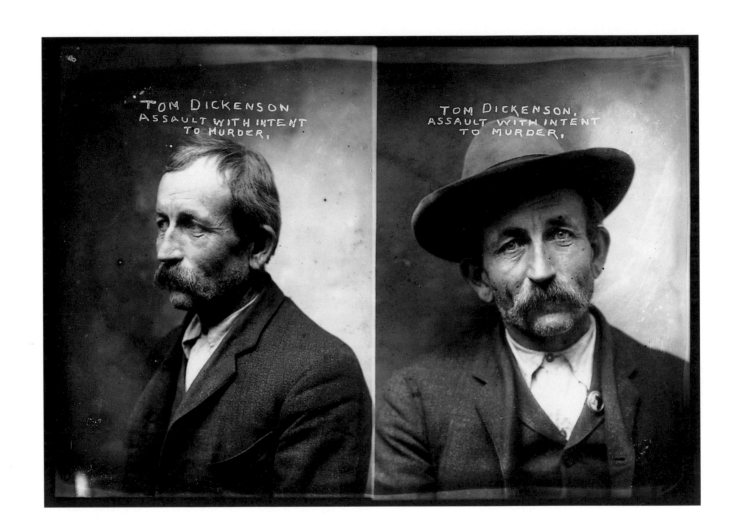

64

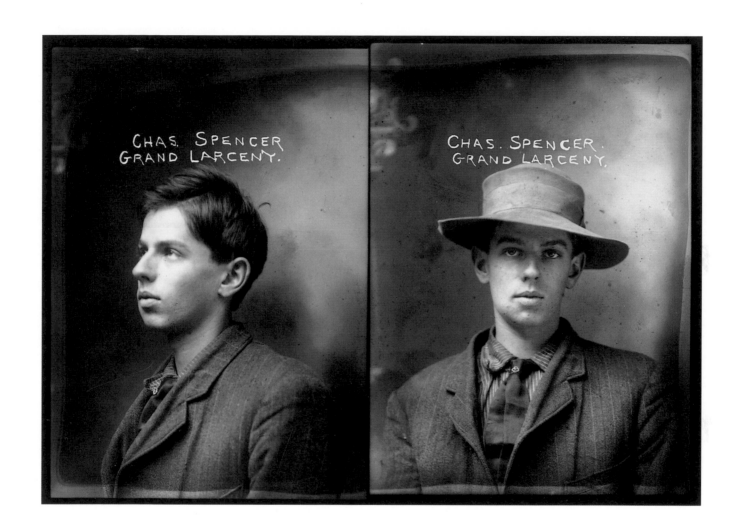

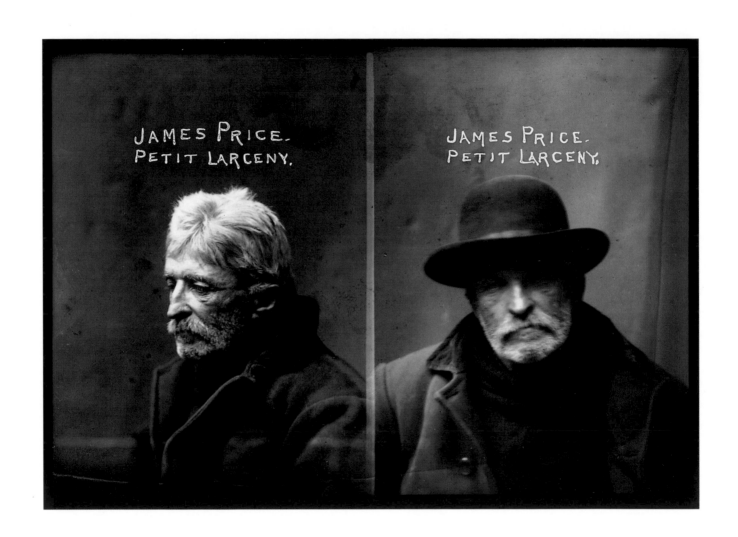

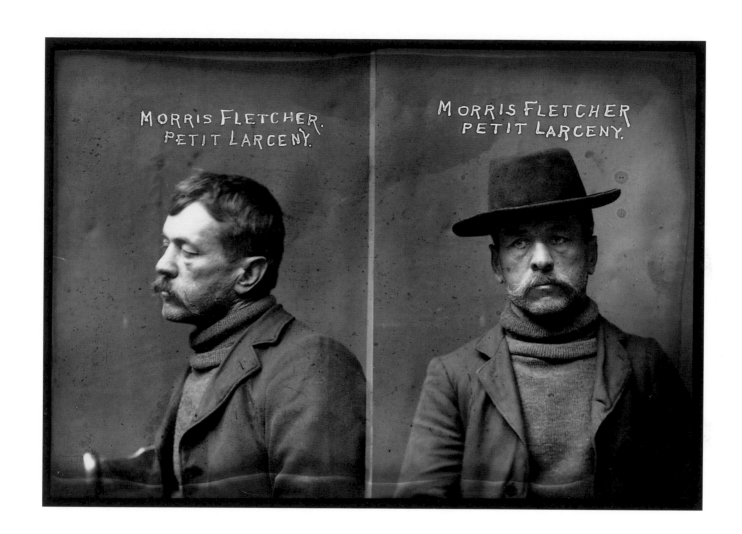

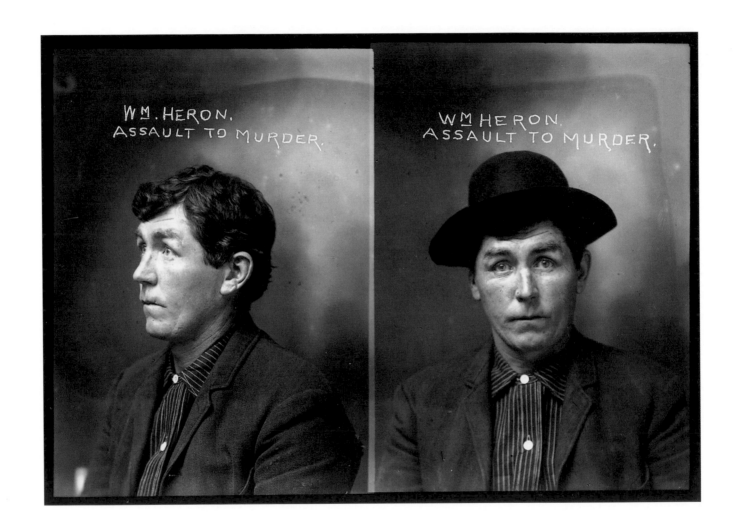

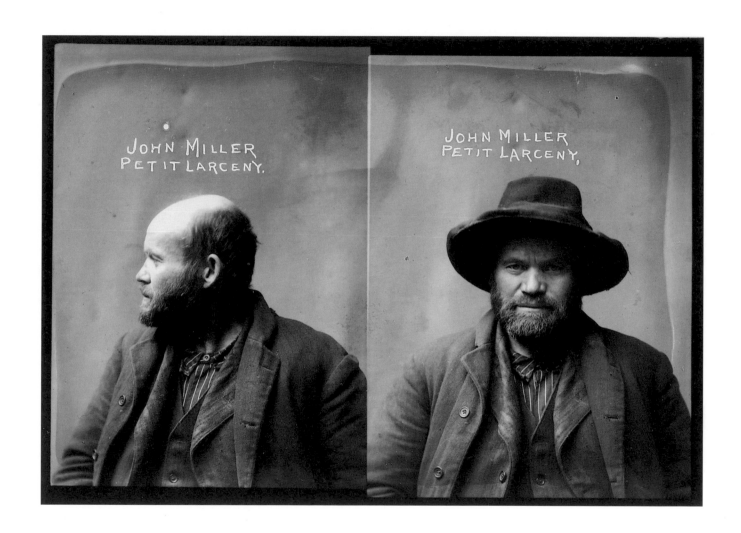

69

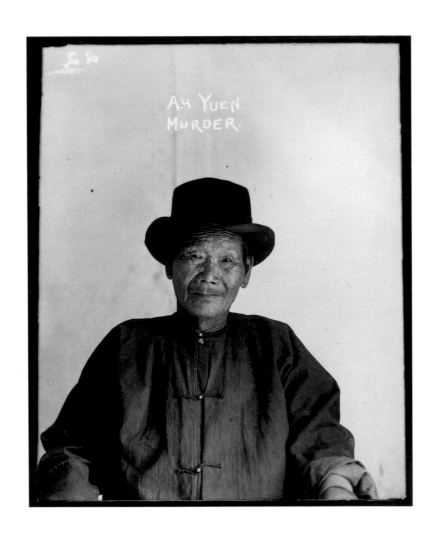

70

Reportage

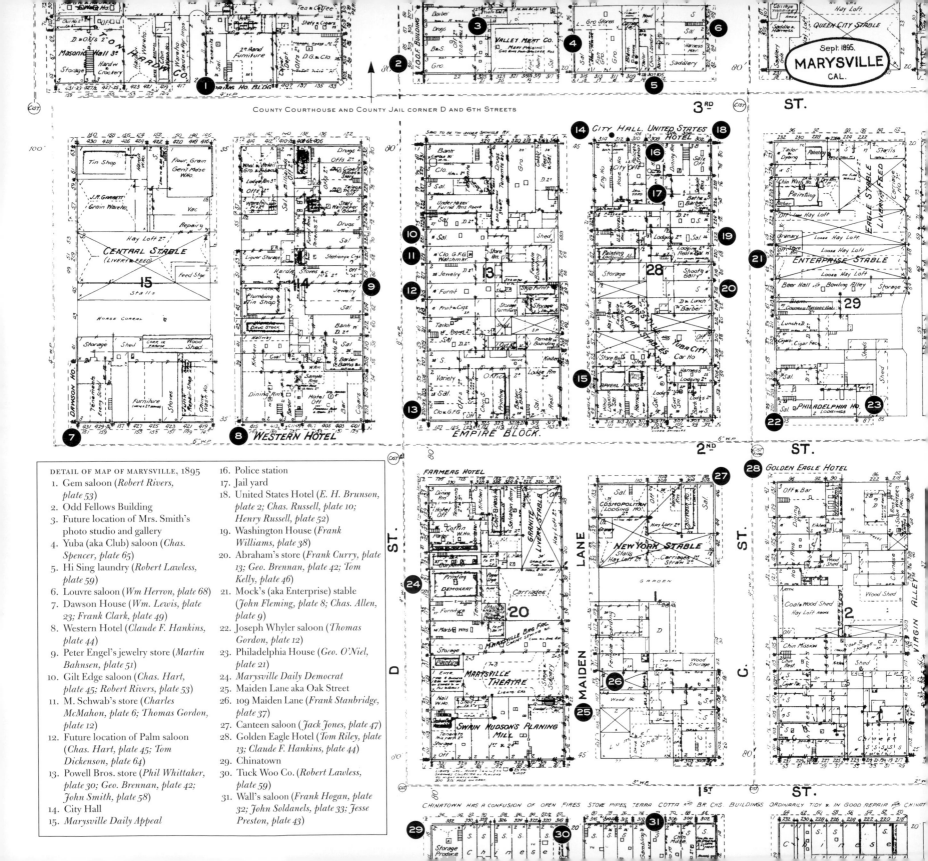

County Courthouse and County Jail corner D and 6th Streets

3RD ST.

Sept. 1895.
MARYSVILLE CAL.

2ND ST.

DETAIL OF MAP OF MARYSVILLE, 1895

1. Gem saloon (*Robert Rivers, plate 53*)
2. Odd Fellows Building
3. Future location of Mrs. Smith's photo studio and gallery
4. Yuba (aka Club) saloon (*Chas. Spencer, plate 65*)
5. Hi Sing laundry (*Robert Lawless, plate 59*)
6. Louvre saloon (*Wm Herron, plate 68*)
7. Dawson House (*Wm. Lewis, plate 23; Frank Clark, plate 49*)
8. Western Hotel (*Claude F. Hankins, plate 44*)
9. Peter Engel's jewelry store (*Martin Bahnsen, plate 51*)
10. Gilt Edge saloon (*Chas. Hart, plate 45; Robert Rivers, plate 53*)
11. M. Schwab's store (*Charles McMahon, plate 6; Thomas Gordon, plate 12*)
12. Future location of Palm saloon (*Chas. Hart, plate 45; Tom Dickenson, plate 64*)
13. Powell Bros. store (*Phil Whittaker, plate 30; Geo. Brennan, plate 42; John Smith, plate 58*)
14. City Hall
15. *Marysville Daily Appeal*

16. Police station
17. Jail yard
18. United States Hotel (*E. H. Brunson, plate 2; Chas. Russell, plate 10; Henry Russell, plate 52*)
19. Washington House (*Frank Williams, plate 38*)
20. Abraham's store (*Frank Curry, plate 13; Geo. Brennan, plate 42; Tom Kelly, plate 46*)
21. Mock's (aka Enterprise) stable (*John Fleming, plate 8; Chas. Allen, plate 9*)
22. Joseph Whyler saloon (*Thomas Gordon, plate 12*)
23. Philadelphia House (*Geo. O'Niel, plate 21*)
24. *Marysville Daily Democrat*
25. Maiden Lane aka Oak Street
26. 109 Maiden Lane (*Frank Stanbridge, plate 37*)
27. Canteen saloon (*Jack Jones, plate 47*)
28. Golden Eagle Hotel (*Tom Riley, plate 13; Claude F. Hankins, plate 44*)
29. Chinatown
30. Tuck Woo Co. (*Robert Lawless, plate 59*)
31. Wall's saloon (*Frank Hogan, plate 32; John Soldanels, plate 33; Jesse Preston, plate 43*)

The following stories were taken from *The Daily Democrat* and *The Marysville Daily Appeal,* the two newspapers published in Marysville, California, at the time of these prisoners' arrests. The text and headlines are printed verbatim from the newspaper accounts, with only a few obvious minor typographical errors corrected; correspondence and prison records are printed without any correction. Occasionally for the sake of clarity and conciseness two articles from consecutive days have been merged to present the story in the most comprehensible manner.

The correct spelling of a prisoner's name was sometimes unknown to the reporters; thus a man's name may appear in a variety of spellings.

Headlines such as "In the Police Court" and "News Epitomized" preceded short lists of the day's activities in the police court or other briefly reported events.

At least one term that appears in some of these stories is no longer common parlance: a man was sometimes given "a floater," a court order given to a person considered an undesirable citizen to leave town. This usually consisted of a heavy sentence on a petty offender that was suspended on condition that he leave the jurisdiction of the court permanently. If the man returned, he was in violation of the court order and subject to imprisonment. In some cases a prisoner is described as having "waived time," which generally means that having pled or been found guilty, he agreed to have his sentence immediately read by the judge. The reasoning was that the judge might be inclined to impose a lighter sentence in return for the prisoner having saved the court time and money by foregoing further court proceedings.

The San Quentin and Folsom Prison records that appear at the end of some prisoners' stories are taken directly from the records kept at either San Quentin State Prison or the California State Archives. Only about 10 percent of the original files have been saved, and many of those are incomplete.

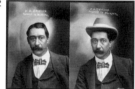

JAMES DONALD

PETTY LARCENIST IN CITY PRISON

James Donald is under arrest and will be charged with petty larceny if evidence can be found to prove that the pile of second-hand grain sacks in his possession was unlawfully obtained. He is believed to have stolen them from the Buckeye Mills, but the positive proof is lacking. [June 26, 1906]

GETS FORTY DAYS FOR PETTY LARCENY

In the Police Court this morning James Donald pleaded guilty of petty larceny, admitting that he stole twenty-four grain sacks from the Buckeye Mills, and Judge Raish sentenced him to serve forty days in the County Jail. [June 27, 1906]

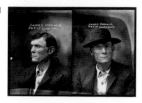

E. H. BRUNSON

ATTEMPTED MURDER AND SUICIDE

THE DEED BEING DONE WITH A PISTOL IN THEIR LODGINGS ABOUT MIDNIGHT.

At about 1:45 this morning Irwin Sayles, the night clerk at the U.S. Hotel heard a pistol shot followed a few seconds later by four in rapid succession. He at once summoned Officers McCoy and Becker and on going upstairs found one of the guests, Ada Clark, lying on a bed in room 62 with her face covered with blood caused by wounds over the right temple and back of her head.

Acting on information received, the officers went to room 59, where they found a man named E. H. Brunson, who was bleeding from a slight wound on his right temple. When asked why he did the shooting he made no reply and was taken to the Police office.

Ada Clark and her friend Agnes Haynes came to this city from Spokane, Washington, a few days ago and registered at the hotel. E. H. Brunson, the man under arrest, came down Wednesday from Oroville, where he is employed at Geo. Martin's saloon, and was seen on the street with the girls.

Agnes Haynes, Ada's friend, informed an Appeal reporter that Ada had promised to marry Brunson about a year ago and that when he followed her to this city she refused to marry him. She stated that they both had been employed at the Palace store in Spokane as saleswomen and that they were on their way to San Francisco.

From another source it was ascertained that the Clark woman was an adopted daughter of the late F. D. Clark, the insurance agent who resided in this city, and that she was on her way to San Francisco with Miss Haynes to visit Mrs. Clark. Her right name is McCrackren, and her father resides in Oroville but they have not been on good terms. She was a very pretty girl.

The officers found the 32-caliber pistol with which the shooting had been done on the roof of the building, all the barrels being discharged. They also found a 22-caliber pistol in the room where the shooting had taken place. This revolver had not been used.

Dr. D. Powell and E. H. Hanlon were summoned at once to attend the injured woman.

The doctor found two wounds, but the one in the back of the head was evidently caused by being struck by a pistol.

The shooting took place in room 59. After the first shot was fired she screamed and the other four shots were fired in rapid succession. She managed to get the pistol away from him after he had tried to kill himself, and then ran out to room 62 where Miss Haynes was and threw herself on the bed. She stated that Brunson had tried to kill her and then turned the pistol on himself.

Miss Haynes stated that the smaller pistol belonged to her and Ada.

Brunson when seen at 3 o'clock this morning still refused to give any reason for the shooting. He said Ada told him to keep his mouth shut.

The Doctors consider her injuries very serious and they may have a fatal termination. [May 10, 1901]

BRUNSON'S CONDITION IMPROVED

HIS VICTIM HOWEVER HAS NOT PASSED THE CRITICAL POINT.

The condition of Ada Clark, who was shot by Eugene Brunson, is as favorable as could be expected, considering that a bullet is supposed to be lodged in her brain.

The following particulars were received from Drs. Powell and Hanlon, the physicians in attendance:

In Miss Clark's case the bullet entered the right cheek one and one-half inches to the right and one inch below the right eye, and passed upward and backward, lodging in the base of the skull; her face bore a number of powder marks. She had a weak pulse yesterday afternoon and was vomiting considerably.

In Brunson's case they found a gunshot wound in the right temple, a 32-caliber bullet having pierced the skull and lodging in the front part of the brain. Brunson's condition seems to be slightly improved, and he has

been visited by his brothers in the County Jail. No attempt has been made to remove the bullet from his skull. It is now expected that he will recover. [May 12, 1901]

THE BRUNSON CASE
THE PRELIMINARY EXAMINATION ON CHARGE OF ATTEMPT TO COMMIT MURDER WAS COMMENCED LAST EVENING.

Preliminary examination of Eugene H. Brunson, the young man who shot Ada McCrackin-Clark in the U.S. Hotel in this city on the morning of May 10th was begun in the City Hall last evening before Judge Raish.

The defendant is charged with assault with intent to commit murder and was represented by Attorney W. H. Carlin. District Attorney McDaniel is conducting the prosecution.

During the proceedings last evening Brunson sat by his attorney deliberately smoking a cigar. The self-inflicted wound in his head has healed and only the scar where the bullet entered the temple is now visible.

Miss McCrackin and Miss Haynes were not present as they had been informed by the District Attorney that their presence was not necessary at that time.

C. A. Smith, one of the proprietors and driver of the La Porte stage, was the first witness. He testified substantially as follows: Was sleeping in the U.S. Hotel on night of May 9th, and about 1:30 in the morning heard three pistol shots fired in room 59; also saw a pistol thrown out of the window of said room onto the kitchen roof. After shooting heard a girl's voice say: "Please don't kill me: I don't want to die: throw the pistol away." One shot was fired and after an interval of two seconds, two more shots were fired in quick succession. It was half an hour after the shooting before the pistol was thrown out of the window. Saw Ada Clark run from room 59 to 62, followed by Brunson. When witness entered room 62, the girl was lying across the bed and Brunson was sitting in a chair.

On cross-examination Mr. Smith said he went to bed at 11 o'clock and had not been asleep when the shots were fired. After shooting heard a man's voice say: "You've raised hell!" Saw an arm throw pistol out of window, but could not say if it was a man's or woman's hand—it was clad in a white garment. Saw no bottles in either room and no particular evidence of a struggle. Both beds were covered with blood. Defendant and girl were both bleeding from wounds in the head.

Charles P. Pierce was the next witness. On night of shooting he occupied room 44, across hall from 59. Heard four shots fired—one, and four or five seconds three more in rapid succession. Heard a female voice say: "Go away." Did not get up that time, but later saw wounded girl in 62 and

the defendant in chair in room 59; heard him say: "I shot her and then shot myself—she says 'say nothing about it.'" The bed in room 59 contained lots of blood, mostly on pillow.

On cross-examination: Heard the woman scream after the first shot. Miss Haynes, Miss McCracken and doctors were in room 62. Did not notice any disorder in room. Miss McCracken wore night gown and defendant was dressed when witness saw them in room 62.

The examination was then continued until 10 o'clock Friday morning. [May 29, 1901]

HELD TO ANSWER
THE PRELIMINARY EXAMINATION OF E. H. BRUNSON CONCLUDED IN THE POLICE COURT THIS AFTERNOON.
BAIL PLACED AT FIVE THOUSAND

The preliminary examination of Eugene H. Brunson was resumed before Judge Raish at ten o'clock this morning at the City Hall.

Drs. Powell and Hanlon, respectively, were the first witnesses called. They testified as to the nature of the wounds received by the lady and Brunson, which have been described before by the DEMOCRAT. Dr. Powell stated that he believed from the symptoms, that the bullet was still in Miss Clark's head; he had made no attempt to remove it. The abrasion on back of head was probably made by a bullet which was found in the bed.

B. F. Davore was called and testified that he was sleeping in a room adjoining the one where the shooting took place. Heard one shot and after an interval of a few seconds heard three more shots in quick succession. Between first and second shots heard girl say, "Don't shoot again, I love you Joe." Heard no disturbance in room prior to shooting; saw woman leave room 59 and enter room 62, the defendant soon followed.

Miss Agnes M. Haynes, the bosom friend of Miss Clark, was then called. She stated that she was 18 years of age, a milliner by trade, and her home was in San Francisco. Arrived in Marysville with Ada Clark from Spokane on the 7th instant. Had been with Miss Clark and Brunson all day Thursday, the 9th, and left them in room 59 at the U.S. Hotel and went to room 62 about 11 o'clock that night; heard no shooting but was awakened about 1 o'clock by Ada calling at her door. Opened the door and saw Ada covered with blood; Brunson followed soon and tried to get witness to leave Ada; witness took him by coat collar and sat him in a chair and told him to remain there. Defendant told her he shot Ada; asked why he did so and he replied, "No one knows but Ada and me." Defendant also remarked that Ada "raised thunder and threw pistol out of the window." He asked witness not to tell anybody or he would go to

penitentiary, and witness replied: "There is where you belong." Witness went out to send for a doctor and defendant locked the door; when she returned he unlocked it. Defendant asked witness how far it was from the window down to the kitchen roof. Brunson and Ada did not drink anything that night.

Miss Ada Clark then took the stand.

The young lady has nearly recovered from her terrible ordeal, and but for the scar of the cruel bullet is not otherwise disfigured.

She stated that on the 9th instant she was in room 59 with the defendant; was awakened by the report of a shot and felt a wound in her face. Remembered very little of what transpired. Brunson was standing near the door with pistol in hand. Asked him to sit down on bed and lay pistol on the window, which he did; she then threw weapon out of the window; when asked why he shot her Brunson said no one else should have her. When witness threw pistol out defendant said "what in hell did you do that for?" Did not see defendant shoot her or shoot himself. Never had any trouble with him before.

A recess was then taken until 1:30 o'clock this afternoon.

When court reconvened this afternoon the cross examination of Miss Clark was resumed. She stated that she got acquainted with defendant two and one-half years ago at [the town of] Biggs. The night of the shooting she had no distinct recollection of hearing a shot fired. Brunson was in room 59 with her when she went to sleep; had no unpleasant words with him that night or the previous night; will be 19 years old next October; did not remember saying: "Don't shoot again; I love you, Joe." On night previous to the shooting slept in room 59 part of time and in 62 part of time. During the fifteen months stay in Spokane had received a number of letters from Brunson of a friendly nature; received money from him on three occasions, the first time $30, three weeks later $40, and then received $10 and a railroad ticket from Spokane to Oroville, but did not care to go to Oroville and stopped in Marysville. Had written to Brunson for the money, but did not state how much she wanted.

The prosecution here rested.

Mr. Carlin, after examining the pistol, announced that he had no evidence to offer.

Mr. McDaniel asked that defendant be held to answer the charge specified in the complaint.

Mr. Carlin asked that owing to the illness of the prisoner he be admitted to bail in a reasonable sum.

The Judge then announced that the defendant be held to answer before the Superior Court with bail fixed at $5000. [May 31, 1901]

BRUNSON PLEADS GUILTY

AND IS SENTENCED TO TWO YEARS' IMPRISONMENT AT SAN QUENTIN.

The following business was transacted in the Superior Court this afternoon, Judge Davis presiding:

In the matter of the People vs. E. H. Brunson, charged with assault with intent to commit murder; plea of not guilty withdrawn and a plea of assault with a deadly weapon entered. Attorney Carlin asked for leniency. Defendant waived time and was sentenced to State's prison at San Quentin for a term of two years. [June 29, 1901]

SUBSEQUENT CRIME

July 10, 1904

A GREENVILLE TRAGEDY

E. H. BRONSON SHOOTS AND KILLS MRS. JESSIE RILEY AND SUICIDES.

E. H. Bronson, a bartender well known in Marysville as well as in Gridley and Oroville, has ended his existence.

On Friday afternoon Bronson created a sensation at Greenville, Plumas county, by shooting and killing Mrs. Jessie Riley, his companion, after which he committed suicide.

Bronson and the woman had arrived from Quincy to which place they had traveled from Oroville, where she had recently received an absolute decree of divorce from her husband, Edward Riley.

It is presumed that jealousy caused the murder and suicide.

Bronson was an ex-convict. It will be remembered that he shot Ada Clark, alias Ada McCracken, in a hotel in this city on May 10, 1901, from which injuries she recovered. He was charged with assault to murder, pled guilty and was sent to San Quentin for two years. On his release he went to Oroville, taking up after a short residence there with Mrs. Riley.

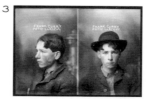

FRANK CURRY

BOY THIEVES ARE IN TOILS

Frank Stone and Frank Curry, two boys from San Francisco, were landed in the toils by Officer Becker yesterday afternoon and booked for petty larceny. Curry admitted to the police of having stolen a

coat from the store of Abe Abrahams a few days ago, and it is suspected that the boys turned other tricks in this vicinity.

On Thursday the boys entered the store of Abrahams and asked to be shown some clothing. Stone picked up a pair of trousers that he liked and went into the rear room to try them on, accompanied by Curry. The pants suited Stone and he came to the front part of the store to pay Abrahams for them. In the meantime Curry was busy in the rear, doing a lightning stunt. He saw a coat and vest hanging in the room and promptly made a switch, leaving behind an old ragged coat. Abrahams did not miss the coat and vest until after the boys had gone. He then notified the police, but his description of the thieves was so bad that the officers had been passing the boys on the streets unnoticed for the past few days.

Abrahams was walking along D street yesterday afternoon and saw the two boys in front of Brown's clothing store. He walked up to them and grabbed Curry by the arm. The boy started to struggle and Abrahams called to one of Brown's clerks to help him.

No help came, however, and when Stone, in a menacing manner, threatened to "sock Abrahams in the bugle" why Abrahams shouted "helup!" and allowed his quarry to escape.

The boys ran to the Tule bottom at the foot of Third street and were captured by Officer Becker, who had been notified by Abrahams as to their whereabouts.

When searched at the prison the boys gave fictitious names, but letters and papers which they had on their persons made their identity clear.

The prisoners came from the neighborhood of Eighteenth and Church streets in San Francisco. Curry had letters in his pockets from his sister and brother, stating that they were glad he was away in the country and safe from the bad influences of a pool room which he had been in the habit of frequenting on Eighteenth street in San Francisco.

The letters were addressed to Curry while he had been picking hop at Wheatland. Both of the boys came from San Francisco on the hop train special a few weeks ago.

Stone stated to the police that his father was a concrete contractor of the Mission street district, San Francisco. Curry refused to talk and, although the younger of the two, seems to be a hard case. Up to a few days ago the boys were working on the levee camp above Yuba City. The police have a clear case of petit larceny against Curry, as he admits taking the coat and vest. The boys are not naturally tough, but have been thrown in with a very bad element since they have been in this section and have got off wrong.

The prisoners will have a hearing before Police Judge Raish Monday morning at 9 o'clock. [August 25, 1907]

BOY CONVICTED OF PETTY LARCENY YESTERDAY MUST SPEND A MONTH IN PRISON

Frank Curry, the boy who was convicted in the Police Court yesterday of petty larceny, was sentenced by Judge Raish this morning to pay a fine of $30 or serve thirty days in the County Jail. Frank Stone, the boy who was arrested with him was found to be not guilty and was discharged. The lads came here from San Francisco and now that he has been sent to prison young Curry is much perturbed over what his parents may think of the matter. [August 27, 1907]

4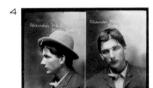

ALEXANDER WHITE

GIVEN SIXTY DAYS

A stranger named Alexander White was charged in the Police Court at 3 o'clock yesterday afternoon before Judge Raish with petit larceny, having stolen a razor, comb and brush from J. D. Laddell at Phillips' saloon.

The defendant pleaded guilty to the charge.

Judge Raish stated that he would like to hear some testimony.

George McCoy testified that while Laddell was drunk in the back room he saw White put his hand in his pocket and held him until an officer arrived.

Officer C. J. McCoy told about finding the stolen property, a white handle razor, brush and comb in the defendant's possession.

The defendant waived time and Judge Raish ordered him confined in the county jail for 60 days.

White was recently discharged from the Sacramento county jail, where he says he served time for battery. He has been working for Hatch & Rock. [August 6, 1905]

5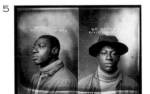

WM. BROWN

NEGRO STOOD OFF OFFICERS

AMUSING INCIDENT WITNESSED LAST EVENING ON D STREET.

A negro who gave his name as William Brown, and who claims to have come from Oroville, created some excite-

ment on the streets early last evening by running down D street with Officer Colford in close pursuit.

It seems that Colford had some trouble with the negro, who had been drinking quite freely on Oak street, and when the officer undertook to place him under arrest he picked up a rock in the street and threatened to pelter the officer if he attempted to arrest him.

The negro refused to surrender unless shown a star or other warrant of arrest.

Colford drew his pistol, but the negro backed down Second street to D and up D to Fourth, waving his hand, in which he held the large and formidable appearing rock.

Colford followed along, but failed to get close enough to place the fellow under arrest, and when nearly to Fourth street Deputy Sheriff Steve Howser pulled his gun on the negro, and told him to halt. This only made him travel faster, and while backing across D street at Fourth he ran into Officer Single, who tapped him on the shoulder with his club and brought him to time. He was then taken to the City Prison by Officer Single, where he will be cared for.

One of the largest crowds ever seen on the streets witnessed the rather unusual performance and as it was exceedingly amusing nearly everyone present had some comment to make or free advice to offer to the negro and Deputy Sheriff. There are some who are of the opinion that the negro thought he was going to be lynched and a coil of rope produced at about that time would have probably sent him flying down the street at double quick time. [May 26, 1906]

IN THE POLICE COURT

William Brown, who was charged with resisting an officer, was given an opportunity to plead guilty to a charge of disturbing the peace. He pled guilty and was sentenced to serve fifty days in the county jail. [June 1, 1906]

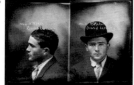

CHAS. MCMAHON

M'MAHON MUST ANSWER FOR CRIME

HIS COMPANION IS RELEASED BUT GETS SENTENCED FOR CONTEMPT OF COURT.

Charles McMahon and Harry Wilson had their preliminary examinations in the Police Court last evening on a charge of grand larceny. McMahon was held to answer before the Superior Court with bail fixed at $2000, but Wilson was discharged, there being insufficient evidence to connect him with the crime.

The offense charged was that of robbing John Kelly while all three men were drinking at the Cliff House on election day.

The case was complete against McMahon; the watch stolen from Kelly being found in his pocket and there being plenty more evidence to connect him with the robbery.

Wilson took the stand in his own behalf and claimed he was not at the Cliff House at the time the robbery was committed. There was not sufficient evidence, in the estimation of the Court, to offset this testimony.

McMahon was unable to furnish bail and was taken to the County Jail this morning. Wilson and McMahon had been "floated" from this city after being convicted of vagrancy, and when Wilson was released from the grand larceny charge he was at once arrested and charged with contempt of Court, for which he got a sentence of four months in the County Jail this morning. [November 10, 1906]

CHARLES M'MAHON ACQUITTED

Charles McMahon, who was charged with grand larceny on election day, November 6th, appeared for trial in the Superior Court at 10 o'clock yesterday morning.

John Kelly, a blacksmith, who swore to the complaint, accused McMahon of having stolen his watch and chain.

District Attorney Brittan represented the people and Attorneys Wallace Dinsmore and E. B. Stanwood appeared for the defendant.

When Kelly, who is known as "Baldy" Kelly by his friends in Sutter County, was called to the witness stand, it was evidently apparent that he was under the influence of liquor and made several contradictory statements to those made when he swore to the complaint. He stated that he had told McMahon to take the watch and chain and keep it for him and made several other contradictory statements evidently trying to shield McMahon.

Judge McDaniel could not help but notice his condition and when the noon hour arrived and the jury had retired he ordered Kelly to be brought before the Court, when he adjudged him guilty of contempt in appearing before the Court in a drunken condition and ordered that he be confined in the County Jail for twenty-four hours. When that time expires it is expected that District Attorney Brittan will have him rearrested on a charge of perjury.

The following other witnesses were examined: Deputy Sheriff J. G. Cannon and Constable W. H. Chism of Sutter county, who testified as to

the arrest of McMahon and the finding of Kelly's watch in his pocket. He was very drunk at the time.

The names of Joseph R. Williams, Henry Reed and W. A. Bevan, employes of Shattuck and Desmond on the pile driver near the Cliff House at that time, were called and as they did not respond, a bench warrant was issued for their arrest. Those men it was claimed were eye witnesses to the robbery.

Attorney Wallace Dinsmore in order to not cause delay, agreed to have their testimony given at the preliminary examination read to the jury, and the District Attorney read the testimony. Two of the missing witnesses had testified that they saw Kelly rolled on the porch of the Cliff House on election day and saw his watch and chain taken. This happened between the hours of 8 and 11 o'clock in the morning on that day.

The prosecution then rested.

Charles McMahon was the first witness on his own behalf to take the stand and he stated that Kelly and himself were at work on the Marcuse ranch in Sutter county and they came into Yuba City the day before election. On election day they went to the Cliff House, had several drinks and then Kelly went to sleep. He hit him with his hat a few times on the head and tried to wake him up. Kelly when he woke up told McMahon to leave him alone and keep the watch for him. He had taken the watch not with the intention of stealing it, but to keep it for his friend Kelly. On cross examination he admitted having been in the Whittier Reform School.

John J. Black of Yuba City testified that he heard Kelly tell McMahon to keep the watch for him.

Attorney Dinsmore then asked the Court to instruct the jury to acquit the defendant. Judge McDaniel advised the jury to bring in a verdict of not guilty and had handed to them a form of verdict.

When the jury returned into Court five minutes later Foreman J. O. Gates handed in a verdict of not guilty and the prisoner was ordered discharged.

Ten minutes after McMahon was released last evening he was placed under arrest by Officer Sayles on a charge of contempt, McMahon having been arrested for vagrancy last March and given a "floater" and then having come back to Marysville. The grand larceny charge that was placed against him was alleged to have been committed at the Cliff House and by being at that place the young man violated his floater. He was tried before Judge Raish in the Police Court this morning and Attorneys Dinsmore and Stanwood who defended him in the Superior Court appeared in his behalf. On the promise that McMahon would reform and cease to be a trouble to his relatives and the officers his fine was placed at $20, which was paid and he was released. [December 7, 1906]

PRIOR AND SUBSEQUENT CRIMES

October 10, 1905

DRANK CARBOLIC ACID BUT SOON RECOVERED

Dr. G. W. Stratton was summoned to John Peters' ranch in Sutter county about 5 o'clock on Sunday evening, Charles McMahon, one of the employes having taken a dose of carbolic acid. The remedies administered were very effective and the doctor returned to this city with his patient about 7:30 the same evening.

March 17, 1906

NEWS EPITOMIZED

Charles Sharkey, alias Jack Williams, and Charles McMahon were arrested last evening after they had handled a Jap in a very rough manner. It is thought they attempted to rob him and the matter was being more thoroughly investigated this afternoon.

January 4, 1907

IN THE POLICE COURT

Charles McMahon was charged with petty larceny having stolen a pair of corduroy trousers from M. Schwab's store of the value of $2.50. He at first pleaded not guilty and stated that he wanted to consult a lawyer. He, however, changed his mind in a few minutes and entered a plea of guilty and waived time.

Judge Raish ordered him confined in the County Jail for four months.

It will be remembered that McMahon was recently tried in the Superior Court and acquitted on a charge of stealing a watch. His attorneys, Wallace Dinsmore and E. B. Stanwood, made a successful fight on his behalf. They probably did not expect that he would so soon again commit a crime and admit his guilt.

June 9, 1907

IN THE POLICE COURT

Charles McMahon was charged under the State law with indecent exposure. His offense was so aggravating that after being convicted he was ordered confined in the county jail for three months.

September 13, 1907

HELD FOR GRAND LARCENY

Fred Roland and Charles McMahon, who were charged with grand larceny, had their preliminary hearing yesterday afternoon.

The men were accused of stealing a watch from Martin Daley last Sunday. Roland stated that he was responsible for the theft and made a statement clearing McMahon. Roland was held over to the Superior Court with bail fixed at $1500 and McMahon was discharged.

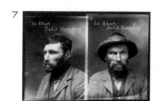

ED SKUR

WILL STEAL ANYTHING HE CAN GET HIS HANDS ON

Ed. Skur, a bad character who has been around town for some time, causing more or less trouble for the police, is under arrest again, having stolen a horse collar Saturday evening from the Pavilion Stables. He was already under conviction for vagrancy and awaiting sentence, having been given a floater. Consequently he is liable on two charges and District Attorney Brittan will be asked to make out the complaints against him. The trial is set for 3 o'clock this afternoon.

Skur has but one arm and to Officer McCoy he said he would steal anything he could get his hands on.

The man has been run out of town several times. A short time ago he reappeared and had with him a dilapidated wagon and an old horse which he put up in a stable before commencing to booze. He is believed to have stolen the outfit and an owner for it is awaited. It is also stated that not long ago he stole a good horse in Sutter County and started to Marysville with it, but that the owner caught him and recovered the horse before he could dispose of it. [January 22, 1906]

NEWS EPITOMIZED

Ed. Skur, the petty larcenist, was ordered to serve thirty days in the county jail. [January 23, 1906]

RELATED NEWS AND PRIOR CRIME

December 20, 1905

CHARGED WITH STEALING CRIPPLE'S BLANKETS

P. H. Gaffney was on trial before Judge Raish in the Police Court this morning on a charge of stealing a roll of blankets from Ed Skur, a one-armed man. Skur swore to the complaint. Gaffney took the blankets to the Vandevere House and put them in the baggage room, asking permission to leave them there until he would call for them, as he expected to find work out of town. When he called for them he was arrested by Officer McCoy, the blankets having been located. Gaffney said a man named Crowley gave him the blankets to use and the way in which he protested his innocence sounded plausible enough. Judge Raish took the matter under advisement until 3 o'clock this afternoon.

January 21, 1906

IN THE POLICE COURT

Ed. S. Kur, charged with being a common drunkard, was given a floater until 9 o'clock this morning, being allowed to go on his own recognizance.

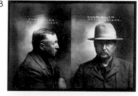

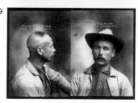

CHAS. ALLEN and JOHN FLEMING

WORKED A FLIM-FLAM

BUT IT LED TO TWO HOBOS GETTING ARRESTED WHEN TRICK WAS DISCOVERED.

A case of flim-flam yesterday resulted in Charles Allen and John Flemming, two tough looking characters, being arrested on charges of petit larceny.

Flemming stole a coat from Mock's stable on C street, but it was taken away from him and hung up again. Allen, Flemming's partner, who was on the outside, then took off his own coat, and deliberately walked into the stable and made a demand for the garment that was hanging up, claiming that it was his property. After the coat had been given to him, some one remarked that he had on a coat when he passed the stable only a moment before, and this led to an investigation.

The statement turned out to be correct as the stable people saw Flemming return Allen's coat to him at the corner of Third and C streets.

The matter was reported to officer Becker, and he later arrested both men. [September 20, 1902]

FLEMING AND ALLEN WILL SERVE TIME AS PENALTY FOR PILFERING

John Flemming and Charles Allen, the flim flam artists, were accused by J. W. Mock of stealing a coat. The evidence against them was clear, so they were found guilty and ordered to appear for sentence at 4 o'clock. When the case was again called up Judge Raish ordered that they be confined in the county jail for 60 days. [September 21, 1902]

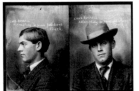

CHAS. RUSSELL

RUSSELL TRIES TO GO OVER WALL

FORGER HELD IN CITY PRISON MADE DESPERATE ATTEMPT TO ESCAPE TODAY.

Charles Russell, an inmate of the City Prison, made a desperate attempt this forenoon to regain his liberty and had climbed half way to the top of the walls surrounding the jail yard when he was detected and forced to come down and be confined in a cell.

Russell was arrested Saturday night for attempting to pass a forged check at several saloons. The check purported to be signed by C. T. Britton and was drawn on the Rideout Bank for $25. The bartenders approached refused to exchange cash for the slip of paper and the matter was reported to the police. Officers Single and Sayles arrested him and found on his person another check made out in the same manner, and still another blank that had not been filled out.

Russell was allowed in the jail yard this forenoon along with the other prisoners. About 11 o'clock Health Officer Hugh McGuire, who has his headquarters in the office of City Clerk Williams, went into the office and was surprised to see a man hanging to the bars of one of the windows overlooking the jail yard.

He immediately reported the matter to Officer Sayles who was on duty, and that officer accompanied by O. L. Meek went into the jail yard to investigate.

Russell was ordered down and his reply was "I will if you'll get me a rope."

While Mr. Meek stood guard Officer Sayles procured a rope with a hook on one end and threw one end up to Russell. He fastened the hook on a bar of the window and slid down the rope, after which he was locked up in a cell.

On going to the Clerk's office on the second floor, a hook that had been used by plumbers in fastening the waste pipes of the prison sewers to the walls was found on the window sill, and attached to it was a long strip of bedticking that had been torn from a mattress in one of the cells.

Russell had pulled the hook from the wall without any great effort, for it stuck only about an inch into the bricks, and, after tying the rope to it he had thrown the hook over a bar on the window and drawn himself up. His next step would have been to throw the hook to the top of the wall and climb to the roof, after which he could very easily make his way through the United States Hotel to the ground. He would probably have made a success of the job had not Mr. McGuire happened into the office at the opportune moment.

Other prisoners who have escaped from the City Prison have done so in the manner attempted by Russell.

The plumbers were certainly very careless to fasten the pipes in the prison in any such manner as they did. The hooks are of iron and large enough to go around a four inch cast iron pipe. The end that goes into the wall is very sharp and the hook makes an ugly weapon, with which a prisoner could easily take the life of an officer. Every one of the hooks should be removed immediately before there is some more startling piece of news to publish.

Russell was to be arraigned this afternoon on a charge of attempt to pass a fictitious check. [February 26, 1906]

FORGER GETS FIVE YEARS IN PRISON

Charles Russell, the debonair young man who tried unsuccessfully a few weeks ago to get several saloon keepers to cash a check for $25 to which the name "Britton" had been signed, pleaded guilty in the Superior Court this afternoon when arraigned on a charge of attempting to pass a forged check, and Judge McDaniel sentenced him to serve five years in State prison.

Attorney J. E. Ebert appeared as counsel for the defendant, having been appointed by the Court, and found no grounds on which to base a defense, so advised his client to enter a plea of guilty and ask for the mercy of the Court.

Russell put up such a brave front after his arrest that he was expected to stand out and demand a trial. He seemed to think he had a chance to escape conviction, but his attorney could not see it that way. [March 12, 1906]

FOLSOM PRISON RECORD

DATE:	MARCH 13, 1906
COMMITMENT NO.:	6403
NAME:	RUSSELL, CHARLES
CRIME:	FELONY CHARGE OF ATTEMPTING TO PASS A BAD CHECK

COUNTY:	YUBA
TERM:	5 YEARS
NATIVITY:	NEBRASKA
AGE:	20
OCCUPATION:	WAITER
HEIGHT:	5' 11⅝"
COMPLEXION:	FAIR
EYES:	BLUE
HAIR:	BLOND
DISCHARGE DATE:	OCTOBER 13, 1909

11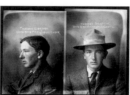

FRANK FOSTER

IN THE POLICE COURT

Frank Foster, who was arrested by Officer Smith for stealing a can of milk, is still in durance vile. The officers have been unable to locate the owner of the milk which this baby got away with. [September 26, 1907]

FOSTER'S HEARING IS SET FOR TONIGHT

Frank Foster has been formally charged with petty larceny for stealing a can of milk from W. A. Wedderein. Foster was trying to peddle the milk when he was arrested by the officers.

Foster appeared in the police court yesterday morning and his preliminary examination has been set for 7 o'clock this evening. There is a prior conviction against him, he having been convicted of stealing a rain coat from the street car barn nearly two years ago.

The prior conviction will be used against him in the present case. [September 26, 1907]

FRANK FOSTER GOES TO SAN QUENTIN FOR YEAR

Frank Foster, the young man who stole a can of milk and a pair of gloves from a dairy wagon, and who pleaded guilty Wednesday to the charge against him, stood up before Judge McDaniel yesterday in the Superior court and was sentenced to serve a term of one year in San Quentin.

Foster admitted to having on a previous occasion stolen a coat and it was on the strength of this prior charge that the sentence was made for a year. [October 25, 1907]

SAN QUENTIN PRISON RECORD

DATE:	OCTOBER 26, 1907
COMMITMENT NO.:	22442
NAME:	FOSTER, FRANK
CRIME:	GRAND LARCENY
COUNTY:	YUBA
TERM:	1 YEAR
NATIVITY:	TEXAS
AGE:	42
OCCUPATION:	LABORER
HEIGHT:	5' 5½"
COMPLEXION:	MEDIUM
EYES:	DARK BLUE
HAIR:	DARK BROWN
WEIGHT:	135¼
FOOT:	5½
HAT:	6¾
DISCHARGE DATE:	AUGUST 28, 1908

IRREGULAR SCAR LEFT CHEEKBONE. PERP. SCAR RIGHT SIDE OF FOREHEAD. THREE SCARS BACK LEFT HAND. LEFT LITTLE FINGER AMPUTATED AT THIRD JOINT. SEVERAL SCARS IN SCALP. BACK OF NECK AND SHOULDERS FRECKLED.

SERVED THREE MONTHS FOR P. L. AT MARYSVILLE 1906.

12

THOMAS GORDON

FORGED A CHECK AND IS IN JAIL
YOUNG MAN COMES FROM WHEATLAND AND IMMEDIATELY GOES WRONG.

Thomas Gordon, twenty-two-years old, was arrested by Officer McCoy and Burroughs last evening and charged with forgery. He admits the truth of the charge and stands to serve a term in a penitentiary.

Gordon came here from Wheatland, where he had been working on the Horst hop ranch. He asked for and was given three blank checks of the Rideout Bank at the store of the W. T. Ellis Company yesterday. Later he tried to pass one of them, which had been filled out for $27.60, at the store of M. Schwab. The name of the Rideout Bank had been cancelled and the words "Farmers' and Merchants' Bank of Wheatland" had been written. The check did not look good to Mr. Schwab and he investigated, learning enough to cause him to refuse to accept it in payment of a pair of shoes.

In the evening the young man passed the check at the saloon of Joseph Whyler at Second and C streets. Officer McCoy had been on the trail since the appearance of Gordon at Schwab's store and he finally suc-

ceeded in getting S. E. Conrad, foreman of the Horst ranch, on the telephone. He learned that the only check given Gordon had been cashed in Wheatland and that the paper passed here was undoubtedly a forgery. Upon this the arrest was made.

The name of Mr. Conrad had been signed to the check, but it was written "Samuel" Conrad instead of "S. E. Conrad," the latter being the way the gentleman signs his checks. The name of the bank was wrong, too. It is the Farmers' Bank of Wheatland. The endorsement on the back of the check is in a different handwriting, but Gordon claims he wrote both sides of the check.

He had $17.60 left when arrested, showing that he had spent $10. Part of the money was spent with Mr. Schwab, probably to show that he bore no ill will for having been turned down by that gentleman. [July 14, 1906]

BAD CHECK MAN GETS THREE YEARS

THOMAS GORDON IS THE SAME PARTY WHO OPERATED IN OROVILLE LATELY.

The preliminary examination of Thomas Gordon, who passed a fictitious check in this city a few days ago, it being cashed by Joseph M. Whyler, was held last evening before Judge Raish in the Police Court and Gordon was held to answer before the Superior Court, his bonds being fixed at $1000.

Mr. Whyler, who is the complaining witness, told of how he was induced to part with $27.60 of good old United States money for the worthless piece of paper that purported to be signed by Foreman Conrad of the Horst Ranch at Wheatland.

F. M. Hollingshead of Wheatland testified that he had cashed many checks signed by Mr. Conrad and knew the one cashed by Mr. Whyler was not signed by that man.

Officer McCoy, the arresting officer, told of his connection with the case and how he found that the young man was getting money for worthless paper, and also of a conversation had with the prisoner after the arrest.

Young Gordon took the stand, admitted that he had made out the check and signed it with what he thought was the correct name of Mr. Conrad. He said the act was committed because he needed money with which to return to San Francisco. He identified the check in evidence as the one he had passed.

The prisoner was taken to the County Jail and turned over to Sheriff Voss this morning.

Last evening Sheriff Chubbuck of Oroville telephoned to Marshal Maben that on June 25th a forged check was passed in that city by a young man who endorsed it as M. F. Gordon. The check was for $35 and the Sheriff stated that some person who had seen the prisoner here is sure he is the man who perpetrated the act at Oroville.

This afternoon Gordon was arraigned in the Superior Court, pleaded guilty and was sentenced to serve three years in San Quentin Prison. He has admitted that he forged the check at Oroville. [July 19, 1906]

SAN QUENTIN PRISON RECORD

DATE:	JULY 20, 1906
COMMITMENT NO.:	21756
NAME:	GORDON, THOMAS
CRIME:	PASSING FICTITIOUS CHECK
COUNTY:	YUBA
TERM:	3 YEARS
NATIVITY:	COLORADO
AGE:	23
OCCUPATION:	TINNER
HEIGHT:	5' 6½"
COMPLEXION:	MEDIUM
EYES:	GREEN
HAIR:	BROWN
WEIGHT:	147
FOOT:	5
HAT:	7⅛
DISCHARGE DATE:	FEBRUARY 20, 1909 (LOST 3 MONTHS' CREDIT)

MOLE RT SHOULDER BLADE, MOLE M.L. BACK OF HEAD, BRWN MOLE BELOW RT NIPPLE, BRN MOLE LOBE RT EAR, 2 MOLES RT CHEEK, MOLE ON LEFT TRAGUS

ONE TIME BEEN ARRESTED FOR THE SAME CRIME AND SERVED TIME IN WALLA WALLA, WASHINGTON.

13

TOM RILEY

NEWS EPITOMIZED

Tom Riley, who stole a package of clothing belonging to Isaac Richards at the Golden Eagle Hotel yesterday, pleaded guilty of petty larceny in the Police Court this morning and Judge Raish sentenced him to serve sixty days in the County Jail. Part of the goods were recovered and returned to the owner. [November 4, 1905]

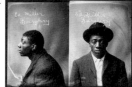

ED. MILLER (alias BLACK SHARKEY)

BURGLAR CAPTURED

PURSUED BY JAPANESE ARMY AND
FIRED UPON HE RUNS INTO ARMS OF
OFFICER SINGLE.

Ed. Miller, alias Black Sharkey, while trying to escape from a small army of Japanese armed with guns, knives, clubs and other weapons, ran into the arms of Officer Single at about 2 o'clock this morning and is now locked in the City prison.

Last Friday night a burglar entered the Japanese boarding house at Fourth and A streets and took away a quantity of plunder. Last night the same or another burglar went into the place but was detected before accomplishing his purpose.

Japanese men swarmed about the intruder and threw him out of the place and one of them fired a shot after him and others grabbed any weapon in sight and started in pursuit up Fourth street.

The noise attracted Officer Single and he nabbed the fleeing man. He was held at the City prison pending the filing of a burglary charge. [November 3, 1904]

BLACK SHARKEY HELD

The preliminary examination of Edward Miller, alias Black Sharkey, who claims that he is the 147-pound champion fighter of the Pacific Coast, on a charge of burglary, took place in the Police Court yesterday afternoon before Judge Raish sitting as a committing magistrate.

Assistant District Attorney Waldo S. Johnson represented the people, and Attorney W. H. Carlin watched the proceedings on behalf of the defendant. At the conclusion of the testimony Judge Raish held him to answer before the Superior Court, and fixed his bond at $1000, which he was unable to get, so he was taken to the County Jail. [November 5, 1904]

CHARGE REDUCED

Ed. Miller, the negro who entered a Japanese boarding house one night in November and, when caught, was charged with burglary, has had the charge reduced to disturbing the peace. This was accomplished through the efforts of Attorney Stanwood and the man pleaded guilty this afternoon and was sentenced to serve sixty days in the county jail. District Attorney Brittan will move to dismiss the burglary charge Tuesday. [February 6, 1905]

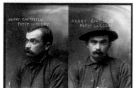

HENRY CHATFIELD

STOLE A PAIR OF SHOES AND WILL GO TO JAIL

Henry Chatfield, who was employed at the Carstenbrook grading camp on the California Midland railroad in Linda township, quit work a little bit early yesterday and stole a new pair of shoes from a fellow workman. He put the shoes on and walked to town. The owner discovered the theft an hour later and he also came to town and spotted Chatfield, who tried to escape.

The police were notified and made the arrest. [January 25, 1907]

GOT NINETY DAYS

Henry Chatfield, who was arrested for stealing a pair of shoes belonging to M. J. Toohey at the Carstenbrook camp and who pleaded guilty in Justice Morrissey's court yesterday, was sentenced late in the afternoon to serve ninety days in the County Jail. [January 26, 1907]

HECTOR BLACK

VICTIM OF GREEK'S ATTACK IS DEAD

After lying for 24 hours in an unconscious state at the county hospital, E. C. Robertson, who was assaulted by Andrew Malidone and Hector Black, two Greek waiters, died last evening at 10:15 o'clock.

The injured man had a severe concussion of the brain from the effects of the fall which he received and never recovered consciousness in order to give his version of the affair.

When brought to the city prison on Friday night, none of the officers recognized Robertson on account of the battered and bleeding condition of his face, but yesterday morning Officer Single succeeded in establishing the dead man's identity and notified his daughter Lulu at Sutter City.

The girl came to this city and went immediately to the county hospital, where she remained with her father until his death.

It was an affecting scene that transpired at the hospital when the little girl was led into the room where her father lay with his battered and broken features. Although she was on the verge of breaking down, she bore up under the strain wonderfully and proceeded to write to her five brothers informing them of their father's condition.

The dead man has been employed as a blacksmith at Hammonton and came to this city to make some purchases. There are several versions of the manner in which the deceased was hurt, but the police have two eye witnesses to the affair and both of them state that Robertson was struck from behind by one of the Greeks and fell on his face against the trolley track that is laid on the sidewalk into the car barn. There is a large blood stain on the sidewalk close to the track, and the police are of the opinion that the man struck the rail, causing the concussion. When found the deceased was lying on his face in the exact position in which he fell.

One of the witnesses of the affair stated that he thought the Greek who struck Robertson had something in his hand, and this blow may have caused the wound behind the dead man's right eye, although the wound could have been received in falling.

Witnesses state that Robertson was arguing with Mrs. Gabriel in front of the restaurant when the two waiters attacked him and he ran. Both of the Greeks gave pursuit and when they reached the front of the car barn one of them struck him, causing him to fall.

Coroner Kelly will hold an autopsy this morning and District Attorney Greely will prepare charges against the prisoners.

The dead man was very quiet in his habits and his friends cannot imagine how he became involved in the brawl with the woman.

He has many friends in the vicinity of Sutter City who will be shocked to hear of his untimely end.

Mrs. Gabriel could not be found yesterday and the restaurant was closed up. Marshal Maben would allow no one to talk with the prisoners yesterday and their version of the affair could not be obtained.

Robertson was a native of this State and aged 42 years. Undertaker Bevan has charge of the remains. [September 8, 1907]

CORONER'S JURY BRINGS IN VERDICT—HOLD GREEK WAITER RESPONSIBLE

The following verdict was rendered by the coroner's jury last evening in the case of William C. Robertson, who died as a result of injuries sustained from a fall caused by being struck by Hector Black, a Greek waiter.

"We, the jury, find that the deceased, William C. Robertson, a native of California, aged 48 years, 5 months and 21 days, came to his death on the 7th day of September, 1907, in the Yuba county hospital, from injuries received by the hand of one Hector Black. Signed, Joseph E. Coombs, foreman; Halsey C. Dunning, Floyd S. Seawell, C. R. Schinkel, John Gavin and H. P. Galligan."

The district attorney will probably prefer a charge of manslaughter against the prisoner today. It is not known as to what action will be taken

against Andrew Malidone, who was with Black at the time the crime is alleged to have been committed.

The autopsy performed Sunday morning revealed the fact that the skull of the deceased was severely cracked in addition to the concussion of the brain. [September 11, 1907]

BLACK MUST ANSWER IN SUPERIOR COURT

At the preliminary examination of Hector Black, charged with the murder of William C. Robertson, yesterday afternoon the murder charge was reduced to manslaughter and the prisoner held to answer before the Superior court with bail set at $3000 or $2000 cash.

Andrew Malidone, who was arrested with Black, was discharged as there was no testimony offered by which he could be connected with the case. [September 17, 1907]

HECTOR BLACK WILL KNOW HIS FATE TODAY

The case of the People vs. Hector Black, a Greek charged with the crime of manslaughter, commenced in the Superior court in this city yesterday and arguments were completed. The jury will take the case this morning.

Attorney Greely represented the People and Attorneys W. H. Carlin and Waldo S. Johnson the defendant.

The alleged crime was committed on September 6, 1907, on C street in this city, when Black is alleged to have pushed a man named Robertson to the sidewalk and he died from his injuries.

The following witnesses were examined on behalf of the prosecution: Dr. J. H. Barr, John Peffer, Clyde Kelly and Charles Stevenson.

They had seen the defendant push a man on C Street named Robertson which resulted in his skull being fractured, causing death.

After the prosecution had rested the defense took up the examination of witnesses and concluded at 4:30, when the case went over until today at 10 o'clock.

Black, the defendant, a good looking Greek, testified that he is but 18 years of age. He heard Robertson call Mrs. Gabriel, who conducts a restaurant on C street, bad names, so he pushed him away and he fell down. [December 6, 1907]

HECTOR BLACK JURY DISAGREES

The trial of Hector Black, charged with manslaughter for the killing of W. C. Robertson, came to an end in the Superior court last night at 9

o'clock, when the jury was discharged after the foreman declaring that it would be impossible to arrive at a verdict.

The case was given to the jury at 11 o'clock yesterday morning and from the first ballot to the last the jurors stood eight for acquittal to four for conviction.

At 4:30 o'clock the jury was brought into court and Judge McDaniel asked if there was a possibility of arriving at a verdict. The foreman declared that he believed it impossible, but, after reading the instructions on excusable and justifiable homicide, Judge McDaniel sent the jury back for further deliberation. At 9 o'clock the jury reported that it stood the same and the jurors were discharged.

The trial proceeded without an objection from either side and was without an exception the most peaceable criminal trial ever conducted in the Yuba County court.

In all probability the case will be dismissed and Black given his freedom. [December 7, 1907]

[Superior Court records show the case was dismissed December 11, 1907, at the request of the District Attorney.—ed.]

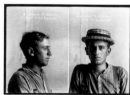

17

EUGENE ROBAGE

NEWS EPITOMIZED

Deputy Sheriff Anderson arrived from Wheatland last evening and returned this morning with Eugene Robage, where he will answer in Justice Manwell's court to a charge of petit larceny. He has admitted the theft of some tools from a Horstville barber. [September 2, 1902]

NEWS EPITOMIZED

Eugene Robage, sentenced to 30 days for petty larceny, was delivered at the county jail by Deputy Sheriff Anderson last evening. [September 3, 1902]

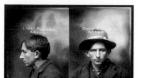

18

CHAS. BOGARD

FIREMAN WAS CAUGHT STARTING A BLAZE

Charles Bogard, a hoseman of the Marysville Fire Department, is under arrest with a charge of arson against him. He was seen starting a fire in the ruins of the Engel House on the east side of B street between Second and Third, Sunday morning, after which he sent in a still alarm and had the fire extinguished. He is believed by many to be responsible for at least three disastrous fires and eight or nine attempts at arson that did not succeed.

Bogard was arrested by Officer McCoy shortly after 8 o'clock Sunday morning upon information furnished by Mrs. Costello who lives in a house adjoining the one that was fired. Mrs. Costello saw Bogard stooping over while lighting the fire. When he stood up he saw her and ran from the house, going to the Vandevere House where he telephoned a still alarm to the Fire Department. When the crew of the chemical engine arrived Bogard joined them in extinguishing the fire and he was pointed out by Mrs. Costello as the man who started the fire.

The night of Thanksgiving Day two fires were started in the same building, one at 7 o'clock and the other at 9. Alarms were prompt each time and no damage was done. Sunday's fire was at 7:20 o'clock in the morning.

HE WAS A SUSPECT.

It now develops that, while Bogard has been kept on the Fire Department he has been suspected for some time of starting at least some of the numerous small fires, while some people have had reason to believe that he caused some of the larger fires. Certain facts in connection with them looked suspicious and these are all coming out since the man's arrest. The promptness with which he turned in the alarms and his quickness in being on hand when the Fire Department arrived at the fires have been causes for comment.

SOME BIG FIRES.

The Turner Hall fire is now being credited to Bogard. He claims he turned in the alarm, and there is a witness who states that Bogard nearly ran over him in getting away from the scene of the fire before the alarm was sounded, yet Bogard says he turned in the alarm, and he was one of the first firemen at the fire. It never was clearly established how this fire originated, the theory generally accepted not being good when investigated.

Some time ago some houses belonging to Mrs. Farrell over on Yuba street were burned. Bogard had lived there and had trouble with Mrs. Farrell.

Bogard was living in the vicinity of the four residences destroyed on B street last spring. The ruins of one of these buildings is where the fires of Thanksgiving night and Sunday morning were started.

NO OBJECT.

What could be the man's object in setting the fires is a mystery. The only plausible reason advanced is that he did it to make a good showing on the Fire Department for discovering fires and being quick to respond when an alarm was sounded. It is seldom that it falls to the lot of one person to turn in more than one fire alarm. Most people never in their lives have occasion to turn in such an alarm. Bogard has done so a number of times in the past two years. The man admits that he served a term in Folsom Prison for burglary committed in San Francisco. He was for awhile an expressman in this city, but has gained the most prominence through the troubles he has had with his wife, she having had him arrested several times.

Bogard has been severely sweated, but has so far refused to confess to any of his crimes. He even denies that he started Sunday morning's fire. He says he went into the building to see what was burning and that he then went to the Marysville Soda Works and telephoned the alarm. The Soda Works was not open at that time so the man only made matters worse by telling the story. [December 3, 1906]

[*At Charles Bogard's preliminary hearing the prosecution called a number of witnesses, all of whom testified that they had seen Bogard in the vicinity of the Engel house around the time of the fire. Bogard had no defense and no witnesses to substantiate his claim of innocence and was held to answer for the crime of arson. His bail was set at $2500, which he was unable to furnish.*

At the trial in superior court, which commenced on February 18, 1907, much discussion centered around whether the crime committed was actually arson or if, as Bogard's attorney argued, attempt to commit arson or malicious mischief were more appropriate charges. At the request of the judge the district attorney inspected the premises and was satisfied that the fire had been confined to rubbish and other contents of the building but had not extended to the structure itself. Based on these findings the charge was lowered to attempt to commit arson, second degree, and a new trial date was set.

Charles Bogard was convicted of this lesser charge on February 22, 1907.—ed.]

CHARLES BOGARD GETS TEN YEARS

HE GOT OFF LIGHT UNDER THE CIRCUMSTANCES
AND PITY HE COULDN'T HAVE BEEN GIVEN MORE.

Charles Bogard, who had been convicted by the jury on an attempt to commit arson, appeared before Judge E. P. McDaniel at 10 o'clock yesterday morning in the Superior Court to receive his sentence.

Bogard, who was hoseman in the Fire Department, does not seem to have extra good sense and seemed to be the most unconcerned man in the court room when the Court passed the sentence.

He was ordered confined in the State's Prison at San Quentin for ten years which means, that if he gets all his credits for good conduct that he will only have to serve a term of six years and six months.

Deputy Sheriff S. Howser will take him to San Quentin this morning.

The sentence in his case was a just one and more lenient than was expected by some. Many thought that the Court would have given him the full limit of the law, which was twelve years and six months, as the evidence was clear and conclusive. While occupying a position of trust for this city he committed the crime for which he was convicted and was credited after his arrest with having set fire to at least half a dozen other buildings. [February 22, 1907]

SAN QUENTIN PRISON RECORD

DATE:	FEBRUARY 23, 1907
COMMITMENT NO.:	22037
NAME:	BOGARD, CHARLES
CRIME:	ARSON, 2ND DEGREE
COUNTY:	YUBA
TERM:	10 YEARS
NATIVITY:	AUSTRALIA
AGE:	35
OCCUPATION:	LABORER
HEIGHT:	5' 6 1/8"
COMPLEXION:	MEDIUM
EYES:	BLUE
HAIR:	DARK BROWN
WEIGHT:	143 1/2
FOOT:	5
HAT:	7 1/8
DISCHARGE DATE:	AUGUST 23, 1913

SCAR BRIDGE OF NOSE, SMALL SCAR RT CHEEK, SM SCAR UNDER POINT OF CHIN, RT SIDE, SM MOLE UPPER LEFT ARM, SM MOLE INSIDE RT FOREARM, SCAR BELOW RT NIPPLE.

SERVED IN FOLSOM (#3775) FOR SAME CRIME.

PRIOR CRIMES AND RELATED NEWS

September 25, 1905

CONVICTED OF BEATING WIFE

Charles Bogard, a local expressman, was tried for battery in the Police Court this morning and pleaded guilty. The complaining witness was his wife, Mary Bogard. She claimed her husband had beaten her once too often and that she could not again make up with him.

Mr. Bogard stated that Sunday he went home and found his wife at the home of David Pugh. He went after her and claimed he was struck on the head with a chair by Pugh.

Mrs. Bogard said she had gone to the Pugh house to wait upon Mrs. Pugh, mother of David Pugh, who was sick abed. She denied that Pugh struck her husband with a chair. She said she had often carried black eyes given her by her husband and that this time was once too many.

Mrs. Hutchins, a neighbor, told of Bogard on one occasion flourishing a knife and, speaking of his wife, said he was going to have a good old Irish wake. She told of Mrs. Bogard being beaten by her husband.

David Pugh said Bogard came into his house when looking for his wife Sunday and said to her "You ———, I want you to come home," and followed it by striking her. She then ran into the sick room and Bogard struck her again, knocking her over on the bed of Mrs. Pugh. Pugh said that he (Pugh) then grabbed a chair and would have used it on Bogard but could not; that Bogard then grappled him and he knocked him down; that quite a little fight followed in which blood was drawn on both.

Pugh was then permitted to testify about a happening of three months ago, which was alluded to several times by Bogard. The explanation was that Mrs. Bogard had come to his home with her boy and that Bogard came after them; that Bogard beat the woman and used bad language and that the woman was afraid to go home alone and was accompanied there by Pugh and his brother as well as by her husband.

Bogard did not like this explanation and testified that he went to Pugh's home at the time stated and found his wife upon the bed with Pugh and that she had been drinking. He alleged that she had sent her boy from the house to get him out of the way and that the boy had told him of the affair.

The woman disputed this version to an extent and excused her intimacy with others by saying that Bogard himself has an Indian girl with whom he is too intimate and that he also drinks freely. She said she works hard to make a living and that her husband pays only the rent and his horse feed.

Judge Morrissey tried in vain to get the couple to banish their troubles and make up, but Mrs. Bogard repeated that she had been beaten once too often and would have none of him.

Officer McCoy also had to admonish them not to quarrel in the Police Court. He was the arresting officer.

Judge Morrissey ordered Bogard to appear at 3 o'clock for sentence. At that hour he was fined $10.

It can be said for Mr. Bogard that he is a quiet and peaceable citizen and has never had any trouble around town. He says that his wife's love for liquor is the cause of the trouble and he did his best to keep the matter out of Court.

December 13, 1905

CHARLES BOGARD'S TROUBLES AGAIN ARE AIRED

In the Police Court this morning Charles Bogard was on trial for disturbing the peace in the vicinity of Second and B streets. The complaint was sworn to by John Galligan and his testimony was to the effect that Bogard, at about 9:30 o'clock last night, appeared in the vicinity and tried to force his wife to go home with him. He and the woman created quite a disturbance and the whole neighborhood was aroused. The woman finally took her hat pin and attempted to use it as a weapon.

Bogard stated that when he went home yesterday he reprimanded his wife for running a meat bill without his knowledge. In the evening, when he again went home, his wife was gone. He looked for her and heard her voice in the Salas home on B street.

After waiting outside for a while, he said the woman came out and was very drunk. One of her shoes was off. When he asked her to go home with him she refused, and when he attempted to take her home she rebelled and tried to stick him with a hat pin, which he took away from her and threw into an adjoining yard.

When he had taken the woman half a block Officer Single appeared on the scene and arrested him.

Judge Raish was not satisfied with the testimony given, so he continued the case until 3 P.M. to hear more witnesses.

It seems that after their recent disagreement, after a trial of which the woman refused to have anything more to do with him, she went back and yesterday was one of several rows they had had. Last evening Mrs. Bogard was trying to procure a warrant for her husband, charging him with battering her with a broomstick.

Bogard put up $20 cash bail when arrested. He is an expressman and does not bear a bad reputation around town.

December 27, 1905

BOGARD'S HORSE IS AMONG THE MISSING

Charles Bogard, who was sent to the County Jail yesterday for striking his wife, is now minus his horse. He gave the animal into the keeping of a colored man named Johnson, and the horse has disappeared. In fact it has not been seen since Mrs. Bogard went to feed it yesterday.

March 12, 1906

CHAS. BOGARD WAS UP FOR CONTEMPT

In the divorce proceedings of Mary Bogard vs. Charles Bogard the defendant was before the Superior Court this afternoon on a citation for contempt, he having failed to pay the alimony assessed to him recently. He explained his case and agreed to give an order on the City Treasury for $16 that was coming to him, upon which he was allowed to retain his liberty.

19

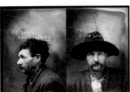

E. L. JONES

E. L. JONES IS DEAD LUCKY

PLEADED GUILTY OF GRAND LARCENY BUT THE JURY ACQUITS HIM.

E. L. Jones appeared in the Superior Court at 10 o'clock yesterday morning to answer a charge of grand larceny, committed in this city on November 3d.

The prosecution was represented by District Attorney Brittan and his Deputy Attorney Ragain, while Attorney W. H. Carlin appeared for the defendant.

The accused it will be remembered drove away J. W. Bradley's horse and buggy from D street on the date mentioned while in a drunken condition.

The driving away was admitted by attorney for the defendant, who, however, claimed that his client had no criminal intent to commit a crime of grand larceny or steal. The evidence showed that the defendant after unhitching the horse opposite Ewell & Co.'s store drove it around the streets until he succeeded in smashing up the rig. For the defense several witnesses were examined to show that the defendant was a working man and had a good reputation. Jones, the defendant, was placed on the stand and he stated he had come to town in a rig similar to that of Bradley's and, being drunk, did not see the difference. He had not intended to steal

it. Attorney Carlin, for the defense, argued that there was no felonious intent proved and he demanded an acquittal. The District Attorney made a vigorous speech for the prosecution.

Judge McDaniel then read his instructions to the jury, who retired to consider their verdict at 2:45 o'clock in the afternoon. After remaining about an hour in the jury room the jury asked for some instructions and were brought into court. Foreman Amos Lane asked the Court to read the instructions he had given them on intent and reasonable doubt. Judge McDaniel said he would read the entire instructions to the jury that he had given. The jury again retired and five minutes later came into court, when their foreman handed in a verdict of not guilty. Judge McDaniel in discharging the jury stated that if he had been a juror himself that he would have found a similar verdict. Before he discharged the defendant he gave him some sound advice as to the trouble he would get into if he continued his drinking habits. [December 8, 1906]

20

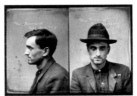

GEO. MENNARD

STOLE A DOG

George Mennar was charged with petit larceny in the Police Court yesterday afternoon of stealing "Booze" a pointer pup, the property of Frank Marshall, which he sold to Roy Parades for $2, although it was valued at $10. Marshall has had the dog since he was five weeks old, and he was picked up at the depot by Mennar. The defendant stated that he never saw the dog before, but while he was testifying "Booze" walked over to him and commenced to smell at his legs. The crime was committed last Saturday morning and Parades on hearing that the dog belonged to Marshall returned it to him.

Judge Raish found the defendant guilty and ordered him to appear for sentence at 9 o'clock this morning. Mennar returned to Parades 80 cents that he had when arrested, but is out and injured $1.20, as Marshall has got his dog "Booze." [October 31, 1905]

IN THE POLICE COURT

George Mennard, who stole Frank Marshall's pointer dog "Booze" and sold it to Roy Parades for $2 was ordered confined in the county jail for fifty days. [November 1, 1905]

GEO. O'NIEL

MUST ANSWER IN SUPERIOR COURT

The preliminary examination in the case of George O'Neil, accused of burglary in entering the room of Mrs. Julia Class at the Philadelphia House and taking twenty odd dollars from a satchel in the bureau drawer, on Sunday, October 29th, came up for hearing before Judge Raish. District Attorney Brittan appeared for the prosecution and Attorney W. H. Carlin for the defendant.

Mrs. Class testified that she had charge of the Philadelphia lodging house and occupied a room on the second floor, one-half of which was partitioned off with a low partition and used by her brother; that she had in a satchel in the bureau drawer two ten-dollar gold pieces, two halves, three quarters and some small change; that she last saw the money about 7 o'clock on the morning of Sunday, October 29th, and on going to the room again about half past nine missed it. The defendant had been rooming at the house for three or four nights, and came in and went to bed on Saturday night a little before 12 o'clock, she showing him his room. She did not see him again until he was brought to the house after his arrest. She identified a satchel shown her as the one the money had been in.

Charles Dietz testified that he was the brother of Mrs. Class and occupied the room partitioned off from that of his sister.

He had seen the money in the satchel in the bureau about 1 o'clock on the morning of October 29th. He had looked to see if it was there because one of the $10 pieces was his.

On cross-examination he stated there were probably forty or fifty lodging in the house at the time and that there was nothing to prevent any one from entering the room in question.

Ed. O'Brien testified that he lodged at the Philadelphia House: that some time after 9 last Sunday morning he saw the defendant opposite Roth & Euler's on Second street; that fifteen or twenty minutes later he saw him coming down the stairs of the Philadelphia House on a run and walk out on the street. Witness was sitting in a chair by the door, reading a paper, at the time.

On cross-examination he stated that the defendant when he first saw him on Second street had a willow cane in his hand and was fooling with a dog. When the defendant came down the stairs of the Philadelphia House no one was behind him, nor did he hear any door slam. He saw nothing in his hand but a cane, nor was there anything in his actions to arouse suspicion.

Officer C. J. McCoy testified that about 10 in the morning Dietz came to the office and said the Philadelphia House had been burglarized and he went over and investigated. A description of O'Neal was given him and he went to look for him and found him standing in front of Peardon & Meyers Saloon. When O'Neil saw him he colored and turned and went into the saloon. Witness followed in and found him in the card room with his face to the door. When O'Neil saw him coming he quickly opened the back door, slamming it, and went into a little shed back of the Empire restaurant. When witness reached there he saw a motion of O'Neil's left hand over a potato keg partly filled with peeled potatoes. He grabbed O'Neil and looked in the keg and saw a $10 gold piece. He then searched O'Neil and found on him another $10 piece, a half and two quarters.

McCoy further testified that later in the day he and District Attorney Brittan told O'Neill that they had evidence that he had been begging on the streets that morning, and asked him where he got his money and why he was begging if he had money. The defendant replied that a man might beg and still have money at the time.

Ah Hong testified to O'Neil running into the kitchen of the Empire restaurant and dropping something into the potato keg when he saw McCoy coming in.

Andrew Maloney testified that sometime between 9 and 10 on Sunday morning O'Neil had asked him if he could help him to a meal, but he had declined to.

Officer McCoy, recalled, stated that O'Neil was booked at the Police Station at 10:30 on Sunday morning.

This closed the case for the prosecution. Attorney Carlin moved that the case be dismissed on the ground that no evidence had been adduced on which a conviction could be had, and summed up the testimony in his usual able manner. District Attorney replied briefly.

The Judge denied the motion and ordered that the defendant be held for trial with bonds fixed at $1000. [November 1, 1905]

FOUR YEARS FOR O'NEILL

George O'Neill, the young man who entered the room of Mrs. Julia Klass at the Philadelphia House on Sunday morning, October 29, and stole about $25 in money, was found guilty by a jury in the Superior Court yesterday, and as he waived time he was immediately sentenced to serve four years in Folsom prison. The trial was begun at 10 o'clock in the morning and continued throughout most of the day. [December 21, 1905]

22 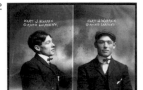 HART J. WARREN

TROUBLES OF HART WARREN

ANXIETY TO GET MARRIED
LEADS HIM INTO A SERIOUS SCRAPE.

The preliminary examination of Hart Warren on a charge of grand larceny took place in the Police Court yesterday morning before Judge Raish, sitting as a committing magistrate.

District Attorney M. T. Brittan represented the people. N. V. Nelson, the liveryman, testified that the defendant called at his stable on October 31st and November 1st and 3rd. He represented that he was an employe of the Sunset Telephone Company and was connected with a gang that was working on this side of Nicolaus. He had stated that he would call for a rig on November 2d, and when he called the following day he said that he had been kept busy at the telephone office and could not get away. He then hired a horse and buggy and stated that he was going to the place where the gang of men were at work near Nicolaus. The horse and buggy that he hired to him was valued at $300. The defendant failed to return with the rig. He would not have let Warren have the rig if he had not informed him that he was employed by the Sunset Telephone Company. Had naturally expected that he would return the horse and buggy on the day that he had hired it, as he had said nothing about wanting it for any stated time.

In reply to District Attorney Brittan Mr. Nelson stated that the defendant said nothing about going to Sacramento.

Sheriff George H. Voss testified about the defendant's arrest at Sacramento and to finding the horse and buggy in the California Feed Stable in that city on Twelfth street. The prosecution then rested.

Hart Warren, the defendant, was then sworn. He stated that when hiring the horse and buggy that he had told Nelson that he was going to take a long ride and wanted some feed put in the buggy; had not told him when he was going to return the rig, or where he was going to. Went to Sacramento to get some money from a friend, and met a drummer [*traveling salesman*], who promised to tell Nelson where the rig was; had never tried to dispose of the rig, and had not received it under false pretenses; had no motive to commit grand larceny. Had contracted an honest debt and intended to pay Nelson for the rig that he had hired from him as soon as he got the money.

On cross examination by District Attorney M. T. Brittan he stated that he had obtained the rig for a pleasure trip, as he intended to get married at Sacramento; had contemplated matrimony for twenty-four years, but had only known the girl he intended to marry four days; he had no money, and the girl telegraphed to her mother for $100, but she received no answer. Had intended to return to Marysville as soon as he got married, but his financial embarrassment prevented his carrying out his scheme.

Judge Raish at the conclusion of the testimony held him to answer before the Superior Court on a charge of grand larceny and fixed his bond at $1500. [November 12, 1903]

WARREN PLEADED GUILTY

Hart Warren withdrew his plea of not guilty to a charge of grand larceny this afternoon and was sentenced by Judge McDaniel to serve a term of two years in the Folsom State prison. [December 16, 1903]

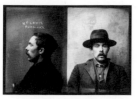

WM. LEWIS

BURGLARS ARRESTED

ONE OF THEM CARRIED A HEAVY BLACKJACK LOADED WITH SHOT.

John Allen and William Lewis have been arrested by Officer Becker and charged with burglary. Allen had a heavy blackjack loaded with shot in his pocket.

Jake Reed reported to the officer that his room at the Dawson House had been entered by burglars and a suit of clothes and a hat stolen. Lewis was wearing the clothes and Allen had the hat on when arrested. It was ascertained by the officer that both men had occupied a room in the Dawson House last Friday night and that they are known about town as sports.

Allen admitted that it was his intention "to crack some drunk over the head with the sand bag, and get away with his dough."

The men were arraigned before Judge Raish this afternoon and will have their preliminary examination at 7 o'clock this evening. These are the fifth and sixth men arrested for small burglaries in this city this month. [November 21, 1904]

IN POLICE COURT

John Allen and William Lewis were charged with petty larceny, having stolen from the room of Jacob Reed at the Dawson House on November 19, 1904, a hat and suit of clothes.

The defendants, who were represented by Attorneys F. H. Greely and E. B. Stanwood, entered a plea of guilty as Deputy District Attorney Waldo S. Johnson had agreed to dismiss the information for burglary against them.

Judge Raish ordered them to be confined in the County Jail for five months each. [December 11, 1904]

PRIOR CRIME

September 18, 1903

THE LEWIS CASE

WITNESSES ARE LENIENT IN THEIR TESTIMONY AGAINST HIM.

The case of the People against William Lewis, charged with having disturbed the peace on August 29th at No. 727 B street by using vulgar and profane language in the presence and hearing of women and children, came up for hearing in the Police Court at 10 o'clock yesterday morning before Justice of the Peace I. N. Aldrich. Assistant District Attorney J. E. Ebert represented the prosecution.

Moses La Plant testified as to the language that was used, but claimed that the defendant was drunk at the time. He did not think that Lewis knew what he was talking about as he was crazy from liquor.

Mrs. Stephens, the defendant's mother-in-law, testified that she had heard some of the language, but could not tell whether Lewis was talking to the horse he was riding, or to the women folks. When he was drinking the witness thought he was not just right in his upper story.

The prosecution then rested, and as the testimony was very weak Justice Aldrich promptly dismissed the case and discharged the defendant.

————————————

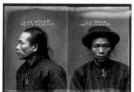

LEE WONG

CHINAMAN UNDER ARREST FOR PETTY LARCENY

STOLE THE PURSE OF A DISSOLUTE WOMAN IN OAK STREET LAST EVENING.

Lee Wong was arraigned on a charge of petty larceny in the Police Court this morning, being accused by Violet Powell, a woman of the half-world, with stealing her purse, containing $4.50 and a beer check. The contents of the purse were found in his pockets when he was arrested.

Ah Fee was sent for to interpret the case for the defendant. He said he wanted to hire an attorney and asked that the matter be continued until Monday, so Judge Raish set it for 3 o'clock of that day.

Kim Wing stopped in at the Police Station to see the proceedings, but refused to act as interpreter which caused City Clerk Williams to ask him if he or the little boy with him belong to some other highbinder [*a band of Chinese professional assassins*] organization. Kim replied that the little boy was no highbinder, but that he thought he would some day be City Clerk. [February 9, 1906]

JUSTICE METED OUT TO MANY

Lee Wong, the chink who took $4.50 from a purse of one of the cribs on Oak St. last Saturday, was found guilty of the charge and was sentenced to serve one year in Folsom prison. [February 13, 1906]

————————————

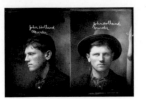

JOHN HOLLAND

WOMAN BEATEN ALMOST TO DEATH

MAN USED LARGE IRON BOLT TO BEAT WOMAN ON THE HEAD.

Josie St. Clair, a woman of the half-world who lived on First street, between Chestnut and B streets, was nearly beaten to death yesterday morning about 9:30 o'clock by a man who was afterwards arrested by Officer Becker and gave his name as John Holland, and claimed to have come here from Oroville.

From what can be learned of the affair it seems that Holland gave the woman some money but later demanded that it be returned. Upon her refusing to give up the coin she was struck over the head with a heavy iron bolt about fifteen inches in length. The woman, although struck several times with the deadly weapon, was not rendered unconscious, but was floored by the blows.

Although the woman's condition is very serious she may recover. She is suffering from five bad cuts, one being on the forehead and about four inches in length, where the skull is exposed. Another three inches long over the left temple and three other very bad cuts on the back of the head, they being from one and one-half to two and one-half inches long. She is also suffering from a small skull fracture.

Dr. Powell was summoned to attend to her injuries, and when he arrived at the scene she was bleeding very profusely.

She was removed to the County Hospital in the afternoon, where she will be treated. She is a woman of about thirty-five or forty years of age. The physician thinks that conditions are hardly favorable for her recovery. [April 25, 1906]

THE VICTIM OF HOLLAND IS DEAD

Josie St. Clair, the woman who was beaten with a heavy iron bolt by John Holland on April 24th, died in the County Hospital at 4:30 o'clock this morning and the body occupies a slab in the morgue, Coroner Kelly having taken charge of it.

Holland has been charged with murder by District Attorney Brittan.

Deceased was a native of Kentucky, aged 33 years and has been married but nothing is known as to her relatives. She had been in Marysville some time.

An inquest will be held next Monday. [May 5, 1906]

JOHN HOLLAND KILLED THE WOMAN

CORONER'S JURY PROBED THE JOSIE ST. CLAIR MURDER CASE LAST NIGHT.

The inquest on the body of Josie St. Clair, the woman who died in the County Hospital on the 5th, was held at the office of Coroner J. K. Kelly at 7 o'clock last evening.

The examination of the witnesses was conducted by District Attorney Brittan.

Dr. E. C. Stone testified that he was Superintendent of the Yuba County Hospital and resident physician; that on April 24th a woman calling herself Josie St. Clair, who had received injuries, was admitted to the hospital and remained there until her death which occurred a little after 4 o'clock on the morning of May 5th. While in the hospital witness treated her for her injuries and at her death performed an autopsy on the body, assisted by Dr. Powell. The autopsy showed a cut on the forehead, another on the top of the head and several severe wounds on the back of the head. There was also a fracture of the skull, causing an injury to the brain and acute meningitis from which she died.

Witness was here shown an iron bolt and stated that such an instrument could produce the wounds found on the head of the woman.

In answer to a juror witness stated that on the autopsy he and Dr. Powell not only examined the brain, but also opened and examined the thoracic and abdominal cavities and found the heart, lungs, liver, stomach and bowels in normal condition, and that the death was undoubtedly caused by the injuries to the head.

Witness identified the body at the office of the Coroner as that of the woman Josie St. Clair.

John C. Colford testified that he was a Deputy Sheriff; that about half past 9 on the morning of April 24th he went into the Phillips' saloon on the corner of First and B streets and was talking with Nolan, the barkeeper, when the bell connecting with one of the cribs on Oak street rang and Nolan went to answer it while witness, as customary, stayed in the saloon and watched out while he was gone. In a few minutes Nolan came back hurriedly and said to witness "Get busy." Witness asked what he meant and Nolan said "A woman is pretty near beaten to death over here." So witness got his gun out and went over and into the house, where he saw the woman on her knees, with her head on the floor and blood over everything. Witness then asked Nolan, who went with him, and who said that he had met a man coming out when he first went in and found the woman in this condition, which way he went, and Nolan answered that he went around the corner and he thought into the saloon. Witness then ran

through the rear, but did not see anybody and told Nolan to ring up for an officer and to get a doctor as soon as possible. In a short time Dr. Powell came and Officer Becker. Witness stayed with Dr. Powell while he dressed the wounds, and while there found the iron bolt shown him. There was a wound across the forehead of the woman, one on the top of the head and three on the back of the head that he recollected positively. The number of the house where the woman was was 123 and the woman was known as Josie St. Clair. The iron bolt he found on the bed, the covers of which were somewhat disturbed. He gave the bolt to Nolan to take charge of and Nolan afterwards gave it to Officer Becker.

In answer to a juror witness stated that the bell answered by Nolan was rung by French Annie who heard the noise in the house occupied by Josie St. Clair, which was next to hers, and that Nolan said that when he met the man coming out of the St. Clair house the man said to him, "I think you had better go in there; I think the woman has got a fit." When he picked up the iron bolt he did not notice whether there was any blood on it.

Philip Nolan testified that he was employed as bartender in the saloon of Henry Phillips on the corner of First and B streets, and that he was acquainted with the location of the cribs running easterly from there. About half past 9 in the morning of April 24th he was called to what is known as the second four, occupied by Annie Mars or French Annie, by the ringing of the bell. The first crib west of that occupied by Annie Mars was occupied by Josie St. Clair. When he received the call from the Annie Mars crib he immediately went there, arriving there in 2 or 3 minutes. When he reached there Annie Mars told him the girl was hurt in the next crib and he went there. When he started to go up the steps he met a fellow coming down them. He heard the girl inside groaning and asked the fellow what was the matter. The fellow said that the girl in there was having a fit. So he went in and found Josie St. Clair lying on the floor and blood all over the floor. He then ran out and tried to catch the fellow he had met when coming in. He hollered to him to stop but the fellow started and ran out of sight. Witness then went back to the saloon and told Colford and returned with him to the house where Colford stayed while witness went to call up Officer Becker and Dr. Powell.

The first time witness saw the iron bolt shown him was when Colford brought it into the saloon and gave it to him. He afterwards turned it over to Officer Becker. Witness afterwards saw the party whom he had met coming down the steps of the St. Clair house. Officer Becker brought him down to the saloon. The man he brought down was the man. He did not know his name.

In answer to a juror witness said he positively identified the man brought to the saloon by Officer Becker as the man whom he met coming down the steps of the St. Clair house when he started to go in there. When he met the man coming out the man seemed to be in something of a hurry, but was walking. When witness after going and seeing the woman lying there came out to catch the man and hollered to him the man started at once to run.

Annie Mars testified that she was an occupant of a place on First street in this city on the morning of April 24th and that she was acquainted with the redlight district, and that she knew Josie St. Clair. On the morning of April 24th she heard the deceased cry for help, and she put in a call by the use of a bell to Phillips' saloon, at the corner of First and B streets. In about three or four minutes after the call was put in, Philip Nolan, bartender at the saloon, came out onto the sidewalk and she directed him to the place occupied by Josie St. Clair. She saw Nolan stop a man in the doorway, and after Nolan entered the house the man started out on a run down around the corner. She was unable to get a face view of the man, as his back was turned toward her.

On cross-examination she said she rang the bell about 9:30 o'clock. She further testified that she heard Nolan as he entered the place remark, "What is the matter of that girl." When asked if she could identify the defendant, Holland, as the man who came out of the place she answered "No," saying she was unable to get a front view of the man. She saw the defendant, Holland, on First street a few days previous to the day the crime was committed.

C. J. Becker testified that he was a police officer and that he was called down to the crib occupied by Josie St. Clair, the woman on whose body the inquest was being held, on the morning of April 24th; that when he reached there the woman was sitting on the edge of the bed, with her hands to her head, and blood oozing from wounds on her scalp. Witness asked her what had happened and she told him a fellow had been in there and wanted money back that he had given her and, on her refusal to give it back, had tried to take it away from her and on her resisting had commenced beating her with an iron bolt. Witness got a faint description of the man and found and arrested him on Second street between 11 and 12 o'clock. When arrested the man gave his name as John Holland. Witness together with the District Attorney was present at the County Hospital, Steward Kenyon also being present, when the woman Josie St. Clair identified the man John Holland, who had been taken there for that purpose, as the man who had administered the injuries to her. Holland when arrested denied having been in the neighborhood of First street or having had any trouble there, but afterwards admitted that he had been on the street but in another house. He said the house he had been in was that next to the St. Clair house. The stairs leading to the two houses are separate, there being

quite a space between. So far as witness could tell the woman Josie St. Clair was perfectly rational at the time she identified Holland. When witness arrested Holland the latter had dark clothes on and witness did not notice any bloodstains, though there was a speck of something on his arm.

Witness identified the iron bolt shown him as that given him by Nolan.

This concluded the testimony. The jury then brought in the following verdict:

"We, the jury, find that the deceased Josie St. Clair, a native of Kentucky, aged 33 years, came to her death at Marysville, Yuba County, California, on the 5th day of May, 1906, from injuries received at the hands of one John Holland." [May 9, 1906]

HAD A CLUB IN HIS CELL

John Holland May Have Been Prepared to Attempt an Escape.

John Holland, who is charged with having murdered Josie St. Clair, was removed from the City Prison to the County Jail yesterday afternoon. After he left the Police Station and when the cell which he had occupied was being cleaned a heavy piece of wood was found in the corner of the room. It was half of an end of a fruit box and it would have been an easy manner to floor an officer with it. What purpose Holland had in view is not known, but he may have been awaiting an opportunity to use the club upon an officer when he was let out for breakfast or supper into the corridor of the bastile. [May 13, 1906]

[John Holland's trial for murder began on June 20, 1906, in superior court and lasted two days. Attorney J. C. Thomas represented the defendant, District Attorney M. T. Brittan appeared for the prosecution, and Judge McDaniel presided. The testimony given was essentially the same as that given during the inquest, and Holland was found guilty of murder in the second degree. The jury had deliberated for seventeen hours; later it was revealed that six jurors had been in favor of hanging; the other six were for life imprisonment. On June 24, 1906, Judge McDaniel sentenced John Holland to twenty-five years in Folsom State Prison; with credits earned he would have to serve at least fifteen years and three months before being eligible for release.

J. C. Thomas, Holland's attorney, had taken a special interest in this case; he was unequivocally convinced of his client's innocence. Four years after the trial's conclusion he mounted a one-man campaign to have Holland released from prison via an early parole. Thomas wrote to the lieutenant governor in support of Holland.—ed.]

J. C. Thomas
Attorney-at-Law
Commercial and Foreign Practice
Sacramento, Cal. June 3, 1910

Hon. Warren R. Porter
Lieutenant Governor of Cal.,
Watsonville, Cal.

Dear Sir:-
I was informed at the Governor's office yesterday, that it was not probable that you would be in this City for some time. There is a matter that I want to bring to your attention. In the first place, I want to disclaim any monitary consideration, and state that what I am doing, and what I have done, is simply in the interests of one whom I firmly believe to be an innocent man.

About three years ago John Holland, an ex-United States Soldier was indicted for the murder of Josie St Clair, at Marysville, California, tryed (defended by the writer) and convicted, and sent to the state prison at Folsom for the term of twenty-five years. The facts upon which that conviction was based, are as follows:-

A girl in an adjoining crib heard some trouble in the crib of Josie St Clair, each of the women were prostitutes. She rang for the "line-runner" and the bar tender Phil Noland the bar-tender at the dive saloon responded. Upon going to the crib of Annie Mars, the girl who rang for him, she notified him that there was some noise in the crib of Josie St Clair. Upon ascending the steps of her crib, approaching the front door Noyland says:- "I met a man comming out of the Crib of Josie St Clair, who I learned was John Holland, and whom I now recognize as the prisoner at the bar. I asked him: 'What is the trouble?' he responded, 'I think that woman in there has a fit or something.' I went in, and found Josie St Clair lying on the floor, or rather sitting on the floor with her hair tangled, and blood streaming down her face, with her head badly lacerated, and bruised. I returned to the door and called to this man who was near the corner to return, but he started to run as soon as I called him."

Madam LaBlanch: testified that she saw this man along by the cribs that morning, and I think she swore that he was seen by her enter the crib. Annie Mars stated that she saw him along there, and he had some talk with her, but she did not see him go in the crib, and did not see him come out. Dr. David Powell was called to dress the wounds of this girl. He had treated her once before, and she knew and recognized him when he called

this time. She was according to his statement on oath, conscious but dazed.

Note the fact of the recognition of the doctor by the St Clair woman, it will play an important part in the case.

A few minutes later, the Police found Holland comming out of a resturant on Second street, where he had gone to get his breakfast. He was making no effort to get away. He was a stranger in town. He was at once taken to the St Clair woman. Was asked if he was the man. The police (who never hear things they do not want to hear, and never see things they do not want to see, and who always hear things that they want to hear and see things that no one else ever saw) say that she said nothing to the question: "Is this the man?" But slowly "shook" her head in the negative. Annie Mars who had been chased out of town for vagrancy by this same gang of police, told me at the Hotel in Chico, that the St Clair woman said "No that is not the man is it Annie?" Holland told me the same thing. I had her subpoenaed as a witness. She always told me the same thing till she took the stand, and then denied any statement having been made. But admitted the head shaking. I saw the police conferring with her several times during the trial. I know that while she was in contempt of the Police Court, having been given what is commonally called a "Floater", she remained in Marysville, occupied a crib for a number of months after this occurred. This was as I predicted to the Court and jury after she had lied to me as she did.

About two weeks after this girl was hurt, the District Attorney M. T. Brittan, and Charles Becker, a policeman took Holland out to see the St Clair woman, and she then (knowing that they wanted a victim, and knowing that if she incurred the displeasure of the Marysville police, she would get a floater) identified Holland as the man who inflicted the wounds.

I told Holland before he took the stand, that if he would take the stand, and admit that he was there, that he entered the crib of this prostitute, and that he saw there was something wrong with her from the back room, turned to go out, and met Phil Noland the keeper of a dive saloon, that Noland asked him what was the matter, that he responded in substance as Noland said. That when Noland called him to return, he ran as Noland said, for the reason that he was a stranger in town, on his way to Sacramento to re-enlist in the service of his country, (having been just honorably discharged) and did not want to be detained as a witness, that it would have the best effect. He responded: "Mr. Thomas, that is not the truth. I was not there. I did pass along some line of cribs that morning, but was not in that crib, and never saw that girl before she was hurt, and will not tell a lie."

He took the stand in the trial of the case, and told the truth, as I believe.

He said he never did this awful thing. That he knew nothing about the same. I will say that during that week, I saw several persons in town, that resembled Holland, and that might easily be mistaken for him.

I was sure of acquittal. I watched the record carefully, and there were no reversable errors at law in the case.

I will add, that Hon. Eugene P. McDaniel, firmly believes in the guilt of John Holland. But there is this to be said in the learned Judges case. He is an old prosecutor. For 13 long years he "Prosecuted the Pleas of the Crown", and with men impued in the prosecutions, a man is almost compelled to prove a negative. I have defended 26 murder cases. All came clear but two, one a baptist preacher in W. Va. was sent up for five years, and my unfortunate friend John Holland who got 25 years. I knew the preacher was guilty, and knew he got off well. Ought to have had more hard time. But Holland I believe was convicted upon the testimony of men and women, degraded in their tastes, corrupt in their principles, and lost to every truly honorable restraint, and sold to the common enemy of both God and man. Not even high toned crib whores, but the lowest order of crib whores.

Not ordinary fairly good saloon men but the keeper of a dive bar, whose sole existence depended upon the success of the prostitutes to get weak men to buy beer at a $1 per bottle.

The District Attorney, Mr. M. T. Brittan was just bringing to a successful conclusion his long and eventful terms, crowned with a brilliant record as a convicter, he had yet to add to his laurels the "hanging of a man". He fully expected to hang Holland. But he too was doomed to disappointment. He wanted to hang Holland.

I want to get Holland out on parole. I will give him employment in my office as a clerk and collector. He is a man who has deported himself well in the prison at Folsom. I would like the testimony transcribed. It was taken down by Mr. Cutter, now Chief Coiner at the U.S. Mint. I ask that you give me such co-operation as you can in this matter. I do not imbibe the feelings of my client. I am asking no honors. I care not if my name is never mentioned in the matter. But I believe in the innocence of Holland and want justice done in his case.

Any suggestions that you may have, shall be glad to hear from you.

Yours truly,
J C Thomas

June 19, 1910
Mr. J. C. Thomas
Attorney at Law
P. O. Box 521
Sacramento, Calif.

Dear Sir:

At a regular meeting of the State Board of Prison Directors held at this Prison June 18, 1910 the matter of the alleged innocence of Prisoner John Holland was presented to the board by Hon Warren R. Porter. After due consideration of the matter, the Clerk was instructed to communicate with you and to inform you: 1st, That Prisoner #6481, John Holland, is not eligible to parole by reason of not having served one half of his term.

2nd, There is not yet sufficient evidence before the Board to warrant them to take any action in his case.

Yours respectfully,
Clerk, State Prison at Folsom

[*John Holland applied for parole again in late 1913 and it was granted, effective December 20 of that year. On January 2, 1914, J. C. Thomas wrote the following letter to Holland, who was still in Folsom awaiting his release.—ed.*]

Mr. John Holland,
Represa, Cal.

My dear Holland:

I will be out of Sacramento for about two weeks, and will, when I return be prepared to take you in, and do as I promised. I have been out several days now, just got back to this City.

Were you to come here in my absence at any time, you can go to Mrs. V. Parkinson's at 1019 6th Street, and get a room and have it charged to me. You can also see my friend Soule, and he will arrainge about board, and this will make you safe in any event.

But I would much rather that you get here about the time I get back from Visalia, and then I can take care of you very nicely.

You can well imagine how glad I was, to know that you were paroled. I feel like it was bust justice for you, and I know better then any one aside from you, that you are not guilty of the deed charged.

It was all the work of Prostitutes, Policemen, and Pimps. I place the three P's in the order of their respectability. The prostitute of course, the

most honorable of the three. I do not mean that there are not good and bad people in the two first classes, but I refer to them as a class.

Enclosed find the paper desired, properly signed up.

Sincerely,
J C Thomas

[*On December 30, 1913, J. C. Thomas had applied to the State Board of Prison Directors with a request to employ John Holland as a clerk in his law office, stating he would pay him $40 a month and provide room and board. For reasons unexplained, the parole officer in charge of Holland's case rejected the attorney's application, and the parolee had to seek work elsewhere. As gainful employment was a condition of parole, Holland was not actually released from Folsom until February 17, 1914, when the Metropolitan Construction Co. of Los Angeles guaranteed in writing his pending employment as a "roustabout and flunky" at $2.25 a week.*

Holland reported to work immediately upon his release. However, on May 10, 1914, he violated the terms of his parole by leaving his residence without the written consent of his parole officer. He was then returned in May 1914 to Folsom to serve the remainder of his sentence.

John Holland was released from prison on September 26, 1921, at the age of thirty-eight.—ed.]

FOLSOM PRISON RECORD

DATE:	JUNE 26, 1906
COMMITMENT NO.:	6481
NAME:	HOLLAND, JOHN
CRIME:	MURDER, 2ND DEGREE
COUNTY:	YUBA
TERM:	25 YEARS
NATIVITY:	OHIO
AGE:	23
OCCUPATION:	TELEGRAPHER
HEIGHT:	5' 9¾"
COMPLEXION:	FAIR
EYES:	BLUE
HAIR:	BLOND
WEIGHT:	160
FOOT:	8½
YEARS AT SCHOOL:	9
PAROLED:	FEBRUARY 17, 1914
VIOLATED PAROLE:	MAY 10, 1914
DISCHARGE DATE:	SEPTEMBER 26, 1921

LARGE VACCINE UPPER LEFT ARM. DIM OBLIQUE SCAR 1ST JOINT LEFT INDEX FINGER OUTSIDE. DIM SMALL V SHAPED SCAR 2ND JOINT LEFT INDEX FINGER OUTSIDE. DIM V SHAPED SCAR HEEL LEFT THUMB FRONT.

SERVED 80 DAYS SOLANO COUNTY JAIL FOR PETTY LARCENY.

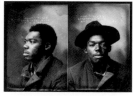

JOHN WALKER

NEGRO ARRESTED ON CHARGE OF AN ATTEMPTED ASSAULT

HID IN HAY IN A BARN BUT WAS FOUND AND GUARDED UNTIL THE ARRIVAL OF SHERIFF VOSS.

Last evening Sheriff George H. Voss returned from the Kupser place, north of this city, with a negro whose name is supposed to be F. Walker, from papers found upon him, and who is held on a charge of attempt to assault a young lady. The negro denies his guilt and claims that he did not arrive at the scene until long after the time at which it is alleged that the crime took place, and although the statement of the young lady has not yet been secured, nor has she been given an opportunity to identify, the circumstances of the case seem to indicate that Sheriff Voss has the right party in charge.

The young lady, who cares for the children of John Schonlan, who resides but a short distance from the Kupser place, was aroused about 5 o'clock yesterday morning by being called to go out to the barn and see that some hay was properly weighed by a negro who wished to purchase some. It was the negro himself who called her, and she soon went out as requested, but noticed that he had no rig as would probably be the case with a man who wanted to purchase hay.

About that time the negro struck her in the face with his fist, breaking her glasses and knocking her down. Her face was badly cut, but she was able to give battle to the brute with much vigor, and her cries at once attracted the attention of the two small children of Mr. Schonlan and they ran towards the Kupser place crying for help. This evidently frightened the negro, for he ran away and disappeared.

Apparently but little was said about the matter until late in the day, and then it became noised about that the young lady had been the victim of an attempted assault. All became highly indignant and a search was commenced for the brute. Mr. Schonlan took his rifle and went through all of the section near the river. In the meantime, however, William Avery, a man employed at the Kupser place, had seen a negro acting in a suspicious manner about the barn on the place and he formed the opinion that the fellow was in the hay. When he went out to feed the horses in the evening he resolved to make a search of the barn, and took a pitchfork and commenced poking it down into the hay. Soon his efforts were rewarded by a loud scream. Avery at once ran out of the barn and towards the house, calling for the other men to come with their guns. It was only a matter of a few moments before the barn was surrounded and the negro commanded to come out, on pain of being shot.

He responded to the challenge and was kept a prisoner to the corral. Word was then telephoned to Sheriff Voss and he started at once to get the man.

During the time that the guards were waiting for the arrival of the Sheriff, Mr. Schonlan arrived and it is said that he made an attempt to put an end to the negro's existence without further waiting. He raised his rifle to shoot, when E. P. Kupser grabbed the gun, which was taken away from Schonlan.

The negro welcomed the arrival of the Sheriff, for he said that one of the guards kept fingering his gun while it was pointed in his direction, and Walker had an idea that the weapon might accidentally go off at almost any time.

On the trip into this city the negro had but little to say. When searched by Sheriff Voss a razor was found stuffed up his sleeve, which he was rather reluctant to give up.

Before the Sheriff's arrival the negro showed his guards his discharge from the United States Army. On examination Kupser and the others discovered that he had been dishonorably discharged from the service. He had belonged to Company F, but the name of the State in which he enlisted could not be read, as it was blurred. When his discharge was handed back to him Walker tore it into small pieces.

The young lady whom the negro attacked is about 20 years of age.

Sheriff Voss will visit the place this morning and will make a complete examination of the whole case, and will endeavor to get the young lady or Mr. Schonlan to swear to a complaint against the negro.

It was reported last evening that two other negroes were implicated in the assault, but Sheriff Voss questioned them very carefully and also investigated their whereabouts at the time, and decided that they had nothing to do with the case, for they were at the Seven-Mile House about 5 o'clock yesterday morning.

Walker is now in the county jail and will be held there pending a thorough investigation of the case.

The negro stands six feet two inches in height and weighs about 220 pounds. [April 25, 1906]

WALKER IS FULLY IDENTIFIED AS THE BRUTE WHO ATTEMPTED THE ASSAULT

Sheriff George H. Voss went to the Kupser place north of this city yesterday morning and made a careful investigation of the attempted assault case which occurred near there, at the Schonlan place, at an early hour on Tuesday morning. His investigation of the case only adds to the brutality

and makes it worse than it was at first supposed, for not only did the negro attempt to assault the young lady, but he also had the intention of robbing the place of a large amount of money which he believed was kept in the house.

It seems that Walker, which is supposed to be the name of the negro, had been working at the steam shovel and had occasionally been sent to the Schonlan place to buy hay for feeding the horses at the place. He quit his work only a few days ago and came to this city and squandered nearly all of his money, and then went back to the Monson camp on the river, instead of to the steam shovel. He apparently did not get work or else did not seek it, for on Monday he made a proposition to Louis Smith, a white man employed at the steam scraper, that they rob the Schonlan place of about $600, which he had understood was constantly kept at the house. Smith declined to have anything to do with any such arrangement, however.

At one time not very long ago Walker told one of the men employed at the Kupser place that he did not intend to work any more, but that he was going to make a living by robbery.

Sheriff Voss also learned further particulars regarding the attempted assault, which show that the negro who attempted the crime is a brute of the first order. When the young lady was asked by Walker to go out to the barn and weigh out some hay for him, she replied that he could get the hay without her, as she had not yet gotten up. The negro replied that Mr. Schonlan had said that she was to see that the weights on each bale of hay was carefully kept. At that she dressed and went out, and when she arrived at the first of the two barns on the place she noticed that the negro did not have a wagon. She became suspicious and rather hesitated, at which the negro grabbed her and carried her into the barn. She fought and scuffled with him and endeavored in every way to get away from his embrace. After a severe scuffle she broke away and ran from the barn, but was caught and carried back again. Then the negro tried to stuff a handkerchief down her throat to keep her from calling for help, and although Walker is a power-fully built man the little woman of but about 20 years managed to fight him off until he finally gave up his purpose. He then demanded that she hand over to him all of the money in the house, to which she replied that she had no money.

"Don't you tell on me or I will kill you," said Walker before he left the barn.

He went away by way of the garden and when near the gate turned and repeated his threat and demand for money.

The young lady watched the negro as he went down to the Kupser place. He first went to one of the barns and looked in, but later entered another barn and she saw him no more.

There were no men at the house at the time, for Mr. Schonlan was employed at the steam shovel. A couple of men stopped at the house during the day and the young lady sent a note to Schonlan telling him of the attempted assault, but through some oversight he did not get the note until late Tuesday evening. He then hurried home and circulated the facts of the case.

In the meantime James Avery, an employe at the Kupser place, missed some clothes and a razor, and when he heard of the attempted assault he at once arrived at the conclusion that the same negro had taken his things. He then made a search of the barn with the result that Walker was found.

Schonlan was acquainted with the negro before, and he said yesterday that Walker had once told him that he was arrested in Kansas for mur-dering a woman but that he got out of that trouble.

In the scuffle in the barn the negro's coat was badly torn and the man arrested by Sheriff Voss wore a coat with a large tear on one side. Besides that fact the young lady was given a thorough description of the negro now under arrest by Sheriff Voss and she positively identified him as the one that had attempted the assault upon her. The razor found up his sleeve was the one stolen from Avery at the Kupser ranch, and when Walker was dug from the hay he had the clothes which had also been taken.

Either the young lady or Mr. Schonlan will be down in a day or two to swear to the complaint against Walker, and it looks as if things would go pretty hard for him, for Sheriff Voss has now gathered a chain of evidence which is beyond dispute. [April 26, 1906]

COMPLAINT WAS SWORN TO TODAY

Miss Ocea S. Taylor, who was assaulted by John Walker, a negro, at the Schonlan place a few days ago, came to town this morning and swore to a complaint charging her assailant with assault with intent to commit rape.

The complaint was sworn to before District Attorney M. T. Brittan and a warrant has been prepared.

It is altogether likely that a complaint charging burglary will also be sworn to, as the fellow entered the barn on the Kupser place and stole some clothing, a razor and other articles and was forced to give them up when he was captured.

Walker was questioned at length by the District Attorney and Sheriff Voss this morning and he was caught in one lie after another. He denied any knowledge of the crime and told the District Attorney a story of his innocence that did not coincide with the story he had told the Sheriff.

He claimed he had been discharged from the army after completing a term of three years, but he was shown his discharge papers, which he had

torn up and thrown away, but which the Sheriff had patched together. This showed that he had joined the army on October 27, 1905, and had been dishonorably discharged on January 20, 1906.

After he had been tripped up in a number of lies he refused to say anything more.

The penalty for assault to commit rape is only fourteen years, but a burglary charge would add several years to this. Efforts are being made to find a prior conviction against him. [April 27, 1906]

HIS PICTURE TAKEN

John Walker, the desperate colored man confined in County Jail on a charge of assault with intent to commit rape, was photographed yesterday and his photo will be placed in the rogues' gallery. His measurements have already been taken and Sheriff Voss will endeavor to lodge a former conviction against him. [April 29, 1906]

WALKER SAYS HE WILL PLEAD GUILTY
ATTORNEY FOR NEGRO CONVINCES HIM HE HAS NO CHANCE FOR ESCAPE.

Attorney J. C. Thomas, who appeared for John Walker at his preliminary examination yesterday on a charge of assault to commit rape, has stated to the Democrat that his client has concluded to plead guilty when he is arraigned in the Superior Court after the holidays close.

This conclusion was reached only after the attorney had used a great amount of persuasion and had convinced the negro that he had not one chance in a thousand of getting anything less than the limit of fourteen years for his crime if he held to his purpose of standing trial, and that he will stand a better show by pleading guilty.

The evidence at the preliminary was very conclusive. Miss Ocea Taylor, the complaining witness, gave direct testimony when the spectators were excluded from the Court room by Justice Morrissey, and the intent of the man when he made his assault was clearly shown. [May 22, 1906]

NEGRO SENTENCED

People vs. John Walker—Arraigned Monday on charge of assault upon Miss Ocea Taylor at the Schonlan place with intent to commit rape. Pled guilty, waived time and was sentenced to serve fourteen years in Folsom Prison. This was the limit of punishment for such offenses and Judge McDaniel expressed regret that he could not impose a life sentence. [June 5, 1906]

[In August 1911 John Walker applied to the State Board of Prison Directors for parole. In answer to a request for information regarding his character, the warden of Folsom Prison received the following letter from J. C. Thomas, Walker's attorney in the 1906 case.—ed.]

San Francisco, Cal.
August 5th 1911

Hon. W. H. Reilly,
Warden State Prison
Represa, Cal.

My dear Sir:
I am very sorry that I cannot recommend a parole for Mr. Walker, the facts are, if the State could have gotten the facts, there is not the slightest doubt, but a more serious charge of actual rape would have been made.

Walker always denied his guilt to me, but there were certain facts that I obtained from the young lady, that makes me believe that there is no question about the act of rape having been committed upon her person.

On cross examination on the preliminary hearing before Justice of the peace J. M. Morrissey, I asked her this question: "When he had you down in the stall in the barn on the hay, did he have any conversation with you? A. Yes sir. State the very words, what they were? A. "Must I say the same words that he said to me?" Q. Yes. She looked around at John Shanlaw, and his little children with whom she was staying, and said: "If some of the people will go out, I will tell it." Then she said these words, after crying. "He said 'if you had been still I would have been through fucking you long ago.'" This made me believe that the act itself had been accomplished and that the girl only withheld the facts for the reason that her pride forbade her telling the whole truth. He had torn her clothing, she wore glasses, and he had broken them, and he was seen going away from the barn by other parties, further more, when Judge McDaniel was pronouncing the sentence, he said to this man, "I suppose you were drunk when you did it? His reply was: Yes sir.

He no doubt would be a very good man if he was casterated before leaving prison, would, I have no doubt be harmless, and he may be a good citizen after this, from this experience, but, he is one of those unfortunate men, like many of his race, and not a few white men, who have trouble controlling their passions for the gentle sex, and while all strong men have strong passions in that direction, yet, they can be managed by the most of men.

My duties to Walker are great, and I am not unmindful of them, but my duties as a citizen, and to myself, and to society are greater than those

to Walker, he is a Southern negro, and I am a Southern man, and every incentive of my nature is prejudiced in favor of the negro, they have been my boyhood companions, they have played with me, they have cared for me, and I love them, I know their weakness, and their ability, while I have had trouble with innumerable whitemen, and some of them, are meaner than any negro, worse than John Walker, I could name some of them of prominent, but the trouble is with Walker, he is weak in that particular. He is unbalanced. Unbalanced in the fact, that his passions for women are greater than his self control, greater than his fear for the prison, greater than his discretion.

No man could regret more than the writer, that I cannot recommend a parole for Walker.

<div style="text-align: right">

Yours sincerely,
J C Thomas

</div>

[*A letter from John Walker's half-sister also arrived in response to the warden's request for information.—ed.*]

7450 Jardan St.
Shreveport, La.
Aug 9th, 1911

Mr. W. H. Reilly, Dr. Sir, I rec'd your message, and was indeed surprised to hear of Johney been alive. We lost trace of him and thought he was dead. Yes I am his sister, his mother is dead, she died three years ago.

Johney was born in Bossir Parish, La and also attend school there, what little schooling he got. He had a good Christen mother. Johney is the only child she had on earth, and she loved the very ground he stood on. She died worrying about Johney. I am only his half sister. His father is also dead.

When he was at home he work on the farm. When he left home he left right out of my house, his mother was living with me. When he left home, he left on public work.

I hope to soon hear from you that Johney is out.

<div style="text-align: right">

Sarah W. Stokes

</div>

[*On August 27, 1911, John Walker's application for parole was denied. Walker applied again for parole in 1913 and the application was granted. He was released on May 14, 1913, on the condition that he never return to Yuba County.*

In August 1914 John Walker was charged with petit larceny for allegedly stealing a bicycle in Sacramento, California. He vehemently proclaimed his innocence during the trial, and after conviction the judge gave him two weeks before sentencing to try to find witnesses to come to his defense. Unable to locate the witnesses that he insisted could exonerate him, Walker was sentenced at the expiration of the two-week stay to six months in the county jail of the city of Sacramento.

On March 13, 1915, the State Board of Prison Directors received the following letter from the prosecuting attorney in this case.—ed.]

<div style="text-align: center">

Sacramento, Cal.
March 12th, 1915.

</div>

Honorable Board of State Prison Directors,
San Quentin, California.

Gentlemen:-
Enclosed please find herewith affidavits of myself and W. L. Howard [*Walker's attorney*] in the matter of the People vs. J. A. Walker, convicted of petty larceny in the Police Court of this city.

I desire to say that Mr. Walker was paroled by the Parole Board of this county several days ago, and he is now living with his wife at number 1327 3rd Street in this city. I have taken some personal interest in this matter for the one reason that as prosecuting officer I did not believe at the time of the trial, nor do I believe now, that Walker was guilty of this offense. My action has been governed by my honest convictions and not because of any influence or request or pull of any person or persons.

Mr. Walker so strongly maintained his innocence of this crime that I took the trouble, after the trial was over, and Walker was sentenced, to investigate on my own account all facts relating to the matter, and it is my honest and firm conviction after having done so, that Walker is not guilty of the crime, and, I therefore ask your honorable Board to consider these facts and not have him returned to prison.

<div style="text-align: right">

Yours very truly,
L. M. Shelley
Prosecuting Attorney
of the City of Sacramento.

</div>

[*Based on the information provided by Mr. Shelley, John Walker's parole was reinstated and he was not returned to the state prison after serving his term in the county jail.—ed.*]

FOLSOM PRISON RECORD

DATE:	JUNE 5, 1906
COMMITMENT NO.:	6451
NAME:	WALKER, JOHN
CRIME:	ASSAULT TO RAPE
COUNTY:	YUBA
TERM:	14 YEARS
NATIVITY:	LOUISIANA
AGE:	21
OCCUPATION:	FIREMAN, TEAMSTER, COOK
HEIGHT:	5' 10⅛"
COMPLEXION:	MULATTO
EYES:	DARK BROWN
HAIR:	BLACK KINKY
DISCHARGE DATE:	MAY 14, 1913 PAROLED
	APRIL 5, 1915 RESTORED

TATTOO RT & LEFT ARMS, DIM SCAR CENTER OF UP LIP.

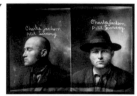

27

CHARLES JACKSON

CHARLES JACKSON ACCUSED OF ROBBING A STRANGER

Chas. Jackson, alleged petty larceny thief, was yesterday arrested and is held in the city jail on suspicion of having robbed a man on Oak street Monday night.

The victim hurriedly reported that he had been robbed and pointed Jackson out. The officers are working on the case, but cannot locate the man who was supposed to have been robbed. [October 30, 1907]

[After the alleged robbery victim could not be located the charges against Jackson were dropped.—ed.]

POLICE COURT CASES TRIED THIS MORNING

In the Police Court this morning Charles Jackson, who was arrested yesterday and charged with vagrancy, was given a floater until 3 o'clock this afternoon. Jackson was discharged from the County Jail last Monday after having served 100 days for having been convicted of vagrancy. He has also served time in the County Jail here for petit larceny. [November 2, 1907]

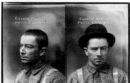

28

EUGENE ROONEY

GENE ROONEY UNDER ARREST FOR ROBBERY

Richard C. Martin complained to the police last evening that he had been robbed and that he suspected Gene Rooney, with whom he had been drinking, of being the robber. He thought he had lost about $14. Rooney, who is not supposed to be flush, had $7 in his pockets. Both men were jailed in order that the case might be investigated when they are sober. [October 19, 1906]

ROONEY GETS FIVE MONTHS IN JAIL

Gene Rooney, who was arrested on suspicion of being guilty of robbing Richard C. Martin in a barn back of Dempsey's Saloon pleaded guilty of petit larceny yesterday afternoon and was sentenced by Judge Raish to serve five months in the County Jail. The man is lucky that he was not charged with grand larceny and held for the Superior Court, in which case he would have gone to a penitentiary. [October 20, 1906]

PRIOR CRIMES

December 28, 1904

JUDGE RAISH HAS MANY HOLIDAY MAKERS BEFORE HIM

Gene Rooney, Fred Denny, Frank Cavello, Pat Morearty, Jack Carr, Charles Gilmore and Frank Becker all pled guilty to having been drunk and were discharged.

December 14, 1905

IN THE POLICE COURT

Eugene Rooney pleaded guilty of being a common drunkard this afternoon and was given a floater by Judge Raish.

JIM MCFARLAND

TWENTY DAYS FOR OYSTERS

Jim McFarland, arrested last evening by Officer Single for stealing two cans of oysters from a Japanese restaurant on Oak street, was the only one to have a hearing in the City Court this morning.

McFarland admitted that he was drunk, but claimed that a friend had given him the oysters, and that the friend had also invited him to dine with him at the Japanese restaurant and then refused to liquidate the expense.

The proprietor declared that it was the third time the prisoner had eaten at his house and refused to pay, and last night he locked him in and went for an officer. While he was gone he put two cans of oysters in his pocket, and they were in his possession when searched at the station.

Judge Raish found the man guilty as charged and sentenced him to serve twenty days in the County Jail. [October 7, 1903]

SUBSEQUENT CRIME

November 17, 1904

AGAIN IN TROUBLE

Jim McFarland was arrested last night by Officer C. J. McCoy on a charge of grand larceny. He went across the levee at the foot of Oak street with a man named Jimmy McDonald and while the latter was asleep McFarland stole his hat and a leather belt and went through his pockets.

Officer McCoy saw McFarland on C street trying to sell the hat and belt at a Japanese restaurant and placed him under arrest. At the police office he charged him with having stolen the articles, and after considerable questioning the prisoner admitted the theft. The officer then got a lantern and accompanied by Chief Engineer Joe Bradley he made a search for Jimmy and found him asleep near the river bank laying on some blankets. When he woke up he missed his hat and belt, and it was discovered that his pockets were turned inside out. He was also taken to the City Jail and locked up for the night.

McFarland is well known by the officers, as he was convicted of petty larceny on October 7, 1903, having stolen some oysters from a Jap restaurant on Oak street.

December 6, 1904

HIS SECOND OFFENSE

Jim McFarland was arraigned in the Superior Court yesterday morning on a charge of petit larceny and prior conviction. He had first stolen two cans of oysters from a Japanese restaurant on Oak street, for which he served twenty days in the County Jail and on the 16th of last month he was arrested for stealing a hat.

In reply to Judge McDaniel the prisoner stated that he did not want counsel employed to defend him. He pled guilty to both charges and waived time for passing sentence.

Assistant District Attorney Waldo S. Johnson informed the Court that both offenses were committed when the defendant was under the influence of liquor. The Judge asked the defendant if he had any legal cause to show why judgment should not be pronounced against him. McFarland blamed liquor for all his trouble and promised in future never to let a drop of intoxicating liquor pass his lips. Judge McDaniel ordered that he be confined in Folsom State Prison for six months.

FOLSOM PRISON RECORD

DATE:	DECEMBER 6, 1904
COMMITMENT NO.:	5910
NAME:	MCFARLAND, JIM
CRIME:	PETIT LARCENY AND PRIOR
COUNTY:	YUBA
TERM:	½ YEAR
NATIVITY:	IRELAND
AGE:	45
OCCUPATION:	LUMBERMAN
HEIGHT:	5' 8½"
COMPLEXION:	FAIR
EYES:	V. BLUE
HAIR:	LIGHT BROWN
DISCHARGE DATE:	MAY 6, 1905

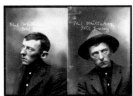

PHIL WHITTAKER

NEWS EPITOMIZED

Phil Whittaker was convicted of petit larceny in the Police Court yesterday morning and waiving time was ordered to be confined in the county jail for 5 months. There were three charges against him, but he was tried for stealing a coat from Powell Bros. [December 17, 1905]

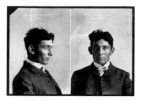

W. H. LOVELETT

LOVELETT CASE BEFORE COURT
ACCUSED OF HAVING ASSAULTED LULU DELPONTI LAST JUNE.

GIRL'S AGE BATTLE GROUND

Much Testimony Given Yesterday as to the Exact Day of Her Birth—No Bible Record in Evidence.

The case of the People vs. William Lovelett was called up for hearing in the Superior Court at 10 o'clock yesterday morning before Judge E. A. Davis.

The information sets forth that on June 14, 1902, the defendant had intercourse with Lulu Delporti, otherwise known as Lulu May Crotzer, a female child being under the age of 16 years, she not being then and there his wife.

District Attorney McDaniel represented the people, and attorneys W. H. Carlin and E. T. Manwell, the defendant.

Mrs. Bessie Kohrummel, who stated that she was Lulu's aunt, testified that she resided in Red Bluff. Lulu was born on November 16, 1886. A record of her age had been made from the family Bible and had been in her possession ten years; it was a correct copy from the Bible that had been destroyed by fire.

I. V. Wible and James Crotzer were examined with regard to the girl's age. The latter, who is her father, stated that he was a railroad man and that his child was born November 16, 1886. Had been separated from his wife since 1894.

On cross-examination by Attorney Carlin he said he could not give the date on which he was married or divorced.

Henry Rathja, another resident of Red Bluff, and a brother-in-law of James Crotzer, stated that Lulu was born in November. But in reply to Attorney Carlin he said he could not remember New Years Day 1892, or 1900; could not tell if it rained on those days.

In reply to the District Attorney he stated that Mrs. Crotzer's first child was born dead in 1885.

In reply to Attorney Carlin he stated that Mr. and Mrs. Crotzer were married in 1884, in Wibel's house in Red Bluff.

Mrs. Della Delponte testified that she resided on Bear River, near Wheatland, last June with her daughter, Lulu, who was born November 16, 1886, at Red Bluff and saw the defendant on June 14. He came to the boarding house and went out with Lulu, who on her return made a complaint. The couple were absent from 8 o'clock that evening until almost 12 o'clock. Lulu was crying when she returned home. The witness then described the condition of her underclothing.

On cross-examination by Attorney Carlin she denied that she had told Mrs. Hetty Miller that Lulu was 16 years of age or over 16, or near 17 years of age.

She was next questioned with regard to some answers she gave at the preliminary examination when she stated that "there was no record in the family Bible of this child's birth." Had found since that it was necessary to have a record. She admitted having stated at the preliminary examination that Lulu was born in 1887. She also said that she had said nothing about what happened for three or four days after Lulu had reported to her. The complaint was made out on July 10th. She denied having heard her daughter tell George Scott at Wheatland that she was "going on" 17 years of age.

The witness was again questioned with regard to the Bible record. She stated that the date and weight were in one handwriting, and the name in another. For fear that her house might burn, she had sent out slips with the ages of her children to her relatives, and when the house was burned and the Bible destroyed, they had those records.

Lulu Delponte, sometimes known as Lulu May Crotzer, was then examined and told what happened on the night of June 14, 1902, when she went out walking with the defendant. She stated that she was born on November 16, 1886, and was not yet 16 years of age.

On cross-examination by Attorney Carlin she stated that Lovelett had called at the house again on June 15th. A question as to whether anything was said about marriage was objected to, and not allowed to be answered.

She denied that she had told George Scott, who asked her age, that she was about 17 years of age, or "going on 17 years."

The court then adjourned until 10 o'clock this morning. [November 11, 1902]

LOVELETT DISCHARGED

The hearing on the case of the People vs. William Lovelett, charged with rape, was resumed in the Superior Court yesterday morning.

Mrs. Annie McDowell was the first witness. She stated that Lulu May Crotzer was her niece; she was born on November 16, 1886.

In reply to Attorney Carlin the witness stated that Lulu was born at Red Bluff, and that she was present at the wedding of Mr. and Mrs. Crotzer, but could not tell when it was.

Lulu Delponte, sometimes known as Lulu May Crotzer, was recalled, and in reply to Mr. McDaniel she stated that she was never married.

Sheriff R. E. Bevan testified that he arrested the defendant on the east bank of the Bear river. Lovelett had admitted to him that it was a "clear case."

On cross examination by Attorney Carlin, the Sheriff stated that he understood from the talk that he had had with the defendant that he was willing to marry the girl.

District Attorney McDaniel then announced that the prosecution rested.

Mrs. Hetty Miller of Wheatland was the first witness for the defense. She stated that Mrs. Delponte and daughter, Lulu, remained at her house for ten days last June. Mrs. Delponte stated to her that Lulu was past 16 years of age; her adopted daughter Myrtle was present when the conversation took place.

Miss Myrtle Miller, when her turn came, stated that she would be 14 years of age in December. Heard Mrs. Delponte state last June that her daughter Lulu was past 16 years of age.

George B. Scott of Wheatland testified that he had a conversation with Lulu last June and had asked about her age. She stated that she was nearly seventeen, or would be seventeen years of age soon. Her mother was present at the time.

William Lovelett, the defendant, was next examined. He stated that he was 26 years of age, and that he had never told any one of any relations that had existed between Lulu and himself.

Attorney Carlin then announced that the defense rested.

The arguments to the jury commenced at 11 o'clock, District Attorney McDaniel setting the ball rolling. Judge Davis gave his instructions to the jury who returned at 3 o'clock to consider their verdict.

The jury came into court at 4:30 and handed in a verdict of not guilty. The defendant was then discharged. [November 12, 1902]

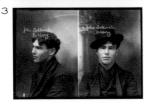

32

33

FRANK HOGAN and JOHN SOLDANELS

SOLDANELS' GUILT IS PROVEN AFTER HE'S FREE

SENTENCE OF HOGAN SUSPENDED BY JUDGE MCDANIEL; GOES TO REFORM SCHOOL FOR FIVE YEARS.

[The following case involved two suspects, John Soldanels and Frank Hogan, both of whom were charged with robbing Frank Dwyar of $10 on November 16, 1906. Frank Hogan, a boy of sixteen, pled guilty, but Soldanels, nineteen, demanded a hearing and was acquitted after a two-day trial before a jury. During the proceedings he admitted knowing Hogan but denied any knowl-
edge of the crime; numerous witnesses were presented by the defense to attest to Soldanels's character, and the victim, Dwyar, could not positively identify Soldanels as one of the perpetrators. Hogan, upon his arrest, had identified Soldanels as his partner in the crime, but at the trial he recanted his testimony and stated he had no idea of Soldanels's whereabouts during the time he was robbing Dwyar.

Hogan was sentenced on January 23, 1907, six days after Soldanels was judged not guilty. The following is the transcript from Hogan's sentencing as reported in The Daily Democrat.—*ed.]*

In the Superior Court this morning, Judge E. P. McDaniel presiding, the only matter set was the passing of sentence on Frank Hogan, charged with having in connection with John Soldanels robbed Frank Dwyar of ten dollars on the levee in November last. Hogan pled guilty and Soldanels stood trial and was acquitted.

Attorney J. E. Ebert appeared for the defendant.

The Court. (To defendant) What is your name?

A. Frank Hogan.

The Court. (To defendant) Where were you born?

A. San Francisco.

Q. Do you know your birthday?

A. No; I do not know the date of it.

Q. You are 16 now?

A. Yes.

Mr. Ebert. It was in the month of August, was it not, that you were born?

A. Yes.

The Court. 1890?

Mr. Ebert. Yes sir. This certificate is dated August 26, 1897, and states he is 7 years old at that time.

The Court. I suppose his birthday then was about the 26th day of August. What was your father's name?

A. I could not tell you his first name.

Mr. Ebert. It is given in this certificate as Daniel.

The Court. Do you think he is living?

A. The way the letter stated he would have been around here. I don't know whether he is dead or not.

Mr. Ebert. This certificate says he is dead: deceased at San Francisco.

The Court. Do you know whether your father was American or foreign born?

A. American born.

Mr. Ebert. A native of New York.

The Court. What was your father's occupation? Do you know that?

A. No.

Q. Do you know what your mother's name was?

A. Mary Lynch.

Q. That was her maiden name?

A. Yes.

Q. She was married to your father?

A. Yes.

Q. Is she living or dead?

A. Dead.

Q. Was she born in this country?

A. A foreign country.

Q. What country?

A. Ireland.

Q. You have no guardian?

A. No.

Q. Was your mother intemperate? Did she drink, too?

A. I could not say; I was too young at the time.

Q. Your father drank?

A. I could not say that either.

Mr. Ebert. The remarks on the certificate are that the parents were intemperate, but the letter from the Sister Superior of the St. Joseph's Orphan Asylum of San Francisco says the father was intemperate and does not say anything about the mother except that she was a refined and respectable woman, but very frail in health.

The Court. Did your parents live together or separate and get divorced?

A. I could not tell you. They lived together, when I was with them.

Mr. Ebert. This letter says the father had abandoned the family.

The Court. Have you ever been convicted of any crime before in your life?

A. No.

Q. Were you ever arrested before this time?

A. No.

Q. Do you use tobacco?

A. I did not smoke before I came to the jail here.

Q. Do you smoke cigarettes now?

A. Once in a while I smoke one.

Q. How often do you drink beer and such things as that?

A. Very seldom.

Q. Did you ever get drunk?

A. Not that I know of.

The Court. In this case I have had a talk with Hogan and he told me just exactly how the crime of which he has been found guilty was com-

mitted. His story to me—and as he told it at the preliminary—was: That after meeting the man Dwyar on the corner and getting a room at the hotel, going down to Wall's place and playing the slot machine and meeting Soldanels—there, Dwyar changed a $10 gold piece at the table at the games that Soldanels then told him to take him—by him I mean Dwyar—for a walk, and that he did so; that they went around the alley to the levee, and that about the same time Soldanels left the Wall saloon, but must have missed them because they were down on the levee ten or fifteen minutes before Soldanels put in an appearance; that he had been sitting on the levee with Dwyar who was inquiring about his history and asked him what he had been doing, where he had been living and what he had been working at, when he saw a man pass along the levee; that he got up with Dwyar and walked on the levee in the direction in which he had seen the man pass; that they had not gone far before Soldanels—confronted them and took hold of Dwyar, and that as Dwyar turned to get away Soldanels knocked him down and kicked him after he was down; that then he—the defendant Hogan—felt in one of Dwyar's pockets and took some of the money and then turned around and started to walk off, and Soldanels said to him "Come back here! Where the hell are you going?" That he then went back and Dwyar was struggling and Soldanels said "Take him by the neck and hold him," which he did; that then Soldanels went through the man's pockets and again kicked Dwyar in the stomach and knocked the wind out of him; that they then left him after agreeing to meet again at Van Buskirk's. That he—Hogan—went up through the alley and stopped at the house of the woman Gladys Alderman and treated her, and then afterwards was arrested at the Wall saloon. That he testified in the way he did at the trial of Soldanels through fear of Soldanels; that after he had made his statement in the case at the preliminary and was brought up to the County Jail Soldanels made an attack upon him, but was prevented by the man, Harry Wilson, a trusty in the jail, from hurting him; that Soldanels told him that if he testified against him at the trial and they were sent to the penitentiary he would make it hot for him; that he had friends in both prisons and would send word to them, even if they—he and Hogan—were sent to different prisons, and that he would get him if possible and would make it very warm for him if in the same prison.

Hogan said that then they were separated and he was taken over into the other jail; that before he was required to testify, at his own request he was put back in the same jail with Soldanels who again repeated his threats and told him the story that he would tell upon the stand: which he did through fear that Soldanels would be able to carry out his threats.

After hearing the story I interviewed Harry Wilson, the trusty, who informed me that Soldanels did actually make an attack upon Hogan, and

more than one time, and that he prevented the boy from getting hurt—and that Soldanels threatened him.

Now it appears to me that the boy is not feeble-minded. Some suggestions in this direction were made the other day by counsel; but I find that he is a boy of fairly good intelligence. He may be incorrigible, but there may still be a possible chance of reclaiming him. And I have determined therefore to suspend sentence. Stand up Hogan.

You Frank Hogan, a boy of the age of 16 years, having been found guilty by the Superior Court of the State of California in and for the County of Yuba, of the offense of robbery, and you being in the opinion of the Court a fit subject for commitment to the Preston School of Industry at Ione, California, the Court does not suspend sentence and, conformably to the provisions of an act of the Legislature of the State of California entitled "An Act to Establish a School of Industry, provide for the management and maintainence of the same and to make an appropriation therefor," approved March 11, 1899, and the several Acts amendatory thereof; or supplementary thereto, it is ordered that you, the said Frank Hogan, be committed to said Preston School of Industry at Ione, California, until you reach the age of 21. [January 23, 1907]

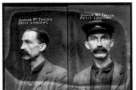

DUNCAN McTAVISH

STOLE FAUCETS

D. McTavish, who was arrested for trying to sell brass water faucets, is not as innocent as he at first claimed to be.

Sergeant Single discovered yesterday morning that he had stolen the faucets from the Hampton Hardware Company, and placed a charge of petit larceny against him.

The trial will take place at 9 o'clock this morning in the Police Court. [October 20, 1905]

IN THE POLICE COURT

Judge Raish had the following cases on his docket in the Police Court yesterday.

Duncan McTavish was convicted of petit larceny, having stolen two brass water faucets, the property of the Hampton Hardware Company, which he tried to sell. On waiving time he was ordered confined in the county jail for fifty days. [October 20, 1905]

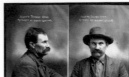

JOSEPH THOMAS DEAN

THOS. DEAN'S SAD PLIGHT

JUST "DONE THE BEST HE COULD" AND DIDN'T MEAN NO HARM.

The next time Mr. Thomas Dean in the goodness of his nature tries to assist a friend in taking care of his money and other valuables by the simple method of transferring them from the aforesaid friend's pocket to his own, he should remember to operate in a place not quite so public as that in which his recent attempt to help out his friend, Mr. Quincy Gorbett, was made. As a result of an entirely disinterested attempt in such regard Mr. Dean is now charged with an attempt to commit robbery, all of which makes it bad again.

It appears that while Gorbett, who was under the spell of sundry ambrosial draughts and who had succeeded in fitting the curves of his body to a nice soft sack of rock salt around in front of the Garrett Company's warehouse on Third street, was sweetly dreaming that he dwelt in marble halls and that Dean's fingers which he felt rummaging his pockets were the digits of a houri softly laying him under their spell, a Mr. McClure, who makes harness and things for the Harris Saddlery Company, chanced to pass that way, and not understanding the affection existing between the men as later related by Dean, yelled to him to stop "touching" the man in daylight. McClure had heard of men being shaken down after dark and possibly wouldn't have been so much surprised had he caught Dean lightening up Quincy's load even after the sun had gone down, but to go right after a man's sack and jewels in broad daylight was too much, so he summoned Officer Colford and poor old Tom was forthwith yanked off to the city bastile and a charge of attempted robbery registered against his name. Quincy, who was taken along for his own good, panned out $10.50 in coin, a silver watch and a white handled knife at the Police Station, which were restored to him later on making quite a little nucleus for him to build to in anticipation of another Saturday night some time in the future.

Yesterday afternoon Dean had his preliminary examination before Judge Raish and was bound over to appear before the Superior Court in $500 bonds, which he failed to supply, and consequently for the time being is forced to occupy bunk 13, a deuced unlucky number in the lower row of Sheriff Voss' flats, where for some little time to come he can amuse himself by watching the hands go around on the clock and ruminating on the uncertainty of events as applied to the life of a man who only wanting to do good is most woefully misunderstood. [October 18, 1903]

ONE YEAR FOR DEAN

Joseph Thomas Dean was arraigned in the Superior Court at 2 o'clock yesterday afternoon on a charge of attempting to commit grand larceny.

The information accused him of attempting to steal, on October 10, 1903, the sum of $10.51 from the person of Quincy Gorbett on Third street, in this city. Dean, in reply to the Court, stated that he did not want counsel appointed to defend him. He pled guilty and waived time.

District Attorney Brittan asked for extreme leniency for the prisoner on account of his pleading guilty. He had known him in Sutter county for about twelve years and had never heard of his committing any crime before.

Judge McDaniel stated that he had also known the defendant for several years, and knew that he was not a member of the criminal element. He would give him a chance on account of his pleading guilty. He ordered that he be confined at Folsom State Prison for one year. Sheriff George H. Voss will take him to Folsom this morning. [November 19, 1903]

FOLSOM PRISON RECORD

DATE:	NOVEMBER 19, 1903
COMMITMENT NO.:	5457
NAME:	DEAN, JOSEPH
CRIME:	ATTEMPT AT GRAND LARCENY
COUNTY:	YUBA
TERM:	1 YEAR
NATIVITY:	NEW YORK
AGE:	47
OCCUPATION:	COOK
HEIGHT:	5' 9 1/8"
COMPLEXION:	FAIR
EYES:	LIGHT BLUE
HAIR:	BROWN
DISCHARGE DATE:	SEPTEMBER 12, 1904

36

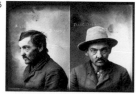

ISAAC DURBIN

STOLE TOOLS AND GOT INTO TROUBLE

Isaac Durbin, a dope fiend, stole some carpenter tools from George Phillips' shop on Oak street today and tried to sell them at a second hand store. He failed to dispose of them and continued on to Yuba City where he was arrested by Sheriff Wilson and Officer Harry Day and brought back here. The tools were found in his pockets and he was charged with petty larceny. [April 2, 1906]

IN THE POLICE COURT

Isaac Durbin was sentenced to serve five months in the county bastile. [April 4, 1906]

37

FRANK STANBRIDGE

STABBED WITH A PENKNIFE

A MULATTO WOMAN ON OAK STREET VICIOUSLY ATTACKED BY A ROUNDER.

Deputy Sheriff John Colford arrested Frank Stranbridge yesterday afternoon for assault with a deadly weapon with intent to commit murder.

About 3 o'clock Stranbridge tried to enter the house of a mulatto woman named Alice Jackson at 109 Oak street. She had locked the door to prevent his coming in, so he burst in the door, breaking the lock and after a few words had been exchanged he cut her on the left side of the throat with a penknife.

The woman screamed and tried to make her escape, and as she ran past him he kicked her out on the street, and followed her running down toward Chinatown. Luckily Deputy Sheriff John Colford appeared on the scene soon after Stranbridge had thrown away the knife and pointing a pistol at his head called on him "to throw up his hands." The knife wielder obeyed and was taken to the Police Office and locked up.

On the way to the Police Office he asked the prisoner why he cut the woman and he said: "That he had a right to cut her."

Dr. J. H. Barr attended to the injuries of the woman and found the wound close to the jugular vein. He stated that if the knife had gone in a little deeper that the result would have possibly been fatal.

Stranbridge is well known by the police. He was arrested recently by Officer Heenan for disturbing the peace at Harry Dalton's saloon, and was sent to the County Jail for fifteen days. He celebrated his release last Friday by getting drunk, was again arrested and when brought before Judge Raish in the Police Court was ordered to pay a fine of $10 or work on the chain gang. Yesterday morning he paid $7 and was released from custody and again started out to get drunk.

The woman stated that the only cause that the defendant had to make the murderous assault on her was that she told him not to enter the house.

Two men saw him throw away the knife and it is now in the custody of Marshal Maben. [December 2, 1904]

TEN YEARS AT FOLSOM

Knife Wielder Standbridge Pleads Guilty
and Is Sentenced.

Frank Standbridge, who cut Alice Jackson, a mulatto woman, in the throat with a penknife, on Wednesday afternoon, was arraigned in the Superior Court yesterday morning on a charge of assault with a deadly weapon with intent to commit murder.

In reply to Judge E. P. McDaniel he stated that he did not want counsel appointed to defend him, as he would plead guilty and waive time for passing sentence.

Assistant District Attorney Waldo S. Johnson explained to the Court all the circumstances attending the crime with which the defendant was charged.

When asked if he had any legal excuse to offer why sentence should not be passed, Standbridge told a fishy story. He stated that Alice had some photographs that belonged to him, and that he went to her house to get them. He denied that he had kicked in the door, and stated that he had only opened it and entered. He said that when he asked her for the photographs she called him a bad name, that he grabbed hold of her, that a scuffle took place and that he accidentally cut her in the throat with a penknife. He admitted that he was angry when he entered the house.

Judge McDaniel listened to him patiently and when he had concluded his little story, the Judge ordered that he be confined in the Folsom State Prison for ten years.

Sheriff Voss will take him to Folsom this morning. If he earns all his credits he will only have to serve six years and six months. [December 3, 1904]

FOLSOM PRISON RECORD

DATE:	DECEMBER 3, 1904
COMMITMENT NO.:	5908
NAME:	STANDBRIDGE, FRANK
CRIME:	ASSAULT TO MURDER
COUNTY:	YUBA
TERM:	10 YEARS
NATIVITY:	WASHINGTON
AGE:	20
OCCUPATION:	ELECTRICIAN
HEIGHT:	5' 8¼"
COMPLEXION:	MEDIUM
EYES:	AZURE BLUE
HAIR:	DARK BROWN
DISCHARGE DATE:	PAROLED JANUARY 26, 1910
	RESTORED MAY 29, 1911

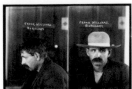

38

FRANK WILLIAMS

COULDN'T STAY GOOD TWO DAYS

Released from Jail Tuesday,
Williams Was Locked up Last Night.

Took Inebriate's Watch

Prisoner Played in Best of Luck Before, But Maybe Witnesses Won't Disappear Again.

Frank Williams was arrested by Officer Single at 5 o'clock last evening on suspicion of having stolen a watch. The officer had been informed that Williams had taken the watch from a drunken man.

After being placed under arrest on C Street Williams threw the watch away, and then refused to go with the officer. He soon, however, changed his mind, when he saw that the officer's club was ready for action. Single saw the watch fall, and it was promptly picked up.

Williams had been an inmate of the County Jail for the past few weeks, awaiting trial for a burglary said to have been committed by him at the Washington House, on C Street. George Yoder, proprietor of the lodging house, had sworn to the complaint and was to be the principal witness.

Fortunately for Williams, however, Yoder took it into his head to fly by night. It's an ill wind that blows no one good, and while Yoder's creditors were sadly weeping, Williams' smile was increasing in width.

The upshot of the whole matter was that when the case came up for trial in the Superior Court Tuesday morning, District Attorney Brittan moved for a dismissal on the ground of insufficiency of the evidence.

The motion was granted, and Williams went free. It seems, however, that he could not be good even when it was plainly to his advantage, as the circumstances leading to his arrest show.

When taken into tow last evening, Williams had in his possession $2.35 and a bottle of whisky. There appeared to be no urgent necessity for one so prosperous to rob a drunk, but to a truly industrious nature idleness is always intolerable.

Then again, "art for art's sake," you know. [February 9, 1905]

GIVEN SIXTY DAYS

Frank Williams was yesterday morning charged in the Police Court with petit larceny, it being said that he stole a watch from C. W. McDonnell and upon pleading guilty, was sentenced by Judge Raish to serve sixty days in the county jail.

McDonnell, who had been drinking heavily, was not sure whether he had made Williams a present of the watch or allowed him to steal it from

him, but the defendant was not aware of this fact and having been in trouble before on a serious charge, decided that it would be better to plead guilty. He seemed pleased with the sentence which was imposed. [February 10, 1905]

RELATED NEWS

December 6, 1904

YODER HAS GONE HENCE
GAVE BAD CHECKS AND SKIPPED WITH MONEY AND A WOMAN.

A padlock adorns the front doors of the Washington House on C street, conducted during the past four months by George Yoder, gaining in that time a very bad reputation.

Sunday Yoder wrote several checks on a local bank for amounts due creditors. The checks were presented Monday but the man had no funds there. The Valley Meat Company attached his place for $20.92 and other creditors levied another attachment for $51.95. About $50 is due employes of the place and it is estimated San Francisco firms have claims aggregating at least $500.

Yoder left early Monday morning taking with him several hundred dollars and a woman, Mrs. Vicencio, recently divorced from her husband in this city.

By closing of this place the saloon license is probably forfeited under the new ordinances and cannot be renewed.

39

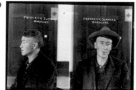

FREDERICK SUMMERS

COULDN'T COME TO AGREEMENT
JURY IN FRED SUMMERS BURGLARY CASE WERE OUT JUST SIX HOURS.

The case of the People vs. Fred Summers, charged with having committed burglary at the Ben Thomas Place at Wheatland on October 31, 1904, was on trial yesterday in the Superior Court. District Attorney Brittan and City Attorney Waldo S. Johnson represented the People, and Attorney J. C. Thomas represented the defendant.

The District Attorney stated to the jury that he would show that Ben Thomas left his home near Wheatland at 7 o'clock on the evening of October 31, 1904, and went into Wheatland and that when he returned home at 10 o'clock the same night he found the place had been burglarized, and that some provisions and a spoon had been stolen. He at once reported

the matter to the officers, who started for the brush along Bear river and when close to their destination they found the defendant in hiding. He had on his person the missing spoon, and some short distance from where he was found they located a sack containing the stolen provisions.

F. W. Anderson, Marshal of Wheatland, told of the arrest of the defendant about a mile south of Wheatland, where he was hiding behind a telegraph pole, of finding the silver spoon in question on his person, and of finding the provisions in the neighborhood. The defendant had made contradictory statements as to where he found the spoon, named at different times three different places.

The prosecution rested, and in the afternoon the defendant, Fred Summers, took the stand. He said he was twenty-one years old and a native of London, England. He denied that he had committed the burglary and claimed that he had picked up the spoon on the railroad track a half mile below the Wheatland depot. He stated that he had no money on the night of the burglary, and had intended to beat a train out of Wheatland, as a man whom he met in Marysville had told him that he had served forty days in jail for sleeping in a box car at Wheatland.

The arguments were then heard. District Attorney Brittan and Attorney Waldo S. Johnson presented the case of the People very strongly. Attorney J. C. Thomas, for the defendant, made a forcible and eloquent plea on his behalf. He asked the jury not to convict Summers on mere suspicion because he was a stranger far from home, and to give him that protection which the laws of this State gives to all men.

Judge McDaniel then read his instructions to the jury and the jury retired to consider their verdict at 4:20.

At 10:15 o'clock the jury were brought into the court room, and it being apparent that they would not be able to agree upon a verdict, they were discharged by Judge McDaniel.

On the last ballot the jury stood ten for acquittal to two for conviction. [February 8, 1905]

SUMMERS DISCHARGED

Upon motion of District Attorney Brittan Judge McDaniel this morning ordered Frederick Summers discharged from the county jail and the charge of burglary against him dismissed. Summers was arrested last November for entering a residence in Wheatland and purloining several articles. He was tried last week and the jury disagreed, only two being for conviction.

On this showing District Attorney moved for a dismissal on the gounds of insufficient evidence to convict. [February 13, 1905]

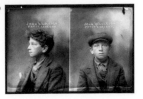

JOHN WADLEIGH

TEN DAYS FOR SLIP OF BOY

John Wadleigh, who claims to be 16 years of age, although he does not look to be over 14 years, was arrested by Officer Sayles at an early hour yesterday morning in a box car at the depot on a charge of petit larceny. He is accused of stealing $13.60, the property of Beverly Crampton.

The youth who claims to have formerly resided in San Francisco, and not to have seen his parents for the past six months, who are at present in Napa, was taken before Judge Raish in the Police Court at 3 o'clock yesterday afternoon and he pleaded guilty to the charge.

Beverly Crampton, who has horses at the race track, testified that the boy told him that he had just arrived from Portland and wanted work. He agreed to pay him $15 a month for exercising horses and took him to the track. On Thursday night he missed him from the track and found that $13.60 had been taken from his pants pockets.

Officer Sayles testified that when he arrested him in the box car that he admitted stealing the money.

The boy at this point seemed to realize his position and broke down completely, tears running down his cheeks. He wanted to write to his folks at Napa and they may be communicated with.

When told that sentence would be passed at 9 o'clock Saturday morning Wadleigh waived time and Judge Raish ordered that he be confined in the county jail for ten days. The youth seemed to be overjoyed at his lucky escape. The money was returned to Crampton. [July 15, 1905]

SUBSEQUENT CRIME

December 8, 1905
NEWS EPITOMIZED

The boy arrested at Benicia a few days ago on a charge of stealing $900 worth of property is believed by Sheriff Voss to be John Wadleigh, who was in trouble here some time ago for stealing money from an acquaintance with whom he stopped at the race track. He is 16 years old.

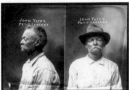

JOHN YATES

TOOK A ROLL OF BLANKETS

John Yates, an old man, was arrested yesterday by Officer McCoy for stealing a roll of blankets and was booked on a charge of petit larceny. [July 4, 1905]

[*No further information regarding the outcome of John Yates's trial was found; however, both Yates and John Wadleigh were later named in an article reporting an escape from the city jail, leading one to believe that Yates was convicted on his petit larceny charge.—ed.*]

RELATED NEWS

July 15, 1905
ESCAPED FROM CITY JAIL

Although one prisoner, George Desmond, made his escape from the city bastile yesterday, it was not a jail break. Desmond had been arrested for being drunk, and he is now enjoying the fresh breezes of the outer ozone.

The plumbers employed in the city hall building made a hole in the walls of the city jail for the purpose of placing some pipe, but were called away before the work had been completed, leaving a place large enough for a man to go through very easily. Although the workmen were absent but a short time, Desmond took advantage of the opportunity and crawled out.

John Yates and John Wadleigh, both of whom are charged with petit larceny, were in the jail and could have also gotten out, but Officer McCoy went into the yard and found that Desmond had disappeared and he at once locked Yates and Wadleigh up in a cell where they would be safe.

The officers will see that no more holes are left through which the visitors at Hotel De Maben may escape.

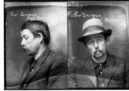

GEO. BRENNAN

NIPPED A NEW COAT

George Brennan was arrested at 11 o'clock yesterday morning by Officers Becker and McCoy and was booked for petit larceny.

He had visited Powell Bros. store on Second street and had stolen a combination coat, one side of which was leather and the other side was

made of corduroy, valued at $6.50. The officers found Brennan at Abraham's second hand store on C street where he was trying to sell the coat for $1.50.

After being arrested he stated that he had purchased the coat at Oroville, but it was identified by Powell Bros. as their property.

The merchants should remember that sneak thieves are very plentiful at the present time and that those that hang out their goods in front of their stores take desperate chances. [December 3, 1905]

PETTY LARCENIST SENTENCED

George Brennan was found guilty of petty larceny when the case was tried this morning and Judge Raish sentenced him to serve sixty days in the County Jail. [December 4, 1905]

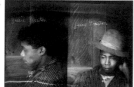

43

JESSE PRESTON

PRESTON IS IN THE TOILS FOR ASSAULT

THREW KNIFE AT C. D. PARKER, BAR TENDER IN WALL'S SALOON, AND LANDS IN JAIL.

Jesse Preston, a colored man, was arrested about 4 o'clock Sunday morning by Officer Sayles and has been charged with assault with a deadly weapon upon C. D. Parker, a bartender at Wall's saloon at the corner of Oak and First streets.

Preston entered the saloon early Sunday morning and was in a fighting mood. When told to keep quiet he refused to desist and consequently was ejected from the house by Parker. After Parker stepped back into the saloon Preston quietly opened the front swinging doors, drew a knife from his coat pocket and threw it directly at Parker. Fortunately Parker happened to turn just as he witnessed Preston draw back his arm and he managed to elude the knife which went flying through the air.

Officer Sayles happened along at that time and when about to place Preston under arrest he started out on a run down First street. He stepped into the outside door of the Wing On building near the corner of C, but Sayles was close behind. Preston hurried up the interior steps and endeavored to conceal himself in some bed clothes, but there was nothing doing, for Sayles was a close second and Preston was strictly up against the real thing. During Preston's flight the officer fired one shot in the air, but that only encouraged Preston on his sprint.

Preston has a bad reputation in local police circles. About a year ago when arrested by Officer Burroughs and when being searched at the sta-

tion house he walloped the officer with a hard right to the jaw and the officer took the count. [December 2, 1907]

PRESTON HELD TO ANSWER FOR ASSAULT WITH DEADLY WEAPON

The preliminary examination of Jesse Preston took place last evening at 7:30 o'clock before Judge Raish. After testimony in the case closed the judge ordered the defendant held to appear before the superior court on the charge shown in the complaint. His bail was fixed at $1500.

District Attorney Greely conducted the case on the part of the prosecution and the defendant appeared unrepresented by counsel.

The prosecuting witness C. D. Parker was the first witness to testify. He stated that on Sunday morning between the hours of three and four in the morning the defendant was in the saloon drinking. He was in a quarrelsome mood and when ordered from the saloon refused to go. Parker then walked up to Preston and when about to eject him from the house, Preston raised his right hand as if he were going to use a knife. Parker then struck Preston a blow on the mouth. With this Preston went out through the swinging doors of the saloon. Preston then opened the doors and hurled a knife at Parker, but he managed to duck and thus escaped being struck by the knife. Parker stated that the knife was open and had he not ducked he would have been struck.

Joe Brown, an employe at the saloon, testified he witnessed the trouble that occurred between Parker and Preston. He stated that he was sitting in a chair near the stove when Preston threw the knife at Parker and that it penetrated in the wall at the end of the building for about a half inch.

Officer Sayles testified to having arrested Preston, who tried to elude arrest by running away.

This concluded the testimony of the prosecution and the defendant was asked if he desired to make a statement. He replied that he did. Preston was then sworn and made the following statement:

That he entered the saloon Sunday morning and spoke to another colored man in the saloon. He was then ordered from the saloon by Parker and on not going out on a run, was approached by Parker, who struck him a blow on the mouth which staggered him. He then went out of the saloon and opened the doors and threw a knife, but not at any particular person. The knife was closed. At this stage he started away. He heard some one order him to stop, but thought that it was one of the parties in the saloon and he started to run. He continued on his flight up into a Chinese house and there hid under the covers of a bed. He was there discovered by Officer Sayles who placed him under arrest. [December 2, 1907]

[*No further records on Preston's trial could be located.—ed.*]

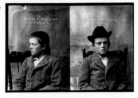

A HORRIBLE CASE OF JUVENILE DEGENERACY

Placing a revolver close to the back of his head, Claude F. Hankins, a fourteen-year-old boy, shot and instantly killed George Mosse, a middle-aged man at the Boles orchard, six miles east of Marysville at about 6 o'clock last evening, after which he took a purse containing $70 from the man's pocket and struck out for this city.

Arriving here he went to the Golden Eagle Hotel, where he registered under the name of Johnny Larkin and went to bed at 10 o'clock. Although he claims he rode to town on a wagon from the dredgers, it is believed he walked, the condition of his clothing showing that he came among brush.

The deed was not discovered until George O. Thompson and Miss May Lassons, the housekeeper, who had been in town, arrived at the orchard at about 7 o'clock. It was noticed the boy did not open the gate for them and neither he or Mosse were on hand to care for the horse.

While Mr. Thompson was unhitching, Miss Lassons saw the body of the man lying in the yard and thought he had fainted. She notified Mr. Thompson and he discovered that a murder had been committed.

A telephone message was sent to Coroner Kelly and Sheriff Voss and other officials were notified and went to the Bolles place. The absence of the boy first directed suspicion to him and his whereabouts was the first thing to be settled.

It was found that a revolver belonging to the dead man had been taken from his bureau drawer and that one cartridge had recently been exploded, after which it had been returned to its accustomed place.

Appearances showed that after the man and boy, who had been in town with a load of fruit, had returned to the farm the man had gone to milk a cow. He was returning when he was killed and had fallen forward on the milk bucket, afterward turning over on his back.

After getting as much information as possible at the orchard the officers came to town and continued their search. The boy was located in the Golden Eagle Hotel and was awakened by the Sheriff, Mr. Thompson being with him. He did not deny knowledge of the affair, but told a cock and bull story to the effect that the wagon in which himself and Mosse were returning to the ranch was boarded by two men shortly after passing the old Schumate place, who asked for a ride, and after reaching the orchard requested that they be given some food. Afterwards having accompanied Mosse to the lot where he had gone to milk the boy heard a shot and running to the bureau grabbed Mosse's revolver and started for the direction from which the report had come. Reaching the ground he saw one of the men standing over Mosse, the other hard by, and forthwith fired at them, but missed and they disappeared in the orchard going in the direction of Barrie's place. Upon being asked where he had gotten the money to pay for his room he stated that he had begged 25 cents from one man and 10 cents from another, but shortly afterward, calling George C. Thompson one side, informed him that under his pillow would be found a sack containing Mosse's money which he had taken from the body, and afterward feeling nervous had obtained his little basket valise and left the ranch, coming to Marysville. Mr. Thompson advised him that he relate these facts to Sheriff Voss, which he did, and the Sheriff took possession of the sack which contained $68.30.

During the questioning the lad related so many statements that were not plausible that no credence is given to what he said. He is a cigarette fiend and it is known that he was sent here by his sister, Mrs. Atwell C. Webb of 1723 Park street, Alameda, to break him of bad associations he had formed.

Letters among his effects show that he was homesick. He had been here only ten days and came as a result of an advertisement in a San Francisco paper. He wrote several untruths about his treatment at the orchard, claiming he had been seriously injured and that he had been to a doctor four times on account of an injured wrist, it being not ascertained when he wrote, on July 13th, whether the member was broken or sprained. There was no truth whatever in the report. He asked his sister if he might come home if he remained here three weeks, and promised to be good and not "play with any boy except John. John is a good boy, that is, has that reputation at home." He promised to wash the dishes morning, noon and night, and remarked that he was 200 miles from home. He seems to have rented a post office box for himself, No. 473, and insisted on having his letters sent to him instead of in the care of Mr. Thompson. The letter referred to ends with "I am homesick."

The boy Hankins hardly appears to be just right. He is about the average sized lad of 14 years, lisps a trifle and can tell as many tales in a minute as there are seconds therein.

There is no manner of doubt but that becoming homesick and being without any money his cupidity was aroused by the display of wealth that apparently had been made in his presence by Mosse and which appealed to him as being the means for a quick return to his home could it be secured. Being well acquainted with the dead man he had no difficulty in approaching him from behind when, before Mosse had an opportunity of knowing of the danger which threatened him, he was beyond all help.

Mosse was a man who bragged of being a Guatemalan insurrectionist and appears to have been an exile from that country. He had been employed

on the Bolles place three months and had not lost an opportunity to tell of men he had killed in South America, his stories being repulsive.

Mosse told several persons in this city that a wealthy Guatemalan woman, who had been educating herself in Cleveland, Ohio, would arrive in Sacramento on the 28th of this month en route to her southern home, and that he would meet and marry her, and that, when he had possessed himself of sufficient money from her fortune he would discover and kill his first wife and the man with whom she is living.

He is supposed to have cleared a 40-acre tract of land in the Santa Cruz mountains, built a house and started a vineyard, after which, leaving his wife in possession he went to South America. When he returned his home was forsaken and his belongings destroyed, while the woman was living with another man in San Francisco.

Mrs. Ella S. Veirs of Newton and Hanover avenues, Peralta Heights, East Oakland, is supposed to be a sister of deceased. He was a mechanic and a man who did not drink liquor to excess.

Coroner Kelly received a telephone message from Mrs. Veirs today to ship the body of Mosse to her address in East Oakland and it will be placed on the 5 o'clock train in the morning. [July 20, 1904]

BOY ADMITS CRIME
Told How He Killed George Morse to Secure a Few Dollars Tuesday Evening After Returning from Marysville.
Correct Name of Deceased

Claude F. Hankins, the fourteen-years-old murderer, has confessed that he killed George Mosse, whose correct name is George B. Morse, Tuesday evening, and he says he waited three days for an opportunity to commit the crime.

He had told so many falsehoods during his interviews with the officers that when they began to show him what he had done and how he had told one lie after another he broke down and told of the crime. [July 21, 1904]

CONFESSION OF BOY MURDERER READ TO CORONER'S JURY
Says That He Did Not Like Mosse a Bit Because He Had Treated Him Mean — Besides, He Wanted the Money Mosse Had and He Made up His Mind to Kill Him and Get It.

District Attorney Brittan read to the jury the confession of Claude F. Hankins that had been made in the presence of himself, Sheriff Voss and Court Reporter Cutter.

In this confession the boy stated that Mosse treated him too mean, and had told him that he would just as soon cut his head off as he would to whittle a piece of wood. So he got nervous and "did not like him a bit." Mosse had sworn at him and called him all kinds of names, and on one occasion he had tried to horsewhip him for letting the horses run away. So, says the lad in his confession, "I made up my mind that I would shoot him and went up back of him and shot him. I had made up my mind to kill him because he treated me too mean, and I did not like him; he had attempted to whip me lots of times. I said to myself, 'I would like to have the money that he had.'

"At dinner time on Tuesday I had made his tea a little too strong and he tried to hit me. I went into my room and when he went out to milk the cows I made up my mind to shoot him. I went to the bureau, took out his pistol and then I went out where he was milking the cows. He was almost through, and when he finished just as he was going to pass me I took out the revolver and shot him. One of the reasons that I shot him was that I liked to have the money that he had and another reason was the way that he had treated me. I took his money about five minutes after I had shot him and put it in my coat pocket and put on my coat and hat, took my satchel, went across the hayfield to Charles Taylor's and he brought me to Marysville. I will be 15 years of age next March. Have attended school, being in the fifth grade."

Young Hankins told the officers his father was killed in the East two years ago while attempting to commit a burglary. His mother had previously obtained a divorce on the grounds that he had been convicted of a felony.

According to the boy's statement he was born in Stockton, Kan., March 19, 1890, and came to California with his parents when only a few months old. His mother died last March in Alameda and he had since been living with his sister, Mrs. Atwell C. Webb, 1173 Park street, Alameda.

In speaking of the boy, Atwell C. Webb of Alameda, his brother-in-law, made the following statement:

"Claude has caused me and my wife endless trouble because of his laziness and inclination to travel with hoodlums. It was only a few days before I sent him to Marysville that he attempted to use a knife on me because I reprimanded him for his bad conduct and idleness. He is opposed to work, and, although I secured many places for him in stores, he refused to continue long at any one job. With my wife I believed that if we could get the boy away from evil companions and into the country he might reform. That was why I obtained the job for him picking fruit and paid his way to Marysville."

Concerning her brother, Mrs. A. C. Webb said:

"Claude has always been shiftless and was fond of knocking about idle with other boys. He liked cigarettes, but I do not know that he was given to drinking intoxicating liquors. It was only yesterday that I received a letter from Mrs. Bolles of the Thompson ranch, in which she wrote that Claude would do nothing and that his employer could do nothing with him. I had planned to see Judge R. B. Tappan today to find out whether my brother could not be committed to a reform school."

What to do with young Hankins is the question now being discussed. He is a confessed murderer and his crime was committed in a premeditated manner that shows the nature of the youngster. Crime is in his blood, yet his age is in his favor. There is no age limit as to hanging him and if he were a man in years that would undoubtedly be his fate. Should he plead guilty in the Superior Court and waive trial by jury the extreme sentence probably would be pronounced, and the Governor only would have power to lessen the penalty. If he stands trial it is improbable that a jury could be secured that would find him guilty in the first degree, yet it cannot be said that he should not be hanged. [July 22, 1904]

PROCEEDINGS FORMALLY INSTITUTED AGAINST HANKINS FOR MURDER
Boy Takes Affair Cooly.

Sheriff Voss swore to a complaint yesterday morning charging Claude F. Hankins, the fourteen-year-old Alameda boy, with the crime of murder. The complaint charges that "he did shoot, kill and murder George B. Mosse, also known as George B. Morse, a human being, on July 19, 1904."

The boy was brought before Justice Morrissey at 2:30 yesterday afternoon.

Justice Morrissey read the complaint and Claude stated that he understood what he was charged with, but had no money to employ a lawyer. He was informed that he had a constitutional right to an attorney when the case came up before the Superior Court. He did not seem to be at all nervous, and did not lower his eyes when the Court read the complaint.

After leaving the court room the boy was taken to Mrs. C. S. Smith's studio in the Odd Fellows' building and photographed, after which he was returned to his cell in the new jail. [July 23, 1904]

HANKINS HAS HIS FIRST CRY
Lad Feels Lonesome in His Cell and Asks the Sheriff to Visit Him Often.

Claude F. Hankins had his first good cry in the County Jail yesterday morning and after it was over he felt much better.

Between sobs he was heard to say: "I do not know why I did it."

Sheriff Voss stated to an "Appeal" reporter last evening that the little fellow eats well and sleeps well. He has asked the Sheriff several times "what they are going to do with him?" He has not the slightest idea that a jury would find him guilty, and order him to be hanged. He thinks that he will be sent to a reform school and wants to know how many years he will have to remain there.

He has asked the Sheriff to visit him several times a day in the jail, as he feels lonesome and prefers to talk to him rather than to the prisoners as he has been very kind to him. The Sheriff has complied with his request and calls into see the boy quite frequently.

When the case goes to the Superior Court it will no doubt be seriously considered by the Court and District Attorney what is to be done with the lad. [July 24, 1904]

[Claude Hankins's trial for the murder of George Morse began October 11, 1904, with Judge E. P. McDaniel presiding, District Attorney Brittan arguing for the prosecution, and Waldo Johnson and W. H. Carlin for the defense. Jury selection began the morning of the 11th, lasted the entire day, and resumed the morning of the 12th. District Attorney Brittan began his opening statements in the late morning of the 12th.

The testimony of the prosecution witnesses was substantially the same as the newspaper accounts of the circumstances of the crime. Mr. George C. Thompson, manager of the Bolles Ranch, and the housekeeper, Miss Lassans, told of finding the body of Morse, Sherriff Voss testified as to the investigation and arrest of the boy, and Hankins's original account of the crime and subsequent confession were admitted as evidence. The gun used in the killing was examined and the coroner testified that the death of Morse was caused by a bullet wound to the brain.

The prosecution rested and the lawyers for the defense opened with the statement that they would not dispute the fact that the boy had fired the shot that killed Morse, but that his action was justifiable. The following is an account of the remainder of the day's proceedings in court.—ed.]

YOUNG HANKINS' DEFENSE
If Boy's Statements Can Be Believed Mosse Got His Just Desserts.

Mrs. Lugenia Webb, defendant's sister, was the first witness for the defense. She stated that her mother died in Alameda and that her father was alive in Bisbee, Ariz. Claude attended school up to the time of his mother's death. He lived with her after his mother's death. He was of an

affectionate disposition, and never had any trouble with the police in Alameda except for jumping cars. She told about his coming to Marysville in answer to an advertisement, she being ill at the time.

On cross examination by the District Attorney, she stated that her husband liked the boy. Had known most of his associates, one of them only that she could call a bad boy; her husband made him stop going with bad boys; he was never out at night.

Mrs. Louisa Rogers of San Francisco was the next witness. She stated that she was Claude's aunt. Her sister had been married to John F. Hankins in Kansas about twenty years ago, but afterward been divorced from Hankins. Claude had been an affectionate child, an exceptionally good boy. On one occasion he ran away from home, returned next day, cried and asked to be allowed to return.

When the Court convened in the afternoon Claude F. Hankins, the defendant was sworn and testified as follows:

My mother died last March in Alameda; she was a dressmaker. I went to school and quit about the time my mother got sick, as I had to stay around the house and help her. My mother whipped me when I went with bad boys. After her death I went to live with my sister, Mrs. Webb in Alameda, where I lived for four months before I came up to Marysville to go to Mrs. Bolles' orchard. I met George Thompson at the Western Hotel, and he took me out to the orchard. I was only to receive my board and lodging. I found Mosse at the ranch; he soon acted mean. Witness told of a crime against nature that he tried to commit with him several times, and told how he had in such attempts torn the buttons from his clothing. The last time that he had tried to commit the crime was the day before the killing; Mosse had threatened that he would twist my neck if I told any one what he had done. I wanted to get away, and was crying most of the time on account of Mosse's actions. Knew that Mosse carried a pistol, as he had shown it to me.

Told of other mean actions of Mosse as a result of which he had concluded to shoot him and get away. So he had secured his pistol, shot him in the back of the head, taken his money and left. I was afraid of Mosse and his treatment of me was the reason that I shot him.

On cross examination by District Attorney Brittan he stated that he had given all his reasons for shooting the deceased. The treatment that he received from Mosse was in the orchard; it was there that he made the improper advances to him. He told about his striking him in the jaw because he allowed a horse to get away. Had never told Thompson about the treatment he was receiving from Mosse as he was afraid that Mosse would kill him if he did so.

"Which of the statements that you made is true," asked the District Attorney, "as to the reason why you killed Mosse?"

The witness answered: "The statement that I am now making is true."

Sheriff Voss was recalled and testified that when Claude was brought to the jail that his pants were tied up with strings, and he ordered a needle, buttons and thread to be sent to him.

Arthur Hill of Yuba City told of cruel treatment that the boy had received from deceased at the packing house of the H. Falk Company.

David Thomas, the day clerk at the Western Hotel, testified that he heard the deceased call the boy "a damn little rascal" opposite the Western saloon.

The defense then announced that they rested.

District Attorney Brittan commenced the opening argument for the prosecution at 3 P.M. He stated that he had fully proved all the statements that he had made in his opening argument. He admitted that Claude was a good boy up to the time of the killing.

Attorney Waldo S. Johnson made the opening argument for the defendant and after reading the law on justifiable homicide, stated that they had made a valid and justifiable defense and were entitled to a verdict of acquittal. Could the jury believe that if Claude was a good boy up to the time of the killing that all of a sudden he became a criminal without any cause. The deceased was living under an assumed name and carried a murderous revolver at all times on his person. It had been proved that his treatment of the boy was harsh and brutal. It was the duty of the jury to do justice to the boy, and not place him in a felon's cell. He asked the jury to do absolute justice and render a verdict of not guilty.

Attorney W. H. Carlin commenced the closing address for the defendant at 4 o'clock. He stated that there would not be the ring of silver or of gold in his voice as both himself and Mr. Johnson had been appointed by the Court to defend this boy. They had heard the revolting story told by the boy, regarding the infamous crime that the deceased tried to commit, a crime against nature the most horrible known to the law. Think of it, a boy 14 years of age, whose mother was dead, made the subject for those licentious attacks. I am asking for no mercy, but for justice for this boy on whom the deceased tried to commit a grievous wrong.

At this stage the Court adjourned until 9:30 this morning, when Attorney Carlin will resume his address and the case will go to the jury in the afternoon. [October 14, 1904]

THE STORY DENIED

CLAUDE HANKINS' FATHER WAS NOT KILLED WHILE ATTEMPTING BURGLARY.

When Claude F. Hankins was arrested, he made a statement to Sheriff Voss that his father was killed while attempting a burglary in an Eastern

State several years ago. The story was published at the time and went out over the country in the press dispatches.

Judge McDaniel, before whom and a jury the murder case is being tried, has received a letter from the father denying the statement and clearing the name of his family of the criminal record attached to it by the boy. The father is located in Bisbee, Arizona.

Marshal Maben also recently received a letter from another relative denying the charge.

So far as the letters go, Claude is the only relative of his father's family that was ever mixed up in a serious criminal offense. [October 14, 1904]

YOUNG HANKINS FOUND GUILTY

The arguments in the trial of Claude F. Hankins were resumed in the Superior Court at 9:30 yesterday morning.

When the court convened Attorney W. H. Carlin resumed his argument on behalf of the defendant. He called the jurors' attention to the fact that the boy's family connections were before them, which gave him a clean record, and showed that he had no criminal ancestry. The revolting and criminal assault that had been made on the boy rendered his act he claimed excusable. He made an eloquent appeal to the jury to do justice to this orphan boy, and render a verdict of acquittal.

District Attorney Brittan then commenced the closing argument for the people. He accused the attorneys for the defendant of being instrumental in having the boy set up the defense that had been presented.

Attorney Carlin resented the accusation and appealed to the Court for protection from insult to himself and his associate, Mr. Johnson, who had honestly and conscientiously at the Court's bidding defended their client to the best of their ability.

The Court admonished the prosecuting attorney to stick to the record in the case.

District Attorney Brittan then resumed his argument. He discredited the statements of Mrs. Webb, the sister of the defendant, that the boy was sent into the country by her husband because she was sick and unable to care for him, and referred to his being cast upon the mercy of strangers penniless and in shabby attire. He warned the jury against turning such a desperate boy loose, as he might select Marysville for his habitation and by so doing defile and pollute the minds of other boys. He contended that the evil influence exerted upon society by having a boy of his age and evil instinct at large was greater than that which a criminal of 25 or 45 years of age turned loose from the State Prison could effect.

Following Mr. Brittan's address Judge McDaniel read his instructions to the jury which were eminently fair and impartial and gave them four forms of verdict: Guilty of murder in the first degree; guilty of murder in the first degree with life imprisonment; guilty of murder in the second degree; and not guilty.

Sheriff Voss and Deputy Sheriff MacLellan were then sworn to take charge of the jury, who retired at 12 noon.

At 3:15 a loud knock was heard at the door of the jury chamber, to which Sheriff Voss responded. He informed the Court that the jury had sent him word that there was no chance of their arriving at a verdict.

Judge McDaniel instructed the Sheriff to tell the jury that they must further consider the matter, and that in case of an agreement not being arrived at that it would be necessary to lock them up all night.

THE VERDICT.

The jury came into court at 8:15, and after answering to their names, Foreman C. S. Brooks informed the Court that they had agreed on a verdict.

Judge McDaniel then read the verdict finding the defendant guilty of murder in the second degree and recommending him to the extreme mercy of the Court.

Judge McDaniel set Monday morning at 10 o'clock as the time for passing sentence. [October 15, 1904]

SENTENCE IS POSTPONED

LETTER RECEIVED FROM SAN FRANCISCO CUTS FIGURE IN HANKINS MURDER CASE.

When the Superior Court was called to order at 10 o'clock yesterday morning Judge McDaniel stated that it was the time set for passing judgment on Claude F. Hankins, who had been convicted of murder in the second degree.

Attorney W. H. Carlin stated that himself and his colleague, Attorney Waldo S. Johnson, had been busy looking up the law in the case. He called the Court's attention to a letter bearing the postmark San Francisco, October 15, 1904, which was addressed as follows:

"Important. C. F. Brooks, Marysville, Cal., foreman of the jury."

This letter read as follows:

"San Francisco, Oct. 15, 1904. To C. F. Brooks:
"Dear Sir—Having read the accounts in the Examiner in regards to the murder of George Morse by Claude Hopkins at Marysville on the Bolles

ranch. As I have work on the ranch before this boy for over a year I can testify as to severe threats that George Morse made against me during the time he was there. If you wish to call me as a witness before the case is closed I will be willing to go.

"I remain, very respectfully,

CHAS. N. DRAY.

"My address is 631 Third street. I am living with my grandmother."

In regard to this letter counsel stated:

"We desire to investigate the matter and see if the evidence that we can procure can be used on a motion for a new trial or in mitigation of the penalty to be imposed. We therefore ask for a continuance until next Tuesday morning at 10 o'clock."

District Attorney Brittan stated that he had no objection to a continuance being granted.

Judge McDaniel stated that no legal showing had been made at this time for a continuance, but that the Court felt that every opportunity should be given to counsel for the defendant to give testimony on the question of mitigation. He wanted to give counsel, who had been appointed by the Court, and who had worked so faithfully and hard on behalf of their client, every opportunity to do all they could in his defense. He would therefore continue the time for passing sentence until next Tuesday morning, at 10 A.M. [October 19, 1904]

THE DRAY BOY TELLS OF SOME OF HIS ALARMING EXPERIENCES WHILE LIVING AT THE BOLLES RANCH

The following statement has been made by Charles N. Dray to an Examiner reporter concerning what he knows about George B. Morse, who was killed by little Claude F. Hankins at the Bolles ranch. Dray is the boy who wrote a letter to Foreman Brooks and which was published in Wednesday morning's "Appeal."

The Dray boy was seen in his home on Third street, San Francisco, Tuesday, and he explained his motive in sending the letter as follows:

"I worked on that ranch for about a year, leaving there on the 4th of July of this year, some time before Hankins went to work on the place. I don't know the boy, but there is certainly some way of explaining his reason for committing the crime. I think that he had been threatened by Morse, for many times Morse had promised to kill me. He was of that nature. He threatened time and time again to cut my head off and take out my heart, and then again he had told me many times of the men he had killed on the plains. I am willing to tell my story to the Judge, for I don't think this boy should go to jail as a murderer.

"We were slaves on that ranch. I worked there for a year, and for the most part of the time I was forced to go with just a few clothes, and poor ones at that. My brother was forced to sleep in the chicken house until he ran away. Many times my mother sent for me to come home to San Francisco, but Thompson, the man I was working for, would not let me go. He never paid me a cent until I received a pass from my mother to come home, and then he gave me a dollar for the year's work. They used to take the letters that were sent to me from home, and I never received them. Morse was continually after me, and one time in the kitchen he came at me with a knife. May, the cook, told me at the time to tell the Sheriff about him, but I was too frightened to do that." [October 20, 1904]

BOY WHO WANTED TO GIVE TESTIMONY IN HANKINS CASE HEARD FROM

DENIES ROASTING THOMPSON.

Last evening George C. Thompson, manager of the Bolles orchard, called at the "Appeal" office and exhibited the following affidavit which would serve so it might seem to set at rest the report growing out of the Examiner publication, that he had been in the habit of habitually treating young lads employed upon the orchard in a cruel manner.

The affidavit referred to is as follows:

To Whom It May Concern:

I, Charles N. Dray, being duly sworn, depose as follows, to wit:

That there appeared in the columns of the San Francisco Examiner on the 19th day of October, 1904, a certain interview reported to have been had with me at the home of my aunt on Third street in said city and county, which I here deny in whole and in part. I was never interviewed by anyone in my life, and I here deny everything contained in the article concerning Mr. Thompson.

My purpose in making this affidavit is to do justice to Mr. Thompson, who has always treated me very kindly—allowing me to attend school, go to picnics and other places of amusement. I do not believe that he ever treated my brother unkindly.

I went to Mr. Thompson's ranch to do chores and work around. I was not a slave on the ranch. I worked for a year, and then went away for a time and returned on my own accord.

I think I wore as good clothes as any other boy who works on a ranch. Mr. Thompson got me shoes, stockings, shirts and everything else that I needed. I do not believe that my mother ever sent me anything that I did not receive. Whenever a letter was brought from town for me from my mother or anyone else, it was given me.

I want it understood that Mr. Thompson always treated me kindly and I have not now, and never had any occasion to complain of his treatment of me, and I have never complained of his treatment.

I have made this affidavit of my own free will and accord. I went to the home of Mr. Thompson's brother after reading the article contained in the Examiner, and told him that I was very sorry to be put in a false position by reporting that I had made such unkind and false remarks about his brother CHARLES N. DRAY.

Subscribed and sworn to before me this 20th day of October, A.D. 1904. OLIVER DRIBBLE, Notary Public, in and for the City and County of San Francisco, Cal. [October 22, 1904]

[*No further mention of Dray's allegations appeared in subsequent reports about the case.—ed.*]

HANKINS SENTENCED

Claude F. Hankins was this morning sentenced by Judge McDaniel to spend sixteen years in the State penitentiary at San Quentin. After sentence was pronounced the Judge informed him that by good conduct he would be given credits amounting to six years, making the total time to serve but ten years.

Attorney Carlin moved for a new trial but the motion was denied. He based the motion on grounds of errors and that the jury received evidence "other than that resulting from a view of the premises," and on "irregular and flagrant misconduct on the part of the District Attorney."

It was claimed that had the Court submitted to the jury a blank form for a verdict of manslaughter it would have been used. To this Judge McDaniel replied that in his opinion the case was murder or nothing.

Next a motion to arrest judgment was offered and denied.

Attorneys for the defense then argued the matter of a correct sentence to be imposed. Much stress was laid upon the age of the boy and the attorneys tried to convince the Court he should be sent to a reform school. The plea of Mr. Carlin was masterly.

In reply the Court stated that Yuba county's experience has been that boys sent to reform schools are not improved, while there are several here now who have served terms in a penitentiary and have returned to live upright lives. He stated that he could see but little hope for reforming the boy and that he is too dangerous to be at large.

He stated it is his opinion that had the defendant been older the jury would have returned a verdict of guilty in the first degree. The boy, in his opinion, possesses a remarkable intellect, as shown by the cunning story devised at first which was weakened by three minor falsehoods only. Had it

not been for these three unnecessary false statements, easily proven wrong, the story would in all likelihood have cleared him. [October 25, 1904]

HANKINS AT SAN QUENTIN

Deputy Sheriff Steve Howser on his return from San Quentin on Friday night stated that Claude F. Hankins was in good keeping. He has been assigned to the hospital and has been supplied with school books by the chaplain, who is taking a warm interest in his welfare. He no longer wears short pants as a suit of prison stripes has been made for him. If he is well conducted he will be treated all right. [November 6, 1904]

YOUNG HANKINS WANTS TO BE FREE
HIS APPLICATION TO YUBA COUNTY OFFICIALS FOR ASSISTANCE IS TURNED DOWN.

On the second anniversary of his crime, July 19th, Claude F. Hankins, the boy who in cold blood murdered George B. Morse at the Bolles orchard in Linda Township, has applied to District Attorney M. T. Brittan to assist him to get a commutation of his sentence. The letter and application, as well as a waiver of publication, were written by the boy himself at San Quentin Prison and were received here yesterday.

The District Attorney, instead of assisting the youthful murderer to get out of prison, will do all he can to keep him there for several more years. Judge McDaniel will not render any assistance to the boy to get out, as he considers it necessary to keep him there several years more to impress upon his mind the fact that it is not a small matter to kill a man. [July 20, 1906]

[*In November 1907 Hankins applied to the prison director for parole. As a condition of this bid for parole, Hankins was required to complete a series of forms, the overall title of which was "Biographical Sketch of Prisoners Eligible to Parole Under Provisions of the Law." The following is Hankins's narrative, which appeared in the section of the form entitled "History of Life from Boyhood to Present Time."—ed.*]

I Claud Hankins was born in the State of Kansas, March 1st 1890. My Father's name is Mr. John Hankins. Mother's name Mrs. Helen E. Miller. Up to Nov 9th 1907 I was under the impression, my Father died when I was a little boy. I was surprised when he came here to see me and now he offers to provide a home and learn me his trade (The Carpenter Trade). Mother and Father came from Kansas to California when I was a child, at 6 years old I was sent to the Public School. Mother was then alone and had to provide

for me and Sister. She done so until health failed then I left school to aid in our support. Mother then died; and Sister and I was alone. My first employment was for Mr. Binder at Binder's Drug Store the work was too heavy for me and Mr. Binder employed a much stronger Boy. My next employment was at the Oakland Cottin Mills. I fell sick from this work and the Doctor advised me to seek outdoor work. About this time Sister secured employment and then I was left to shift for myself, having no home I wandered from place to place doing odd jobs whenever I could find it. My next and last employment was on a Ranch up near Marysville Yuba Co. employed as a laborer. On the Ranch at this time was a Man by the Name of George Morse, he seemed to take a voilent dislike to me from the outset, and made my life miserable, he had no call to boss me but he done so and drove me to the verge of breakdown making me do heavy work I was totally unfit to do, and when I objected to his authority he beat and kicked me. The night of the fated Tragedy he was drunk and horse-whipped me for some trivial cause. In sheer madness and desperation I grabbed up his Pistole (he always carried one) and shot him. I then took his Pistole and what Money he had in his Room at the Bunk House and walked to Marysville where I was arrested. I was tried and convicted and sentenced to sixteen years at San Quentin Prison. I was Fourteen years of age when I came here to Prison. I have tried to do what the Prison Officers told me and have improved my time. I was only a boy and did not realize the awfull enormity of my crime. I now know I have done wrong and every night in my Prayers I ask God to forgive for taken the life of a fellow humane being.

Should the Prison Directors allow me to go home to my Father on Parole I promise to be a good Boy and learn a good Trade and become yet a good and usefull Citizen.

Claud Hankins

[*The following letter from E. P. McDaniel, the judge presiding in the 1904 Hankins trial, was received on November 24, 1907, by Brainard Smith, the clerk at San Quentin State Prison, in response to a request from the prison's directors for the judge's recommendations regarding parole for Hankins.—ed.*]

Dear Sir:

Yours of Nov. 21st in regard to the application of Claude Hankins for a parole has been received.

In reply to your question relative to his statement of facts as set forth in your letter I can state that he has not told the truth in a single particular except that he shot and killed Morse on a ranch near Marysville where both were employed.

The murder was cold blooded and deliberate, having been carefully planned and carried out for the purpose of obtaining between $60.00 and $70.00 which Hankins knew Morse had upon his person. The facts were fully stated in a letter of mine to Governor Pardee shortly after Hankins' conviction. They may be briefly recapitualated as follows:

One Morse and the boy Hankins were both employed upon the Boles Ranch near Marysville. Upon the day that the murder occurred, both Morse and Hankins had ridden together in a wagon to town where Hankins saw Morse received a sum of money. They returned to the ranch in the afternoon, Mr. Boles, (the ranch owner), and his housekeeper (a lady whose name I do not recall at this moment) were both absent from home, so Morse and Hankins were alone upon the place except for some Japanese laborers who were working in a field at a distance of probably half a mile from the house.

Morse went to a barn corrall near the house and was seated upon a stool milking a cow when Hankins approached him from the rear, shot him through the back of the head with a pistol he had procured in the house, rifled the body obtaining the amount stated above, and then went across fields to a neighbor's place. There he hired a man to take him to town. He registered at one of the local hotels under an assumed name and retired to his room where he was arrested by the Sheriff, G. H. Voss.

Upon being arrested and questioned he told a very ingenious story of explanation. He said that Morse had been murdered and robbed by tramps; that he (Hankins) had become badly frightened and had fled to town with the intention of going to Oakland where a sister of his was living; that he was so badly frightened and rattled he had not thought of reporting the murder to the authorities.

He told several lies as to how he had come into town, as to telephoning to a brother-in-law, etc. and when caught in the untruths he finally made a confession which was fully corroborated by all the facts and circumstances discovered at the scene of the killing.

Upon his trial, he charged that the deceased Morse had attempted to commit "the crime against nature" upon him, but this was undoubtedly a fabrication.

The testimony of Mr. Boles and the housekeeper showed that the boy was kindly treated by all upon the ranch including Morse. He made no such excuses or charges against Morse when he confessed to the Sheriff and to the District Attorney, Mr. M. T. Brittan. There is no doubt that the story of mistreatment by Morse was suggested to Hankins by prisoners in the county jail.

I make this last statement from information obtained from Sheriff Voss who says that he has learned that one Ben Salas, a prisoner then

confined in the county jail was the person who suggested the story to Hankins.

There was no conflict in the evidence, the facts proved were substantially as set forth above. The prisoner's extreme youthfulness was all that saved him from a conviction of murder in the first degree and probably from capital punishment. . . .

My opinion is that the boy is a degenerate absolutely without conscience or moral sense. The statements he makes in his application are so ingeniously false that I have no faith in his reformation nor hope that he would become a useful member of society if released upon parole. In fact, the circumstances of the murder itself and the subsequent ability and ingenuity in the concoction and telling of lies for the purpose of plausibly extenuating his crime convinces me absolutely that this boy, although so young in years, is a very dangerous and a confirmed criminal. . . .

Yours very truly,
Eugene P. McDaniel, Judge

[Parole was denied Hankins in 1907 and again in 1908. On November 1, 1909, his application was approved, and he was released from San Quentin State Prison to serve out the remainder of his sentence under the stewardship of the California State Parole Board. Hankins fulfilled the conditions of his parole and was restored (freed of his parole constraints) to society on November 1, 1914.—ed.]

SAN QUENTIN PRISON RECORD

DATE:	NOVEMBER 1, 1904
COMMITMENT NO.:	20863
NAME:	HANKINS, CLAUDE
CRIME:	MURDER, 2ND DEGREE
COUNTY:	YUBA
TERM:	16 YEARS
NATIVITY:	KANSAS
AGE:	14
OCCUPATION:	
HEIGHT:	4' 1 1/2"
COMPLEXION:	MEDIUM
WEIGHT:	86
EYES:	GREY
HAIR:	LIGHT BROWN
DISCHARGE DATE:	PAROLED NOVEMBER 1, 1909
	RESTORED NOVEMBER 1, 1914

TWO SM MOLES UPPER LEFT ARM, SM SCAR 2ND JOINT LEFT INDEX, LARGE BURN SCAR ON RIGHT FOREARM, BURN SCAR INSIDE OF RT UPPER ARM. SC INSIDE LEFT FOREARM.

45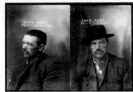

HART STEALS WHISKEY—CAUGHT WITH GOODS

Charles Hart wandered into the Palm saloon last night. Charles was in a festive mood really; he felt so giddy that when the barkeep's back was turned he reached over the bar and hooked a bottle of Tippecanoe whiskey. The barkeep turned round in time to see Charles beating it for the door, and although he gave chase Hart made a getaway.

Hart, however, is pockmarked and the barboy knew it, so he rang for the police and told Officer McCoy, who was on the job to go and get one man, pockmarked, and having a bottle of Tippecanoe in his pocket. Officer McCoy figured that whoever had that bottle would be in some nice dark place lubricating his spark plug. So the trusty sleuth started to make the rounds of the back rooms in the different saloons along the main stem. Needless to say all back rooms are dark, but the one in the Gilt Edge saloon is the darkest and in the aforesaid dark room Officer McCoy found the aforesaid Hart, tipping the aforesaid bottle of Tippecanoe to his head and drinking therefrom. McCoy forthwith took Hart to the City Jail and booked him for petty larceny. Hart claims to be a cousin of Marvin Hart, the fighter, but it is not thought that this fact will aid him in getting a decision over Judge Raish at this morning's session of the Police Court. [June 4, 1907]

NUMEROUS CASES ARE TRIED IN THE POLICE COURT

Charles Hart, who stole a bottle of whiskey from the Palm Saloon last night, pleaded guilty of petty larceny and got forty days in the county jail. [June 4, 1907]

46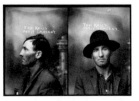

PETTY LARCENIST ARRESTED

Tom Kelly, a hobo, stole a pair of trousers from Brown's store this morning and sold them at Abraham's for 75 cents. He spent the money for booze and was arrested by Officer Sayles. A charge of petty larceny has been placed against him. [September 18, 1905]

A PETTY LARCENIST IS SENT TO THE COUNTY JAIL

Tom Kelly pleaded guilty of petty larceny in the Police Court this morning and Judge Morrissey sentenced him to serve ninety days in the County Jail. He is the man who stole a pair of pants from a store yesterday and sold them. [September 19, 1905]

47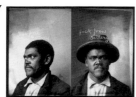

JACK JONES

JACK JONES, A NEGRO, SLASHED AT FRANK MARSHALL AND CUT ARTHUR WHITNEY ON THE TEMPLE

What came near being a serious or possibly fatal stabbing affray occurred yesterday afternoon at the corner of C and Second streets in this city, when Jack Jones, a colored man, made a desperate attempt to stab Arthur Whitney, a laborer for John Peters in Sutter county. An attempt was also made by the negro to stab Frank Marshall, proprietor of the Canteen saloon.

Jones had been drinking quite heavily and was very quarrelsome and when ordered out of the saloon by Marshall became very angry and objected to going out. After some talk he finally went out onto the side-walk in front of the saloon. Marshall then went to the door and seeing Jones standing nearby went out and again told him to stay out of the place. With this the negro made a slash at Marshall, who managed to step back and guard off the blow. Marshall then went back into the saloon, Jones still remaining on the sidewalk.

A man by the name of Arthur Whitney, who was inside of the saloon at the time the trouble was going on and who had also had some trouble with the negro, then went out onto the sidewalk and remarked to Jones, "Why don't you stay out of the saloon as Marshall told you to do." The negro took exception to this, became very angry and squared up to Whitney and in an instant made a slash at him with the knife, which he held in his right hand. The negro, in drawing back his arm when preparing to strike, struck Marshall, who at that time was standing back of him, and inflicted a slight wound on Marshall's finger on his left hand. Jones then made another slash at Whitney, who tried to guard off the blow, but the knife penetrated the brim on the right side of his hat and slightly cut his head just above the temple. A tussle ensued between the two men and Whitney succeeded in striking Jones several times with his

fist. Officer Becker, who was standing down the street, noticed the trouble and hurried to the scene and separated the two men and placed them under arrest. When Becker arrived the negro still held the knife in his hand. The officer then proceeded to the Police Station with the two men and Jones was charged with an assault with a deadly weapon with intent to commit murder, and Whitney was booked for safe keeping, but was later released from custody.

The knife used by Jones had a two and one-half inch blade and had he struck an accurate blow he would probably have killed Whitney on the spot, as it would have penetrated his temple, which would have meant death.

As it was Whitney may consider himself lucky that he is around with nothing more than a slight scalp wound.

He stated, upon leaving the jail, that he would be back Monday to swear out a warrant charging Jones with an assault with a deadly weapon with intent to commit murder.

Jones occupies a cell in the city cooler and has nothing to say regarding the affray. [April 1, 1906]

JONES CHOOSES TO FIGHT THE BATTERY CHARGE

Jack Jones, the colored man who struck Arthur Whitney on the head with a knife Saturday afternoon, inflicting a slight scalp wound, was arraigned in the Police Court this morning on a charge of battery, but said he was not ready to plead and would not be until he had seen Attorney Carlin. The arraignment was continued until Tuesday morning at 10 o'clock.

He was first charged with assault with a deadly weapon but it was thought he would plead guilty of battery and there would be no question of securing witnesses, but now that he wants to fight the lesser charge he may have to answer for the greater one. [April 2, 1906]

GETS NINETY DAYS

Jack Jones, the colored man who stabbed Arthur Whitney a few days ago, pleaded guilty of battery in the Police Court yesterday afternoon. This morning Judge Raish sentenced him to serve ninety days in the county jail. [April 4, 1906]

JOSE AJTUREY

AYTUREY TO ANSWER FOR MAYHEM

Bit a Piece from the Left Ear of Juan Garrat.

Jose Ayturey, charged with mayhem, came up for his preliminary examination before Judge Raish in the Police Court last evening at 7:30 o'clock.

A. G. Ramirez had been previously sworn by the Court to act as interpreter for both the defendant and complaining witness, who are Italians and unable to speak English plainly and understand sufficiently to carry on a conversation in the English language.

E. P. Reed was the first witness called to the stand. He stated that he was employed as bartender at the Royal saloon on D street on Monday morning of this week and that the plaintiff Juan Garrat and defendant, Jose Ayturey, were in the saloon on that morning and had a few drinks over the bar; that Garrat went out of the rear door of the saloon and upon his return found Ayturey lying on the floor in the rear of the saloon. Garrat then took hold of Ayturey to raise him to his feet and told him that if he wanted to sleep he would provide for a bed for him at a hotel. Upon this Ayturey commenced to struggle with Garrat and in the scramble that followed Ayturey bit a piece out of the left ear of Garrat. He did not hear Garrat say anything to Ayturey that would antagonize him in any way. He parted the two men.

Juan Garrat, the plaintiff, was then called and testified that he and Ayturey had been to supper; that he went out of the rear of the saloon and upon returning found his partner lying on the floor. He went up to him and raised him to his feet and told him that if he was sleepy he would go and secure a bed for him. Ayturey at once became angry and drew a knife upon him. He grasped Ayturey's arms and it was then that Ayturey bit a piece out of his left ear. He said that he and Ayturey had previous to this time been the best of friends and that he has known him for as much as fifteen years and could not account for his committing the crime. He had never before at any time had any trouble with him.

Upon this District Attorney Brittan stated that the prosecution was closed. The defendant was then asked if he wished to make a statement to the Court in which he replied that he did not.

Judge Raish then held that the defendant be held to appear before the Superior Court on the charge made out in the complaint and that his bond be fixed at $2000. [November 28, 1906]

JOSE YTURRI GETS OFF ON MAYHEM CHARGE

Jose Yturri, charged with mayhem and who was arraigned last week and his trial set for January 17th, was brought before Judge McDaniel in the Superior Court yesterday and on a request of District Attorney M. T. Brittan, was released from custody, there not being sufficient evidence to convict. It will be remembered that he was charged with mayhem by Juan Garat, the result of a combat in the Royal saloon on D street some weeks ago. [January 4, 1907]

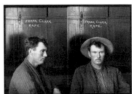

FRANK CLARK

THE MAN WHO ABUSED HIS LITTLE STEP DAUGHTER MUST FACE THE MUSIC

Deputy Sheriff James F. Nelson of Live Oak swore to a complaint yesterday before Justice of the Peace J. M. Morrissey, charging Frank Clark with having committed rape on Elizabeth Clark, formerly known as Alice Foster, his step daughter, and who is but 12 years of age. On the complaint being sworn to a warrant was served by Sheriff George H. Voss on Clark in the County Jail.

Mrs. William Brizendine of Live Oak accompanied the girl to this city yesterday, and after a conference had taken place between District Attorney M. T. Brittan and Drs. Powell and Hanlon the complaint was sworn to.

Clark admits that he was the husband of the girl's mother, who is dead, and that they came to Marysville from Susanville.

It was ascertained that he had hired a room at the Dawson House for a week, but had only remained there one night, going to Chico the following day with the girl, where they also remained for a night, after which they went to Live Oak, where the girl told Mrs. Brizendine how she had been assaulted, and begged of her not to allow her to leave again with Clark. The lady at once communicated with the law officers of Sutter county, and Clark was arrested.

Clark has a criminal record, having been arrested in Butte county on charges of stealing a watch in Chico and some sheep. He is a son of Andy Clark, who formerly resided at the Buttes.

Clark was arraigned yesterday afternoon. Justice of the Peace J. M. Morrissey set his preliminary for Saturday morning at 10 o'clock, and fixed his bonds at $5000. No attorney has as yet been engaged to represent him. [January 2, 1904]

CLARK BOUND OVER

The preliminary examination of Frank Clark took place yesterday morning in the Supervisor's room before Justice of the Peace J. M. Morrissey sitting as a committing magistrate. District Attorney M. T. Brittan prosecuted. The defendant was not represented by counsel. Deputy Sheriff J. F. Nelson testified that at the time of the defendant's arrest he had admitted to him that he had roomed with the little girl at the Dawson House on the night of December 16, 1903. The girl had informed him that she would not be 13 years of age until next May.

Alice Foster was called to the witness stand and, after informing the court that she understood the nature of an oath, related her sad story between sobs. She accused her stepfather of having committed the crime at different places on five different occasions. She stated that she would not be 13 years of age until next May and that her mother was dead. [January 3, 1904]

FRANK CLARK RECEIVES A SENTENCE WHICH ABOUT FITS THE CIRCUMSTANCES OF THE CASE

District Attorney M. T. Brittan filed an information yesterday morning in the case of the People vs. Frank Clark charged with rape.

Upon being asked by Judge McDaniel if he desired counsel, Clark stated very coolly that he would not require an attorney and would plead guilty to the charge, waive time and take his sentence.

District Attorney M. T. Brittan informed the Court that the girl on whom the crime had been committed was the stepdaughter of the prisoner. Her father and mother were both dead, and she had been under the protection of the man who had committed the crime to which he had pled guilty. It was a crime there was no excuse for; while the child was only 12 years old, the defendant was 35 or 36 years of age. He was her protector, but he had ruined her life. He had no recommendations to make the Court.

Judge McDaniel stated that under all of the circumstances of the case the defendant was not entitled to much consideration. The crime was a beastly one, and he regarded it as a more wicked crime than murder. There were no mitigating circumstances. He ordered that the defendant, Frank Clark, be imprisoned in the State Prison at Folsom for a term of forty years.

When Clark heard the fatal words he reeled backward, but Sheriff Voss soon had a hold of him, and led him out of the court room down to the County Jail. His bravado soon returned when he was locked up in his cell, and he jocularly remarked "that he had drawn the capital prize."

If Clark gets all his credits he will still have to serve twenty-four years, which would make him 60 years of age when he is released.

Sheriff George H. Voss will take him to the Folsom State Prison this morning. [January 6, 1904]

CLARKS APPLIES FOR PAROLE

Frank Clarks, who was sent to Folsom for a term of forty years from Yuba county in 1904, has applied for parole to the state board of prison directors of Folsom. His case was referred to District Attorney E. Ray Manwell and Sheriff C. J. McCoy of this county yesterday by the prison directors. So far neither the district attorney nor the sheriff have decided on their answer, but it is probable that it will be unfavorable, for Clarks was sentenced for a statutory crime and at the time public excitement against him was intense. He has served eleven years of his forty year sentence. [November 11, 1915]

[Frank Clark's request for parole in 1915 was denied, but his application in 1916 was approved and he was released from Folsom on February 8 of that year. His parole required him to be gainfully employed, so upon his release Clark went to work at the Tagus Ranch in Tulare County, California; he was paid $1 a day plus room and board for the job of "ranching."

In late 1927 the State Board of Prison Directors received the following letter from Clark's parole officer.—ed.]

San Francisco, Calif.,
December 30th, 1927.

State Board of Prison Directors,
State Prison at Folsom,
Represa, Calif.

Gentlemen:
I, Ed H. Whyte, State Parole Officer, hereby charge CONVICT NO. 5495, FRANK CLARK, with having wilfully and with evil intent violated the terms and conditions of his parole and ticket of leave on or about the 22nd day of December, 1927, by being received at Folsom Prison from the County of Tulare to serve a sentence of from 0 to 50 years for the crime of RAPE & PRIOR. (a new charge)

The said Frank Clark was received at Folsom Prison January 7th, 1904, from Yuba County for the crime of Rape, sentenced to 40 years and released on parole, February 8th, 1916.

Credits on a forty year sentence amount to 192 months.

Respectfully submitted,
(Signed) Ed H. Whyte
State Parole Officer.

[Apparently Clark committed another rape, this time in Tulare County; his parole was revoked and he was returned to Folsom Prison. He died six months later (June 8, 1928, 12:40 A.M.) in the prison hospital of undisclosed causes.—ed.]

FOLSOM PRISON RECORD

DATE:	JANUARY 7, 1904
COMMITMENT NO.:	5495
NAME:	CLARK, FRANK
CRIME:	RAPE
COUNTY:	YUBA
TERM:	40 YEARS
NATIVITY:	CALIFORNIA
AGE:	34
OCCUPATION:	TEAMSTER
HEIGHT:	5' 10½"
COMPLEXION:	MEDIUM
EYES:	LIGHT BROWN
HAIR:	BLACK
DISCHARGE DATE:	PAROLED FEBRUARY 8, 1916
	VIOLATED PAROLE DECEMBER 22, 1927
	DIED JUNE 8, 1928

VACCIN LEFT UPPER 3½" ABOVE ELBOW. OVAL SC RT 4ARM FRONT 3½" UNDER ELBOW FOLD. HORZ. SC LF 1½" RT CHEEK FROM TRAGUS. SM SC ON BACK OF WRIST 1" RT OF MED. LINE.

50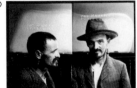

JOE ROGERS (alias JOE AUGUST)

PORTUGUESE WHO SWIPED VALISE SENTENCED TO THE COUNTY JAIL

Joe August, sometimes called Joe Rogers, a Portuguese, was brought before Justice of the Peace I. N. Aldrich yesterday morning and charged with stealing a leather valise, the property of Jim Martin, from Harry Carstenbrook's railroad camp.

August pleaded guilty. He stated through the interpreter, M. F. Gomez, that he waived time and was ready for sentence.

Justice Aldrich then asked him why he stole the valise.

The defendant replied that his own coffee and blankets were stolen in Sutter county, and that he made up his mind to steal all he could to get even.

Rogers appears to be slightly demented, and his case may be called to the attention of a lunacy commission in the near future.

Justice Aldrich sent him to the County Jail for ninety days. [September 21, 1902]

51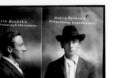

MARTIN BAHNSEN

SOAKED THE SPARKLER
BEN SHAFFER ENTRUSTS HIS DIAMOND TO THE WRONG MAN.

Martin Bahnsen, commonly known as "Fritz," was arrested in Chico on Monday night at the request of Marshal Maben on a charge of embezzling a diamond setting, the property of Ben Shaffer.

It was reported to the police officers on Monday that "Fritz" had received the diamond from Shaffer, whom he had informed that he had a customer who would purchase it. This was last Saturday, and Shaffer waited for two days for the return of the diamond or the money before making complaint.

The officers went to work on the case and found that "Fritz" had sold the diamond at Peter Engel's jewelry store.

"Fritz," who is about 20 years of age, had been in attendance on the late Jacob Gingell for a few days, and after his death worked around Shaffer's house for about a week. He knew that Shaffer had the diamond setting, and was anxious to sell it for him. When he told him that he knew a young man at one of the hotels who would purchase it, Shaffer handed it to him, never suspecting that he was crooked.

The arrest in Chico was made by Officer Peck, who found him at the Johnson House bar at about 11 o'clock on Monday night. He had registered at the Johnson House as P. Petersen. He admitted that he was the man wanted in Marysville and acknowledged that he had sold the diamond setting to a jeweler. He claimed that the owner had told him to sell it.

Brahnsen was willing to swear on a stack of Bibles that he was not guilty of embezzlement. He claimed that Shaffer had given him the diamond setting to do just what he pleased with. He admitted that he had sold it for $15 and stated that if given a chance he would go to work to earn the $15 and return the money to the man who had purchased the diamond. He was willing to pay the Marshal's expenses in going after him to Chico. He also made the statement that Shaffer had told him that he was in no hurry about the return of the money. [September 16, 1903]

[After a trial in Police Court Justice I. N. Aldrich judged Martin Bahnsen guilty of misdemeanor embezzlement and ordered him confined to the county jail for 90 days. The court then ordered the diamond setting be returned to Ben Shaffer and the $3 found in the possession of Bahnsen be returned to Mr. Howard, the man who had purchased the diamond.—ed.]

52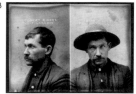

HENRY RUSSELL

A YOUNG MAN STOLE A RAZOR AND WILL ANSWER FOR HIS CRIME BEFORE JUDGE RAISH

Henry Russell, a young man of neat appearance, was charged with petit larceny, the theft of a razor from Henry Burner at the Western barber shop. Yesterday the young man went into the shop and asked permission to comb his hair, which was granted. While thus engaged he took a razor from the rack and put it in his pocket. When the razor was missed the matter was reported to the police and a description of the young man, on whom suspicion rested, furnished. Officers McCoy and Colford soon located him in a room in the U.S. Hotel and found the razor among his effects. He then admitted the theft. In court he asked for time to employ an attorney and the case was postponed until 9 o'clock Wednesday morning. [May 28, 1901]

NEWS EPITOMIZED

Henry Russell, the razor thief, was convicted of petty larceny in the Police Court yesterday morning, and was ordered to pay a fine of sixty dollars or, in default, serve one day for each dollar's fine in the County Jail. He is now a boarder with Sheriff Bevan. [May 30, 1901]

53

ROBERT RIVERS

RIVERS STEALS A CORD OF WOOD TO BUY DRINKS

Bob Rivers, who is pretty well acquainted with the Marysville police, is under arrest and is charged with petty larceny. He is a very industrious thief. Yesterday he bargained to sell a cord of wood to the Gem saloon at a figure that looked good to the proprietor. The wood began arriving shortly but it came in Rivers' arms. This looked suspicious so just before the cord had all been delivered the purchaser refused to accept it and ordered it removed. He then notified Officer Sayles, who followed Rivers while the latter was carrying the wood back, and found it had been taken from the Gilt Edge saloon. [January 10, 1907]

IN THE POLICE COURT

Bob Rivers, who was charged with petty larceny, having stolen some stove wood from one saloon man and then sold it to another, entered a plea of guilty and was ordered confined in the County Jail for twenty-five days. [January 12, 1907]

54

E. C. O'NEIL (alias ED TREMENHERE)

ASSAULT TO MURDER

AT GILLESPIE'S STABLE SATURDAY NIGHT AN OLD MAN WAS BEATEN WITH A ROCK QUITE SERIOUSLY.

During the early part of Saturday night an old man, J. M. Bennet, while asleep in the rear of Gillespie's Stable on C street, was attacked by E. C. O'Neil and severely beaten about the head with a rock. Orrin Nickell, who was also sleeping near the old man, heard the outcry and went to his assistance. O'Neil is a powerful man, and, although a lively scuffle ensued, Nickell was unable to hold the would-be murderer and he escaped in the darkness. During the fight O'Neil lost his watch out of his pocket and Nickell picked it up. The matter was at once reported to the police and a thorough search was made without result.

Sunday evening a man approached Nickell at the stable and wanted the watch. He was recognized at once as the man wanted for beating Bennett. Under pretext that his wife had the watch and that he would get it at once, Nickell stepped to the telephone and notified the officers, who hurried to the stable and placed O'Niel under arrest, charging him at the station with assault to commit murder.

O'Neil, who is a stranger in this city, appeared before Judge Raish this morning and his preliminary examination will be held Thursday morning at 10 o'clock.

Bennett stated this morning that O'Neil was a stranger to him and that he had never seen the man before. Had not Nickell come to the rescue when he did, O'Neil would this morning be charged with murder, as the old man was hammered almost to death, and covered with blood.

O'Neil will make no statement and the cause of his vicious attack is unexplainable, unless robbery was the motive. [August 3, 1903]

ANY OLD NAME IN A PINCH

E. C. O'Neil is not a stranger in this city as it was at first thought he was. Under the name of Ed Tremenhere he was convicted of petty larceny on August 30, 1895, and served 30 days in the County Jail. He had stolen a keg of beer from Klempp's saloon. [August 7, 1903]

VERDICT IN O'NEIL CASE

E. C. O'Neil, the defendant, was called to the witness stand and was examined by Attorney W. H. Carlin. He told about having worked for William Brockman [*in Yuba City*] for four days, ending July 31st, and coming to Marysville on August 1st to get some clothing. Had remained around town until about midnight and having no money left went to Gillespie's stable to sleep. Went into the corral; it was very dark and he stumbled over some one and then had a scuffle with him and another man. When he was struggling with Bennett he had used no more force than was necessary to protect himself; was not down on the ground until after he went down with Bennett. Had no stone in his hand during the struggle with Bennett, but had a knife in his pocket. Had slept in the corral before; would not have known the men he had the struggle with in the corral if he had not seen them at the preliminary examination.

At 12:45 this morning the jury came into court and handed in a verdict of simple assault.

Judge McDaniel fixed next Saturday at 2 o'clock as the time for passing sentence. [September 30, 1903]

[*Superior Court notes show E. C. O'Neil was sentenced on October 30, 1903, to serve fifty days in jail or pay a $100 fine.—ed.*]

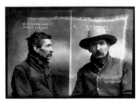

W. F. SPENCER

SPENCERS IN LIMBO

W. L. Spencer, aged 52, and Sarah Spencer, aged 53, were arrested on Saturday afternoon across the levee, near the brickyard, by Officer Becker on a charge of petty larceny. Both are morphine fiends and have been around this city for the past few months and claim to be husband and wife. [October 20, 1903]

THE SPENCERS NOW WENDING THEIR WEARY WAY TO OTHER FIELDS

W. L. Spencer and Sarah Spencer were charged in the Police Court yesterday morning with having stolen a woolen robe and wagon canvas sheet, the property of John Ruff, on September 23rd. Spencer informed the court that he had not secured an attorney, and the case was continued until 1 o'clock.

At that hour the defendants were still without an attorney and the case was proceeded with.

John Ruff positively identified the woolen robe as his property, but was not so sure about the wagon canvas sheet.

Mrs. Spencer claimed that she had purchased the property they were charged with stealing from a man named Wells, and proceeded to make several contradictory statements.

District Attorney Brittan stated that while the defendants were objects of pity, they were just the kind of people that lived by the commission of crime, and who were a detriment to any community in which they were allowed to remain.

Judge Raish asked the defendants if they were addicted to the use of morphine. They admitted that such was the fact, but claimed that they had first taken it under a physician's orders and could not overcome the habit. They asked to be allowed to leave town.

Judge Raish stated that they clearly belonged to the vagrant class, but on account of their condition were objects for pity. He found them guilty as charged, but gave them a floater until 3 o'clock this afternoon, at which time they were ordered to appear for sentence. [October 21, 1903]

[*No photograph of Sarah Spencer could be found.—ed.*]

PAUL SUNA

BOY GETS FIVE DAYS IN JAIL

YOUTHFUL PAULINE SUNA IS A SUBJECT THAT PITY AND CHARITY MAY BENEFIT.

There was a trial in the Police Court this morning that was more touching than the usual run of Police Court cases.

Young Pauline Suna, whose father was recently given a floater after being convicted on a vagrancy charge, was on trial for petty larceny. He was accused by Mrs. George Woods of entering her rooms and stealing several articles of jewelry, which he traded and gave away to several parties.

The boy works as a bootblack and he and his father had a room in the same building in which the Woods family resides. After the father was compelled to leave town the boy had a hard job making a living. He is about fifteen years old. He continued to sleep in the room and took his meals at the table of Mr. and Mrs. Woods, paying them what he could.

The boy claims that the Woods children stole his personal effects and some groceries he had in his room and that he only wanted to get even on the deal.

Judge Raish gave the boy some advice and told him he was very sorry to have his good opinion of him destroyed. He had given him credit for being a good boy even under adverse circumstances.

A sentence of five days in the County Jail was imposed and the lad was warned that a second conviction for petty larceny would make him liable to a term in State's prison.

Something should be done to assist the boy when he is released from jail next week. He seems to be industrious, considering the manner in which he was brought up. He has no home and no money and is likely to go to the bad very quickly if no helping hand is extended. [December 7, 1905]

SUBSEQUENT NEWS

May 2, 1906

PAULINE SUNA DIES OF POISONING IN OROVILLE
LAD WHO WAS KNOCKED ABOUT FROM PILLAR TO POST ATE
TAINTED MEAT.

Pauline Suma, the young man who was for awhile conducting a bootblack stand on Third street in this city, died in Oroville yesterday.

Sheriff Voss received word from Sheriff Chubbuck of Oroville yesterday saying that Suma had a day or so before eaten some canned meat that stood for a day or two and he had died of ptomaine poisoning.

Sheriff Voss was asked to notify some relatives of the boy in this city.

Young Suma was at heart a good boy, but he had no chance to be anything. His father was frequently an inmate of the City and County Prisons for bad conduct and is even now serving a sentence in the County Jail at Oroville. He was floated out of Marysville.

Young Suma was also arrested here on a minor charge and spent a day in the County Jail. He was pitied more than condemned.

RELATED NEWS

[The following are articles about Pauline Suna Sr.—ed.]

August 11, 1904

D. Coughlan, who was charged with having committed battery on Pauline Soona, with a chair, had his case set for 3 o'clock and was released on a deposit of $5.

February 12, 1905

Pauline Suna, who was drunk and committed a nuisance in a saloon, and J. Mitchell, who was drunk and disorderly, were fined $10 each and with the option of working ten days on the chain gang.

October 25, 1905

Pauline Suma is under arrest again and this time he is charged with being a common drunkard, which is a vagrancy charge. He will be tried this afternoon.

August 27, 1907

Pauline Suna, who has been in jail more times than Kid Rockefeller has raised the price of oil, was convicted of being drunk and took ten days on the chain gang.

57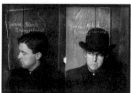

JAMES CLARK

A WHEATLAND BICYCLE THIEF IS UNDER ARREST

Sheriff Voss and Constable Anderson, the popular Wheatland peace officer, went to Tudor at 4 o'clock this morning and placed under arrest Jas. Clark upon a charge of grand larceny. He was brought to this city and lodged in the County Jail until this afternoon, when he was taken to Wheatland to be arraigned.

Clark borrowed a bicycle at Wheatland Monday and failed to return. Yesterday the two officers went to Woodland to locate him, but failed there.

On the way back the Constable asked a man at Tudor if he had seen a bicyclist in that vicinity and as the train rolled away the reply was made that the man had hired a bicyclist the day before. He proved this morning to be the party wanted and will have to explain his action to the Judge. He claims he was drunk when he rode the wheel away. [July 25, 1906]

BICYCLE THIEF GETS ONE YEAR

James Clark, the young man who borrowed a bicycle from a friend at Wheatland and rode away with it, being arrested later at Tudor by Constable Anderson and Sheriff Voss, was before Judge McDaniel in the Superior Court this morning and withdrew his plea of not guilty, entering one of guilty, to the charge of embezzlement. He waived time and was sentenced to serve one year in San Quentin Prison.

Clark ascribes his troubles to his fondness for strong drink and thinks if he had been more temperate he would not have committed the offense.

Deputy Sheriff Steve Howser took the prisoner to San Quentin this afternoon. [September 12, 1906]

SAN QUENTIN PRISON RECORD

DATE:	SEPTEMBER 13, 1906
COMMITMENT NO.:	21818 (REPEATED, 26306)
NAME:	CLARK, JAMES
CRIME:	EMBEZZLEMENT
COUNTY:	YUBA
TERM:	1 YEAR
NATIVITY:	AUSTRALIA
AGE:	22
OCCUPATION:	SHINGLER
HEIGHT:	5' 5"
COMPLEXION:	MEDIUM
EYES:	BLUE
HAIR:	DARK BROWN
WEIGHT:	148 1/2
FOOT:	6 1/2
HAT:	6 7/8
DISCHARGE DATE:	JULY 18, 1907

SCAR M L FOREHEAD, SCAR 3RD PHAL LEFT INDEX.

FEBRUARY 14, 1913: JAMES MARTIN (ALIAS JAMES CLARK) BURG 2ND DEGREE IN FRESNO. TERM: 2 YEARS, DISC OCTOBER 14, 1914

58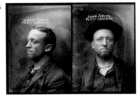

JOHN SMITH

WAS HUNGRY—STOLE SHOES

John Smith was arrested yesterday afternoon by Officer C. J. McCoy and booked for petty larceny. He stole a pair of shoes from Powell Bros. store on Second street, and when arrested had the shoes in his possession.

When asked why he stole the goods he said that he was out of work and wanted to raise some money to get something to eat.

How far that story will go when he tells it to the judge this morning, remains to be seen.

The shoes were of no value to the man for they were not mates. [August 24, 1907]

JOHN SMITH GETS THE LIMIT FOR STEALING SHOES

In the Police Court this morning John Smith pleaded guilty, waived time and was sentenced to sixty days in the county jail. [August 24, 1907]

R. LAWLESS (alias R. M. McCLELLAN)

ACCUSED OF BUNCO GAME

SHEEPSHEARERS CLAIM THEY WERE FLIMFLAMMED BY THE CONTRACTOR.

A man whose name was not ascertained, informed the police officers this morning that two sheepshearers had been swindled out of $12.50 on the train coming from Red Bluff by a confidence man who was in this city, and he desired to swear a warrant for his arrest. He was pointed out to Officer Single who escorted him to the police station. He gave the name R. M. McClellan, Sacramento, as his home, and denied positively any flimflam transaction but admitted having borrowed $5 from one man, but the other $7.50 he claimed to have no knowledge.

However he deposited $12.50 at the police station, $5 of which was to go to one man and $7.50 to the other, providing the latter would make affidavit that McClellan owed it to him.

The accused man stated that he had been employing sheepshearers for contract work and the men had gone on a spree and accused him wrongfully. He was not detained. [September 25, 1902]

A SHREWD OPERATOR

WHO FOUND THE MARYSVILLE POLICE NOT SO EASY AND IS NOW WONDERING HOW IT HAPPENED.

Robert Lawless, alias R. M. McClellan, has proven himself to be a clever confidence man and burglar, but he was not clever enough to evade the police officers of Marysville. In consequence he is now in the city jail and will be charged with crime of felony.

Lawless, or McClellan, is the young man who was accused of swindling a couple of sheep-shearers out of $12.50 on the train this morning,

an account of which appears in another column. He had no sooner been released after his smooth talk than he began another confidence game.

He called at the store of Tuck Woo on First street and represented himself as a water inspector, informing the Chinese merchant that the water pipes at the rear of his store would have to be changed, which would cost $8. The money was paid without question, and the "inspector" departed. He then called at the laundry of Hi Sing on Third street, where he made the same representation, and was told to make the necessary repairs. While pretending to do so he robbed four bunks, securing $33.

Tuck Woo reported the matter at the police station and officer Colford arrested the man just as he was about to board the afternoon train for the south. [September 25, 1902]

LAWLESS IS BOUND OVER

Man Alleged to Have Flim-Flammed Trusting Chinese Held to Answer.

The case of the People vs. Robert Lawless, alias R. G. McClellan, on two charges of burglary, came up before Judge Raish in the Police Court yesterday afternoon, he sitting as a committing magistrate.

District Attorney McDaniel represented the People, and Attorney Waldo S. Johnson the defendant.

The first case called was the one in which Hom Mow accuses Lawless of entering the store of the Tuck Wo Company, No. 318 First street, with intent to commit larceny.

Hom Mow was sworn and told how the defendant called on him last Wednesday at his butcher shop, and telling him that he came to fix the water pipes for the city, succeeded by a flim-flam process in getting $8 from him. Lawless went back in the yard to measure the pipes, and afterwards made his escape by the roof on to the levee. He concluded that it was better to report the matter to the officers, and did so at once.

Officer Colford testified that Hom Mow told him at the depot that he had been flim-flammed, and he pointed out the defendant in a saloon near by and accused him. Lawless then pulled out of his pocket $17, told him to give the Chinaman the $8 he had borrowed from him, and then asked him to make no arrest.

This concluded the testimony. Judge Raish held the defendant to answer and fixed his bond at $1000.

The second charge was then called up. Yee Foo accused the defendant of entering the building known as the Hi Sing laundry at 307½ Third street, with intent to commit larceny.

From the testimony of Yee Joe and Yee Foo, it appeared that the defendant went to the laundry and stated that he wanted to fix the water pipes, and that it might be necessary to shut off the water from one to two hours while he was at work. He also stated that the city was about to fix new sewers and closets, and that there would be nothing more to pay. He remained in the back part of the house alone for some time and after he had departed Yee Foo, the "bosses man," missed his purse and about $28. Defendant was observed taking measurements with a rule, and was also seen in Yee Foo's room, but the Chinaman thought at the time that he worked for the city and was a "good man."

On cross examination, Yee Foo stated that the purse containing $28 was in his trouser's pocket in the bed room. There was a ten-dollar gold piece, two five-dollar gold pieces, $4 in silver and $3 in half dollars, besides some small coins.

Officer Single testified with regard to finding an empty purse, memorandum book and razor under a bundle of blankets and close to a chair on which the defendant sat when he was first taken to the police office. The name "Hi Sing" was written on the last page of the memorandum book, and the purse was identified by Yee Foo as his property.

Judge Raish also held Lawless to answer on this charge, and fixed his bonds at $1000. [September 27, 1902]

LAWLESS GETS FOUR YEARS

The case of the People vs. R. Lawless, alias R. A. McClellan, charged with burglary on two specific informations, was called for trial in the Superior Court this morning at 10 o'clock. Before the jury was empaneled the defendant withdrew his plea of not guilty and substituted one of guilty to the first information—that of burglarizing the store of Tuck Woo Co. He asked for immediate sentence and Judge Davis ordered him confined in the State Prison at Folsom for a term of four years.

On motion of the District Attorney the second information was dismissed. [November 26, 1902]

FOLSOM PRISON RECORD

Date:	November 28, 1902
Commitment no.:	5254
Name:	Lawless, Robert (alias R. A. McClellan)
Crime:	Burglary
County:	Yuba
Term:	4 years
Nativity:	California
Age:	28
Occupation:	Horseman
Height.	5' 6"

60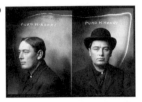

PURD H. HENRY (alias R. C. VAN SYCLE)

GOOD CAPTURE MADE OF MAN WANTED ELSEWHERE

Officer C. J. McCoy has made another good capture. He has a man named Purd Henry, who is wanted in Modesto on misdemeanor charges. His correct name, or the one he used in Modesto, is R. C. Van Sycle.

The description of the man sent out from Modesto was not correct, but McCoy took a chance and the fellow confessed today after being convicted of vagrancy and sentenced by Judge Raish to spend 40 days in the County Jail.

Van Sycle is a dope fiend now, but he says in days gone by he was a pugilist and was a sparring partner of Pete Van Buskirk. The prisoner admits that he and another man committed a robbery in Oregon some time ago, getting $1000. He was caught, tried, convicted and sentenced to serve ten years, but succeeded in getting a new trial and his relatives squared the case.

The Modesto officers have been notified of the capture, but probably will wait until the prisoner has served his forty days. [August 21, 1906]

61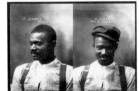

J. JAMES

ROBBED INDIAN IN EATING HOUSE

TWO COLORED MEN GUILTY OF
SERIOUS OFFENSE BUT WILL ESCAPE
LIGHTLY.

J. James and Henry Hayward, two negro laborers from grading camp of C. W. Reed, north of town, are under arrest and will be tried in the Police court tomorrow morning on a petty larceny charge, although they are guilty of grand larceny, if anything.

Last evening the two colored men took an Indian named James Perdue into a private box in the Empire restaurant and ordered a fine meal—probably the best they ever sat down to enjoy. Whether the Indian was drunk when he went in or whether he was drugged by his new friends is not known, but at any rate he was so drunk before he got out of the restaurant that he did not know what happened to him.

There was a witness to what happened in the private box. Frank Murphy was sitting outside, but he saw the two colored men take Perdue's watch and money from his pocket, after which they took him out of a back door into Oak street and dumped him upon the sidewalk.

Policeman Sayles and Constable Turrell happened along and Murray told them what he had seen. The two colored men and the Indian were taken into custody and locked up. The watch and chain and some money were found in the possession of one of the negroes, but he claims the watch has belonged to him a long time. It has been identified by the Indian, however, and by his brother as his property. Perdue says he misses about five dollars in money that he ought to have.

For the reason that it is believed Perdue would not appear to prosecute the case if a charge of grand larceny were placed against the men, necessitating trial in the Superior Court, the offense was booked as petty larceny and the trial will be held tomorrow afternoon.

Perdue was anxious to put up $5 and get out this morning, so it is not likely he would prosecute the case if reopened. He is charged with drunkenness. [August 30, 1906]

TWO NEGROES SENT TO COUNTY JAIL

In the Police Court this morning J. James, one of the men who robbed Charles Perdue, an Indian, in the Empire Restaurant a few nights ago, was sentenced to spend five months in the County Jail. His partner, Henry Haywood, was given three months in the same institution. These two make a total of six negroes confined in the County Jail at the present time. Most of them came here to work in the railroad camps.

These two men were tried last evening and the case against them seemed plain, but James still maintains that he is not guilty. [September 3, 1906]

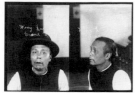

WONG QUONG TOO MUCH FOOLE

AN ILLICIT CHINESE LOVE AFFAIR IS TOLD IN COURT.

AH MOY'S FAITH SHATTERED

Witnesses State That She Gave Away Her Husband's Money Then Found Her Lover to Be False.

The preliminary examination of Wong Quong on a charge of grand larceny commenced at 10 o'clock yesterday morning before Justice Morrissey. Lem Goon, who swore to the complaint, accuses the defendant of stealing on or about September 27, 1904, the sum of $875.

The prosecution was represented by District Attorney Brittan and by special counsel to assist, and the defendant by Attorney W. H. Carlin.

Lem Goon, the prosecuting witness, testified that he had resided in Marysville sixteen years and was acquainted with the defendant, Wong Quong. The witness had gone East about five months ago and during his absence his wife, Ah Moy, died. Before leaving Marysville he gave his wife $1000 to take care of. Besides this there was $200 worth of groceries and $500 worth of opium in the store. When he returned his wife was dead and there was no money at the house. Coroner Kelly had given him a little over $400. Had sent his wife $60 from the East, as he thought that she might want it.

On cross examination by Attorney W. H. Carlin he admitted that $500 of the $1000 that he gave his wife belonged to his cousin, Ah Gong, who was to receive it from his wife when he wanted it, but he did not get it. He also admitted that the $500 worth of opium had been sold to him on credit and had not been paid for when he left Marysville.

He further stated that he had been employed in a gambling house in Marysville by Wong Quong, the defendant.

Tuck Kim of San Jose was the boss who furnished the money and he employed the defendant and the witness to run the game; Lem Goon was only paid $5 a week. Wong Quong was the manager of the business, but he did not live in the same house as his wife; he lived on the opposite side of the street.

In reply to further questions Lem Goon stated that the defendant was not very well acquainted with Ah Moy when the witness went East, but was told that they had become very intimate after he left.

He further stated that he had received two letters every month from his wife during his absence, but had burned them up on the day of the funeral according to the Chinese custom. He did not burn up a vest with money sewed in the inside, as he received it after the funeral.

Bock Chung testified that while he was smoking opium at Lem Goon's house a few days before Ah Moy's death that Wong Quong entered and said to Ah Moy: "I want to talk to you," and then they went into another room, and he continued smoking. He heard Wong Quong ask Ah Moy to give him that money, and she answered: "I can't give it to you, it belongs to my husband, who will return home in a few days."

"Soon afterward," continued the witness, "I heard a noise in the room where Wong Quong and Ah Moy were and asked what was the matter, but got no answer. I got up, and as the door was open, I saw Ah Moy reach down under the bed, get money from under the floor and give it to Wong Quong.

"When Ah Moy came out of the room I asked her if that was money that she gave Wong, and got no answer, so I repeated the question and she smiled and said yes. Heard Wong say: 'I go to San Francisco first you come after.' Ah Moy said nothing, but smiled."

On cross examination by Attorney Carlin the witness stated that he could not tell how much money Wong got. Had seen him about 10 o'clock the night before Ah Moy died on C street. She died at 4 o'clock next morning. Had told no one about Wong getting the money until Lem Goon returned, although he knew that Wong was a Suey Sing man [*a member of the Suey Sing tong, an organization involved in gambling and traffic in narcotics*].

Wah Yem, who was smoking opium at the same time as Bock Chung, also testified that he heard Wong ask Ah Moy for the money, but did not see him get any.

Ah You testified that he had talked with Ah Moy before her death. She was crying and very sick. Wong was not present.

Attorney Carlin objected to the testimony and was sustained.

Gim Ton testified that on the evening before Ah Moy's death he heard her say:

"Too much foole me; Wong Quong he foole me."

A motion to strike out this testimony was denied.

Attorney Carlin admitted that the sum of $875 was taken from the defendant when he was arrested in Wheatland.

The Court at 5 o'clock adjourned until 7 o'clock last evening so as to conclude the hearing.

When the hearing was again resumed Wong Sing, who stated that he was a cousin of the defendant, testified that he called to see him in the Wheatland jail soon after his arrest and that he had admitted that he took Ah Moy's money.

On cross examination he stated that the defendant had become a Suey Sing and that he had no further use for him.

Charles Page and Marshal Maben were examined and the prosecution rested.

For the defense Sheriff Voss was examined and stated that a Chinese returned to his city in the same car with him on the morning of the death of Ah Moy. The defendant had told him that he was the Chinese, but as the witness was lying down he could not identify him.

Yick Ken testified that the defendant got $900 from him at San Jose about October 28th to help to run the club or gambling house that the witness owned in Marysville. The witness further stated that he paid Lem Goon $5 a week and the defendant $7 a week to run the game.

Lee Hee testified that he told the defendant that the Hop Sings suspected him of poisoning Ah Moy and he became frightened and left town.

Justice Morrissey held the defendant to answer and fixed his bail at $2000. [October 20, 1904]

WONG QUONG FINALLY GETS CLEAR OF ALL ACCUSATIONS AGAINST HIM

This afternoon the charge of grand larceny that was preferred against Wong Quong some months ago was dismissed upon motion of District Attorney Brittan, it being deemed impossible to convict the man, and a trial would be very expensive to the county, all the witnesses being in San Francisco and San Jose.

Wong Quong was first believed to be responsible for the death of a Chinese woman in this city. Next he was accused of taking about $800 from her house after her death. For this alleged crime he was arrested for grand larceny upon a complaint of the woman's husband.

Col. E. A. Forbes was engaged as special prosecutor and the defendant employed Attorney Carlin. [January 31, 1905]

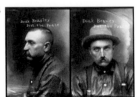

DOAK BEASLEY

BAD MAN FROM COLORADO HAS BEEN SENT TO PRISON

Doak Beasley, who was determined to have money even if he died in the attempt, was tried in the Police Court this morning on a charge of disturbing the peace, and was ordered to serve thirty days in the County Jail.

Mr. Beasley, while he is a decent appearing fellow, gets rather "rambunctious" when under the influence of liquor. He was just out of jail Thursday and was arrested that night. He had appeared at Phillips' saloon at First and B street and said he was "broke" and might as well be dead as broke; that he intended to have money before morning at any cost. He sized up the saloon very carefully and appeared to have a large stone in his pocket to be used as a weapon. The bartender, H. T. Coats, became alarmed and kept a six-shooter handy in case there should be an attempt at robbing him.

Officer McCoy says the fellow served two years of a thirty months' sentence in the State Prison in Colorado for killing a man and violated the parole on which he was released. He is also said to have served eighteen months at the Government prison on Alcatraz Island. [October 14, 1905]

PRIOR CRIME

October 9, 1905

GOT BAD BOOZE

Doakley Beasley was arrested for drunkenness and became very violent. It took two officers to hold him while another removed his valuables from his pockets to keep other prisoners from getting them. He had taken a very bad brand of fire water. Judge Raish sentenced him to serve ten days on the chain gang.

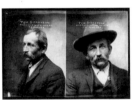

TOM DICKENSON

LOPEZ ESCAPED DEATH BY FRACTION OF AN INCH

The usual quiet of this city was broken last evening by a shooting scrape in the Palm saloon in which Tom Dickenson, an ex-convict, fired one shot at Joe Lopez, a sheepshearer. Both Dickenson and Lopez and a man named Harry Thomas, who is not unknown as a baseball player, are in jail. The case will be investigated by Marshal Maben and District Attorney Brittan this morning.

From what could be learned last evening it seems that Lopez and Dickenson have not been on good terms for some time.

It is understood that a year ago last New Year, Lopez entered the Palm saloon and engaged in a card game that was going on at the time. He was found cheating and disbarred from the game, and William Brooks told him to leave the place and never return. At that time Lopez flourished a revolver and created a scene in the saloon.

Last evening shortly before 6 o'clock Lopez again went into the saloon and engaged in a game of cards. It is said that he seldom plays a fair game and was caught cheating last evening and barred from the game.

After being barred from the game, Lopez went over close to Dickenson, and the next thing that was known of the trouble was when the pistol shot brought all hands to their feet. Dickenson had taken one shot at Lopez, but was overpowered before he had time to take another. The weapon with which the shooting was done was a 41-caliber army Colts revolver. It was given to J. A. Pieratt by those who took the gun away from Dickenson, and was later secured by the police.

One witness told of hearing Lopez say he would cut out Dickenson's heart and lights. Another witness heard Dickenson say that Lopez had been run out of town.

Lopez came as near to gracing a slab in the morgue as he wants to and it is nothing short of a miracle that he escaped death. The bullet passed under his arm and just missed his body by the smallest space. It penetrated the zinc back of the stove and sunk about four inches into the wall on the north side of the building.

After the shooting Lopez had some words with Pieratt and was going to assault him when Pieratt struck Lopez on the forehead and made a small bruise, which was later dressed by Dr. J. H. Barr.

The shooting occurred at about 6 o'clock and it was about 6:45 when Officer Joe Single placed Dickenson under arrest and took him to the Police Station, and placed a charge of assault with a deadly weapon against him. He was considerably under the influence of liquor at the time.

District Attorney Brittan, as soon as he heard of the affair, went to investigate and while near the saloon was approached by Harry Thomas. Thomas asked the District Attorney how much it would take to square the matter. Brittan's reply was an order to place Thomas under arrest, which was done, and when searched at the Police Station he handed over a five-cent piece and some tobacco—rather a small amount with which to ask such a question of the District Attorney. Thomas was charged with disturbing the peace.

District Attorney Brittan is trying to trace the trouble back to an old grudge. Dickenson is an ex-convict. In the southern part of the State some time ago he shot one man and wounded one or two more. For this he was sent to prison. Recently he stated in this city that one of the men he had trouble with that time was in this city. The men he shot were Mexicans and Lopez is also a Mexican.

Lopez was also placed in the city jail for safe keeping so that he will be on hand as a witness. [January 23, 1906]

MAN WHO TOOK A SHOT AT GAMBLER PLEADED GUILTY THIS MORNING

Thomas Dickenson, the man who fired a pistol shot at Joe Lopez in a D street saloon a few weeks ago, and who was awaiting trial on a charge of assault to commit murder, withdrew his plea of not guilty this morning and pleaded guilty to a charge of assault with a deadly weapon. Judge McDaniel sentenced him to serve one year in Folsom prison. The man probably did not know the complaining witness has disappeared. [February 28, 1906]

FOLSOM PRISON RECORD

DATE:	MARCH 1, 1906
COMMITMENT NO.:	6388
NAME:	DICKENSON, THOMAS
CRIME:	ASSAULT WITH A DEADLY WEAPON
COUNTY:	YUBA
TERM:	1 YEAR
NATIVITY:	MARYLAND
AGE:	53
OCCUPATION:	WOOD-TURNER
HEIGHT:	5' 6⅞"
COMPLEXION:	FAIR
EYES:	V. BLUE
HAIR:	GREY
DISCHARGE DATE:	JANUARY 1, 1907

65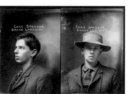

CHAS. SPENCER

YOUNG MAN SNATCHED FROM PRISON DOORS

THROUGH IGNORANCE CHARLES SPENCER CONDEMNED HIMSELF BUT HIS ATTORNEY JOHNSON INTERVENED.

Charles Spencer was arraigned in the Superior Court this forenoon on a charge of grand larceny, he being the young man accused of robbing Thomas Riddle of a watch.

Spencer entered a plea of guilty, waived time and asked for immediate sentence.

Judge Mahon, who presided, wanted to hear some of the facts of the case from the defendant and when they were recited Attorney Waldo S. Johnson asked for a stay of further proceedings, after which he volunteered to act as attorney for the lad and was appointed as such attorney.

A request for permission to withdraw the plea of guilty was then granted and the arraignment was continued until next Thursday at 10 o'clock.

Spencer, through ignorance, appeared to think he had no show in Court and would not make a defense. Now one will be made for him by Attorney Johnson and it seems probable he will be kept out of prison. He came very near to being sentenced this morning. [December 22, 1906]

FOUND GUILTY OF GRAND LARCENY

The case of the People vs. Charles Spencer, charged with grand larceny, in having stolen a watch from Tom Riddle in the Club saloon on December 17, 1906, came up for hearing yesterday before Judge McDaniel.

District Attorney Greely and Attorney Brittan represented the people. Attorney Waldo Johnson represented the defendant.

The following witnesses were sworn on behalf of the people: Tom Riddle, Peter Engel and Officers Becker, Sayles, McCoy and Tyrrell.

They proved that after defendant had lifted the watch from Riddle's pocket he ran away and when followed threw it inside a fence. The prosecution then rested their case.

Charles Spencer, the defendant, then took the stand and in reply to Attorney Johnson stated that he met Riddle in the Yuba saloon and engaged with him in conversation until Riddle went to sleep. While he was asleep he took his watch and chain from out of the left-hand pocket of his vest in order to have some fun with him. When Riddle woke up he missed his watch and accused him of having taken it. He made a grab for the watch and chain that he, the defendant, had. He became frightened when he saw an officer coming into the saloon and ran away, throwing the watch behind a fence. He would solemnly swear that he had no intention to steal it when he took it as he had a watch and chain of his own.

District Attorney Greely declined to cross examine the witness. The case was then argued by the jury and after receiving instructions from the Court they retired to consider their verdict.

The jury after a brief consultation brought in a verdict of guilty as charged. [January 18, 1907]

LENIENCY EXTENDED THAT HE IN REASON SHOULD REGARD

Charles Spencer, who was found guilty in Superior Court Thursday evening of grand larceny, appeared for sentence in the Superior Court at 10 o'clock yesterday morning.

District Attorney Greely asked the Court for leniency as the defendant was only 21 years of age and had not the appearance of a criminal. The testimony of the prosecuting witnesses showed that he was under the influence of liquor when he committed the crime.

Attorney Waldo S. Johnson, who appeared for the defendant, stated that he was much obliged to District Attorney Greely for his asking for leniency for his client in this case. He thought the Court could temper justice with mercy and could even suspend judgment as the defendant had shown that he had been an honest hardworking boy since he came to California.

Judge McDaniel in passing sentence stated that the defendant when first brought before Judge Mahon had entered a plea of guilty and had afterward changed it and asked for trial. He ordered that he be confined in San Quentin Prison for a period of one year.

The defendant seems to be well satisfied with the leniency shown him. [January 19, 1907]

SAN QUENTIN PRISON RECORD

DATE:	JANUARY 20, 1907
COMMITMENT NO.:	21971
NAME:	SPENCER, CHARLES
CRIME:	GRAND LARCENY
COUNTY:	YUBA
TERM:	1 YEAR
NATIVITY:	MAINE
AGE:	21
OCCUPATION:	GILDER
HEIGHT:	5' 8⅜"
COMPLEXION:	FAIR
EYES:	GREEN/HAZEL
HAIR:	BROWN
WEIGHT:	130
FOOT:	8
HAT:	6⅞
DISCHARGE DATE:	NOVEMBER 20, 1907

SM MOLE LEFT FOREARM. SCR POINT LEFT INDEX. MOLE ON RT UPPER ARM NEAR ELBOW.

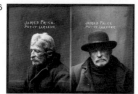

66

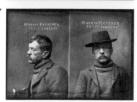

67

JAMES PRICE and MORRIS FLETCHER

GAVE THEM FIVE APIECE

JUSTICE METED OUT TO PURLOINERS
OF EWELL'S BLANKETS.

James Price and Morris Fletcher were charged in the Police Court yesterday afternoon with stealing two pairs of blankets, the property of S. Ewell & Co.

They admitted having the stolen property in their possession, but claimed that they got it from another man to sell.

Judge Raish found the defendants guilty and ordered that they be confined in the County Jail for five months each. [December 23, 1904]

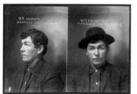

68

WM HERRON (alias LARRY DEMPSEY)

HERRON CONVICTED BY JURY

The case of the people vs. William Herron, alias Larry Dempsey, charged with assault with a deadly weapon with intent to commit murder upon Timothy McCarthy, came up for hearing in the Superior Court yesterday morning.

District Attorney M. T. Brittan represented the people and Attorney Waldo S. Johnson the defendant.

The trouble took place at the Louvre saloon on C street on October 2d.

The assault was committed by Herron on McCarthy with a razor and he cut him eighteen inches across the abdomen. The defense put in a plea that the defendant was not accountable for the crime as he was not sane at the time he committed the act. The prosecution clearly proved that the assault was committed. The defendant's counsel put on the witness stand Dr. J. H. Barr, as an insanity expert. He stated that he only wondered that the defendant is still alive. He pointed to a hole in his skull back of the right ear and stated that it was the result of an operation performed in San Francisco and that it was possible that it might result in the defendant going insane. He did not state, however, that when he saw the defendant that he saw any evidence of insanity.

James Jones, a colored man, who is serving time for petty larceny in the County Jail, told about the nervous spells the defendant had during his confinement there and the habit he had of talking to himself.

Officer Sayles was examined in rebuttal and stated that the defendant was confined in the City Jail for two weeks after October 2d. He was drunk when he was arrested, but after he had sobered up his condition did not differ from any other men in jail.

Under Sheriff H. M. Lydon testified that the defendant had been in the County Jail since October 16th and had acted quite rational at all times. This closed the testimony on both sides and the arguments commenced at 2:45 o'clock in the afternoon. After receiving instructions from Judge McDaniel, the jury retired at 3:50 to consider their verdict.

They reached a verdict at 4:55 o'clock, which Foreman M. Schwab handed to the Court. It read "Guilty of assault with a deadly weapon." [December 6, 1906]

HERRON GETS 2 YEARS IN PRISON

MAN WHO USED A RAZOR ON TIM MCCARTHY'S STOMACH
SHOULD BE PLEASED.

In the Superior Court this morning the first business was the passing of sentence on William Herron, convicted of assault with a deadly weapon. His attorney, Waldo S. Johnson, Esq., made a strong plea for extreme leniency on the part of the Court because of the mental condition of the defendant, due to former injuries to his head, but requested that in case he be committed to a penitentiary he be sent to San Quentin for the reason that the climate there was cooler and less liable to aggravate his brain trouble.

Judge McDaniel then asked the defendant if he had any legal cause to give why sentence should not be passed at that time.

Herron replied that he had no legal cause to offer.

Judge McDaniel in passing sentence stated that it had been clearly proved that he had slashed McCarthy with a razor across the abdomen. It was true that he had received injuries to his head and had interposed a plea of insanity to the information on that account. He had been charged with assault with a deadly weapon with intent to commit murder, but the jury rendered a more merciful verdict of omitting the intent to commit murder. He certainly was a dangerous man to be at large when under the influence of liquor. He then ordered that he be confined in the State Prison at San Quentin for a period of two years, which is the limit of punishment for that offense. [December 8, 1906]

SAN QUENTIN PRISON RECORD

DATE: DECEMBER 8, 1906
COMMITMENT NO.: 21914
NAME: HERRON, WILLIAM

CRIME: ASSAULT WITH A DEADLY WEAPON
COUNTY: YUBA
TERM: 2 YEARS
NATIVITY: IRELAND
AGE: 33
OCCUPATION: IRON WORKER
HEIGHT: 5' 6³/₈"
COMPLEXION: MEDIUM
EYES: LIGHT BLUE
HAIR: BROWN
WEIGHT: 154
FOOT: 7
HAT: 7¹/₄
DISCHARGE DATE: AUGUST 8, 1908

INDIAN INK: BRACELET AND CLASPED HANDS RT WRIST. RING ON 2ND AND 3RD RT FINGER. WREATH INSIDE LEFT FOREARM. BRACELET AND HEART ON LEFT WRIST. HEART AND SHAMROCK BACK LEFT HAND. RINGS ON 2ND AND 3RD LEFT FINGERS. FEMALE BUST AND WREATH BACK RT HAND.

SCAR LEFT EYEBROW. SC UPPER RT ARM, NEAR ELBOW.

LARGE HOLE, SIZE OF DOOR-KNOB IN SKULL OVER RT EAR.

69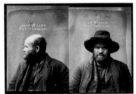

JOHN MILLER

HORSE BLANKET STOLEN

Officer Single arrested a man named John Miller yesterday on a charge of petty larceny. He is accused of stealing a horse blanket, the property of the J. G. Cohn Company, from Nelson's stable, and some potatoes, the property of some unknown person.

Miller has a criminal record as he stole a turkey in Wheatland and was just released after serving 20 days in the County Jail. He will now be charged with petty larceny and a prior conviction.

The arresting officer thinks that Miller is an ex-convict and that he served a term at Folsom. [January 12, 1905]

NEWS EPITOMIZED

John Miller, a petty larcenist, was sentenced this afternoon to spend fifty days in the county jail. [January 12, 1905]

70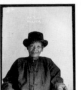

AH YUEN

CAMPTONVILLE CHINAMAN FOUND DEAD IN THE ROAD

Shortly before midnight last night Sheriff Bevan received a telephone message from Camptonville telling of a tragedy that had shortly before been enacted near that town. Theodore Wayman told the story, the substance of which is as follows:

At Freeman's Crossing, three miles this side of Camptonville, where the toll bridge over the Yuba on the road leading to Nevada City is located, two cabins, of late occupied by a couple of Chinamen, have stood for many a day. One of the celestials has been considered "queer" for some time and it was in contemplation to have him examined by a commission in lunacy at an early day.

Last night, however, about 11:30, his dead body was found in the middle of the road, in front of his place, with what appeared to be an ugly knife wound in the back, and a hatchet clutched tightly in one of the hands. The man's cabin had been destroyed by fire.

The other Chinaman has disappeared. [May 24, 1901]

THE MURDERED CHINAMAN

It has been ascertained that the Chinaman who was found dead on the road near Freeman's Crossing on Thursday night by Frank Bradbury was named Ah Gin, a miner, about 65 years of age. The celestial who is supposed to have killed him is named Ah Guen, or Gun. The Grass Valley Union states "that the garments of the murdered Chinaman were saturated with blood. That for years he has worked the river tailings in his neighborhood. He lived in a cabin, and in the other end of the same building was another Chinaman named Ah Gun. The latter has been thought for a long time to be weak-minded, if not, indeed, to be partially insane. As the latter could not be found last night it is suspected that his probable disappearance has something to do with the case." [May 25, 1901]

THE MURDERER CAPTURED

Sheriff Bevan and Coroner Hopkins returned to-day from Freeman's Crossing where they had been to investigate the murder of Ah Gin, an account of which was given in the DEMOCRAT last evening.

Coroner Hopkins held an inquest yesterday and the jury returned a verdict that death resulted from a stab in the back with a knife or spear in the hands of parties unknown.

The weapon with which the deed is thought to have been committed was found near the burned cabin of the supposed murderer and is an ugly improvised spear manufactured from an old file and attached to a pole about eight feet in length. The blade entered near the left kidney, ranged upward and pierced the spleen and left lung.

The deceased was buried last evening at San Juan.

A telephone message was received this afternoon stating that the murderer had been captured about three miles from the scene of the tragedy. Sheriff Bevan had offered a reward for his capture before leaving Camptonville, and men started after the missing Chinaman, with the result as stated. The Sheriff started this afternoon to bring the prisoner down to the jail. [May 25, 1901]

CHINESE MURDERER IN JAIL
The Fellow Evidently Done the Killing with the Spear Found.

Sheriff Bevan returned from Freeman's Crossing about 10:30 o'clock last night, bringing to the county jail Ah Yuen the murderer of Sue Quan who was captured Saturday afternoon. The prisoner admits that the spear found near the burned cabin was made by himself. He stated to District Attorney McDaniel today that Quan was a bad man, that he owed him (the prisoner), $1 and would not pay. Yuen also claims that Quan had been stealing his household goods. [May 27, 1901]

THE MURDERER ARRAIGNED

Ah Yuen, the Chinese charged with the murder of Soo Quon, near Freeman's Crossing on the 23d of May, was arraigned in Justice Morrissey's court this forenoon and the preliminary examination was set for Tuesday, June 25th, at 10 a.m.

The defendant has called on his company for assistance but it was stated by the interpreter that they refuse to have anything to do with the case. Ah Yuen is either a very cunning man or is slightly demented. [June 18, 1901]

CHINESE MURDER TRIAL NOW ON
A Verdict of Murder in the First Degree with Recommendation that He Be Imprisoned For Life.

The case of the People vs. Ah Yuen, charged with having murdered Soo Quon, alias Ah Jim, in this county on May 23, 1901, came up for hearing in the Superior Court at 10 o'clock yesterday morning.

District Attorney E. P. McDaniel and Col. E. A. Forbes represented the People while attorneys E. T. Manwell, Waldo S. Johnson and A. H. Redington appeared for the defendant.

Theodore Wayman of Freeman's Crossing was the first witness. He stated that about 11:30 o'clock on the night of the murder a fire was discovered at the cabins of the deceased and defendant, put out the fire at the latter place, but it was started up later. Ascertained later that the body of Ah Jim had been found on the road.

Identified a spear, the handle of which was partly burned, and stated that he had a conversation with the defendant about the spear, who said he had poked the deceased with the same, but that it was not sharp enough to hurt him; he showed him where he had made it; saw Dr. Lord fit the spear to the wound, and it fitted exactly.

The witness next testified concerning trouble previous to the murder between the two Chinamen; had been told that they had not been speaking for three days before the murder; found blood stains half way between the cabin and where the body was found.

In reply to District Attorney McDaniel he said the defendant told him that the deceased had gone to China.

Dr. F. K. Lord who made the autopsy was the next witness. He described a wound that he had found in the back of the deceased which had passed through the lower portion of the left lung, the wound was such as a spear would make, death resulted from internal hemorrhage which was necessarily fatal. Deceased was about 60 years of age, weight 130 or 135 pounds, height about 5 feet 6 inches; the wound slanted upwards.

On cross-examination by attorney E. T. Manwell he testified that the wound was about ten inches in length, it was a jagged wound.

Frank Bradbury, of North San Juan, who was at Freeman's Crossing at the time of the murder was the next witness. He told about seeing the fire at both cabins, and putting out the blaze in one of them, twenty minutes later the same cabin was on fire. Made a search for the defendant after finding the body of the dead Chinaman, and discovered him in an old deserted cabin sitting on a bed, took him to the hotel. He stated that the deceased had gone back to China.

Henry Zohurst testified as to finding the body of the deceased, and helping to put out the fire at the cabins, and to the finding of the defendant. Spoke to the defendant in English; he seemed to understand what I said; he said Ah Jim had gone to New York; afterwards said he had gone to China.

On cross-examination by attorney Waldo S. Johnson he said defendant did not speak about the dead Chinaman until he asked him where he was; he said "Ah Mow, he sabe."

The witness identified the spear, and stated that it was in the same condition now as when it was found. He also stated that an explosion woke him up before he saw the fire; saw the Sheriff pick up a long barrel pistol where the fire took place. The defendant had borrowed his shotgun some time previous, and it was returned to him by other parties; he had told him that some Chinaman at San Juan wanted to fight him, and that he was afraid. Ah Yuen had discharged the gun the first night he got it; it was returned to him the evening before the murder. The defendant said he made the spear when he could not get a gun to defend himself.

District Attorney McDaniel offered the pistol in evidence and announced that the prosecution rested. [September 24, 1901]

AH YUEN IS GUILTY

When court reconvened this morning the defense announced that they would offer no testimony.

The prosecution offered no testimony in rebuttal, and Judge Davis ordered the arguments to proceed.

Col. E. A. Forbes made the opening talk for the People, and claimed that the murder of Soo Quon was cruel and deliberate. In his opinion the defendant had set fire to the cabin of the deceased in order to smoke him out of the building, and he had finally broken out with a hatchet in his hand and had been pursued by the defendant with a spear in his hand. It was evident that the defendant was bending over when he was struck; it was probably when he was going up the steps that he received the fatal jab with the pike pole. The defendant had admitted poking the deceased with the spear, and they should take into account the evidence of flight. There was in his opinion no doubt of the guilt of the defendant.

Attorney E. T. Manwell made the opening argument for the defendant, whom he claimed had been deserted by his countrymen on account of his old age. The Chinamen who wanted vengeance had employed the leader of the bar of Yuba county (Col. E. A. Forbes) to assist in the prosecution. Counsel contended that there was no motive shown why defendant should kill the deceased. Counsel then took up the testimony of Theodore Wayman, who he claimed was not a careful observer, as he had passed the body of the deceased and did not see it although he had a lantern in his hand. It would in his opinion take an athlete to do the killing in the manner described by Col. Forbes. He commented on the fact that there was not a drop of blood on the handle of the spear. This was a case that was shrouded in mystery. It had not been explained why the deceased should burn his own cabin. The defendant had made no admissions that connected him with the crime. From all the circum-

stances in the case the finding of a pistol in the cabin of the deceased, and a hatchet in his hand, evidenced that there may have been a fight. There was he contended no evidence to connect the defendant with the death of the deceased.

Attorney Waldo S. Johnson made the closing argument for the defense. He commenced by replying to the argument made by Col. Forbes, and then took up the testimony, and disputed the theory advanced by the prosecution as to how the murder took place. There was nothing in the theory that the deceased refused to come out of his cabin, and that the defendant then set fire to same. There was testimony that the defendant had borrowed a shot gun, as he was in mortal fear of some one. It was not denied that he had made the spear to defend himself. He asked the jury to give the defendant the benefit of all reasonable doubts, and acquit him.

District Attorney McDaniel made the closing argument, and contended that there was no defense in the case. He claimed that there was no doubt that the defendant killed the deceased. The nature of the wound showed that the deceased was fleeing at the time he received the wound. The defendant had admitted that he poked the deceased with the spear and this is what inflicted the death wound. There was no defense of insanity, no evidence of insanity in this case, and it should not be considered. He had been defended by three young men of ability, but all the testimony showed a premeditated murder.

The Court then adjourned until 1 o'clock, at which time Judge Davis read his instructions to the jury, who retired to consider their verdict at 1:30.

The jury came into court at 2 o'clock, when the foreman, John P. Swift, brought in a verdict of guilty of murder in the first degree and adjudged that the prisoner suffer confinement in the State Prison for life.

Judge Davis set Thursday morning at 10 o'clock as the time for passing sentence. After the jury had been discharged it was ascertained that one juryman voted for capital punishment for several ballots; two voted for murder in the second degree, and one for manslaughter. It took half an hour to arrive at the verdict that was finally rendered. [September 25, 1901]

CONDENSATIONS

Ah Quen, who will receive a life sentence to-morrow for the murder of Ah Jim, is said to have murdered a Chinaman on a previous occasion in Downieville. He was also caught in the act of stealing chickens at North San Juan and took a shot at his pursuers, the bullet grazing a young man's head. [September 26, 1901]

AH YUEN SENTENCED

Ah Yuen, convicted of murder, was brought before Judge Davis in the Superior Court yesterday afternoon, a jury having convicted him of murder in the first degree, and having adjudged that he be imprisoned in the State Prison for life.

Judge Davis ordered that he be confined in San Quentin State Prison for the term of his natural life. When Ah Yuen was being taken back to his cell he stated that two other Chinamen had committed the murder. He complained that several of his countrymen had come to his cell the night before and disturbed his slumbers. When told that he was the only Chinaman in the jail he laughed. He claimed to have several hundred dollars buried near Freeman's crossing, and stated that a Chinaman named Ah Mow had $400 belonging to him. The story is not believed, he having borrowed $1.50 the day before the murder, promising to return it when he sold some gold dust. [September 29, 1901]

SAN QUENTIN PRISON RECORD

DATE:	OCTOBER 3, 1901
COMMITMENT NO.:	19202
NAME:	YUEN, AH
CRIME:	MURDER 1ST DEGREE
COUNTY:	YUBA
TERM:	LIFE
NATIVITY:	CHINA
AGE:	70
OCCUPATION:	MINER
HEIGHT:	4' 11 1/2"
COMPLEXION:	COPPER
EYES:	MAROON
HAIR:	BLACK
DISCHARGE DATE:	DIED DECEMBER 11, 1908